Photographing Nature

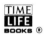
TIME
LIFE
BOOKS ®

Other Publications:

The Seafarers
The Encyclopedia of Collectibles
World War II
The Great Cities
Home Repair and Improvement
The World's Wild Places
The Time-Life Library of Boating
Human Behavior
The Art of Sewing
The Old West
The Emergence of Man
The American Wilderness
The Time-Life Encyclopedia of Gardening
This Fabulous Century
Foods of the World
Time-Life Library of America
Time-Life Library of Art
Great Ages of Man
Life Science Library
The Life History of the United States
Time Reading Program
Life Nature Library
Life World Library
Family Library:
 How Things Work in Your Home
 The Time-Life Book of the Family Car
 The Time-Life Family Legal Guide
 The Time-Life Book of Family Finance

Photographing Nature

BY THE EDITORS OF TIME-LIFE BOOKS

TIME-LIFE BOOKS, ALEXANDRIA, VIRGINIA

ON THE COVER: From stars above to earthworms below—or from abstract owl to literal cabbage leaf—the nature photographer's domain is illimitable. And with nature more than any other subject, he can achieve noteworthy pictures by simple means as well as complex. To photograph this cabbage leaf, Paul Caponigro simply propped it against the inside of a window on which he had spread tissue paper to make the glass translucent instead of transparent, and shot the leaf against daylight to bring out its veins and folds.

But for Horst Haider the portrait of an owl was only the beginning. He transferred a detail of the head to copying film and solarized it, preserving the border lines between contrasting areas of tone value as fine transparent lines. Next he made a negative on which these lines appeared as black on white. This line negative was registered exactly with a negative made from the original picture, then printed under an oblique light to expose all but the thin lines. On the resulting white-on-black print he painted in the black eye dots. Each in his way, one brilliantly simple, one ingeniously complex, produced a striking example of the world around us, which is the province of this book.

Contents

Time-Life Books Inc.
is a wholly owned subsidiary of
TIME INCORPORATED

FOUNDER: Henry R. Luce 1898-1967

Editor-in-Chief: Hedley Donovan
Chairman of the Board: Andrew Heiskell
President: James R. Shepley
Vice Chairman: Roy E. Larsen
Corporate Editors: Ralph Graves,
Henry Anatole Grunwald

TIME-LIFE BOOKS INC.

MANAGING EDITOR: Jerry Korn
Executive Editor: David Maness
Assistant Managing Editors: Dale M. Brown,
Martin Mann, John Paul Porter
Art Director: Tom Suzuki
Chief of Research: David L. Harrison
Director of Photography: Robert G. Mason
Planning Director: Thomas Flaherty (acting)
Senior Text Editor: Diana Hirsh
Assistant Art Director: Arnold C. Holeywell
Assistant Chief of Research: Carolyn L. Sackett

CHAIRMAN: Joan D. Manley
President: John D. McSweeney
Executive Vice Presidents: Carl G. Jaeger (U.S.
and Canada), David J. Walsh (International)
Vice President and Secretary: Paul R. Stewart
Treasurer and General Manager:
John Steven Maxwell
Business Manager: Peter G. Barnes
Sales Director: John L. Canova
Public Relations Director: Nicholas Benton
Personnel Director: Beatrice T. Dobie
Production Director: Herbert Sorkin
Consumer Affairs Director: Carol Flaumenhaft

LIFE LIBRARY OF PHOTOGRAPHY

Editorial Staff for *Photographing Nature:*
EDITOR: Richard L. Williams
Picture Editor: Patricia Maye
Text Editor: Anne Horan
Designer: Raymond Ripper
Assistant Designer: Herbert H. Quarmby
Staff Writers: George Constable,
Maitland A. Edey, Suzanne Seixas,
John von Hartz, Bryce S. Walker
Chief Researcher: Nancy Shuker
Researchers: Helen Greenway, Lee Hassig,
Don Nelson, Jane Sugden, John Conrad Weiser,
Johanna Zacharias
Art Assistant: Patricia Byrne

EDITORIAL PRODUCTION
Production Editor: Douglas B. Graham
Operations Manager: Gennaro C. Esposito
Assistant Production Editor: Feliciano Madrid
Quality Control: Robert L. Young (director),
James J. Cox (assistant),
Michael G. Wight (associate)
Art Coordinator: Anne B. Landry
Copy Staff: Susan B. Galloway (chief),
Barbara Fairchild, Ruth Kelton, Florence Keith,
Celia Beattie
Picture Department: Dolores A. Littles,
Gail Nussbaum

CORRESPONDENTS: Elisabeth Kraemer (Bonn);
Margot Hapgood, Dorothy Bacon (London);
Susan Jonas, Lucy T. Voulgaris (New York);
Maria Vincenza Aloisi, Josephine du Brusle
(Paris); Ann Natanson (Rome). Valuable
assistance was also provided by:
Carolyn T. Chubet, Miriam Hsia (New York).

In most areas of photography man glorifies himself and his possessions. He, his species and his works, good and bad, are spread across acres of film and printing paper that display his babies and buildings, his arts and artifacts, all the things he sells and buys.

Not here. In this book about photographing the natural world, man is really just an offstage voice. He is the inventor-operator of the imagemaking apparatus, but is not in the picture itself, and does not belong there.

Our aim has been to show the natural world in all its infinite variety, almost as if man were the one animal that did not exist in it. Since he has left his mark nearly everywhere by now, ignoring his presence is not always easy for the photographer. But it can be done, and it is not necessary to go to the ends of the earth to do it. There are pictures here from exotic places, but there also are pictures made in zoos and aquariums, in nearby woods and even in home studios. The pure landscape is here; the scenic highway, the gas station—even the backpacker—are not.

The subject of this book is as big as all outdoors and a lot older than photography. But two things about it are relatively new. One is that nature photography has become an increasingly popular activity for the nature-loving nonprofessional. By the hundreds of thousands, amateurs are discovering and rediscovering nature with camera clubs and wildlife societies on photographic field trips, and at zoos and botanical gardens, some of which even have photography courses.

The other new fact is that nature photography has become extremely versatile technologically. This book is intended to help even the neophyte by showing him how to make the most of the various types of equipment. Several specialized pursuits, such as underwater, safari, zoo, close-up and landscape photography, are examined in detail. The reader should not feel disappointed, though, by the fact that in one lifetime he cannot possibly explore and exhaust them all. No one can. The whole subject is just too big. But by the very nature of nature, each part can be as rich and satisfying as the whole.

The Editors

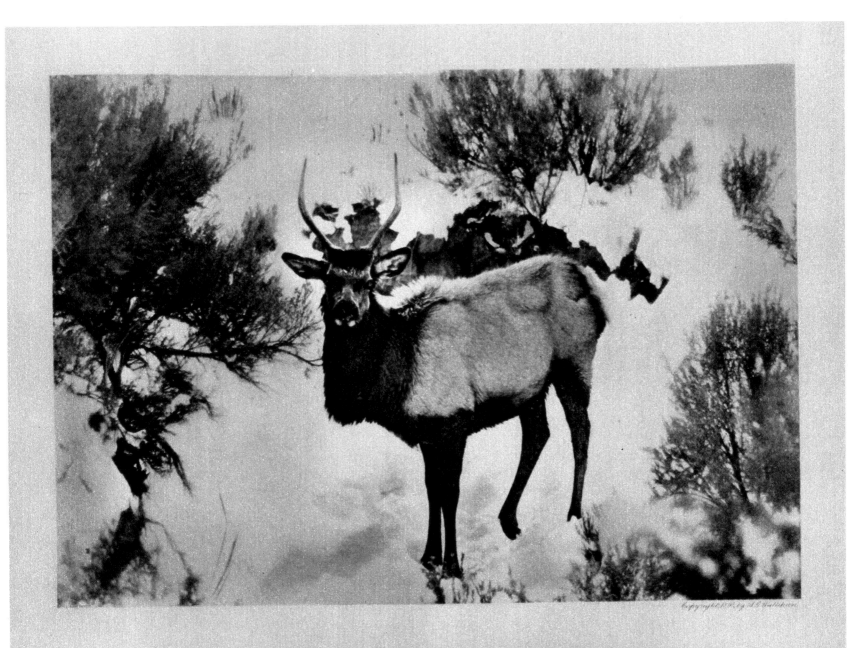

Portrait of an Elk

Photographed from life by A. G. Wallihan

A. G. WALLIHAN: *Portrait of an Elk*, 1895

The Lure and the Lore of Nature Photography

One of the most pervasive human interests is a fascination with nature. From the child's collection of beetles to the latest photographs of jungle creatures, from amateur deep-sea diving to microscopic research of single-celled plants and animals, there is an eternal appeal about nature that is tied to the central truths of life itself.

Today that natural interest is compounded by nostalgia. Defeated by the cities, sheltered from the elements, divorced from the earth, the urban dweller daydreams of unpolluted streams, unpopulated woods, the freedom of birds and fish. Nature photograhy is a postcard from and an homage to an age of innocence. In an era concerned with ecological preservation, pictures of nature are visible reminders of what is worth preserving.

Nature photography is at once an art, a science and a sport. As an art, it can make the ordinary remarkable, discovering intricate beauty in a snowflake, in a rain-silvered cobweb or in humble dandelions. And at many points the search for beauty blends with the search for scientific truth. The photograph depicts the beauty of the savanna and its inhabitants—and simultaneously reveals what the naturalist had not seen before.

Most nature photographers, however, are primarily neither artists nor scientists, but sportsmen armed with cameras. Disdaining the rifle, these hunters prefer to bag their quarry on film. The camera safari is replacing the big-game expedition, and a color photograph of a leaping gazelle, rather than a stuffed lion's head, hangs over the mantel.

When photography was born in the 19th Century, the nature photograph was born with it. One reason for this early fascination with nature was the era of Romanticism. Taste at the time turned toward the exotic, the extraordinary, the superlative. Music lost its measured accents and became turbulent with passion. The balanced couplets of Alexander Pope were displaced by the sensuous imagery of Byron. The lords and ladies of the salon gave way to Rousseau's noble savages. Even the way nature itself was perceived underwent a change. Mountains were no longer regarded as obstacles to travel but rather as marvels to thrill the human spirit.

So the photographers of the last century scaled the Alps, sailed to the Orient, flocked to America's great West. And they brought bizarre sights back to the cluttered Victorian drawing room. During the 1850s the stereoscope was introduced to the public, and between 1854 and 1858 the London Stereoscope Company sold two and a half million views of the Canadian woods, the Alps, the Nile and other spectacles of nature.

A second great cultural force that influenced nature photography was the science boom. Johann Wolfgang von Goethe took time out from his poetry to write a treatise on granite and to propound a theory of color (it was

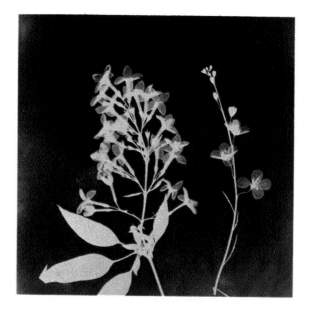

A negative print of botanical specimens was made in 1839 by William Henry Fox Talbot, pioneer of the negative-positive process. The image was made directly, without a camera, by placing the specimens on a piece of photosensitized paper and exposing it to light. To make a positive print, Talbot discovered, such a negative image could be placed on a second sheet of photographic paper and re-exposed. Talbot called this kind of work photogenic drawing, which he explained as being "the process by which natural objects may be made to delineate themselves without the aid of the artist's pencil."

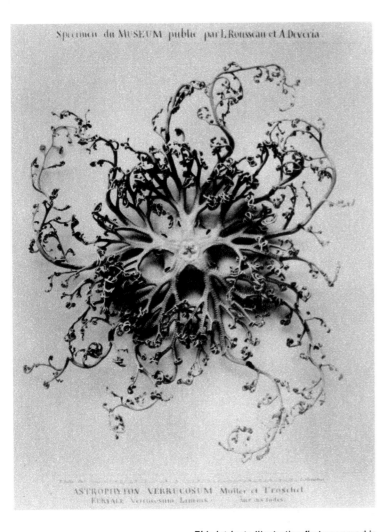

ASTROPHYTON VERRUCOSUM Müller et Troschel
EURYALE Verrucosum Lamarck sur ses faces

This intricate illustration first appeared in 1853 in Photographie Zoologique, a nature encyclopedia published in Paris. The printing plate was made by exposing the image onto a light-sensitive metal surface. The picture is of a sinuous relative of the common starfish, and was taken by the Bisson brothers, best remembered today for their photographic ascent of Mont Blanc.

inaccurate). An American painter named Samuel F. B. Morse became more famous by inventing the telegraph. Oliver Wendell Holmes speculated on visual perception. Henry David Thoreau studied animals in their natural habitat around Walden Pond. Alfred, Lord Tennyson attempted to reconcile the new theory of evolution with Christianity in his long poem *In Memoriam.* Nature photography satisfied the scientific vogue as well as the craze for romantic exotica, though many Victorians would have been hard pressed to specify which taste they were indulging at any given moment.

In the earlier decades the chief subject of nature photography was scenery, mostly because it didn't move. The long exposures required by both the daguerreotype (introduced in 1839) and the collodion wet-plate process (1851) gave the nature photographer little choice. Yet he was ready to brave any hardship in order to capture a striking picture. In 1861 the French photographer Louis Auguste Bisson—and 25 porters carrying a virtual factory to prepare and develop wet plates—scaled 16,000-foot Mont Blanc. At that dazzling snow-clad height Bisson had to erect a dark tent where he could coat his glass plates with liquid collodion and bathe them in silver nitrate. After the plate was exposed, snow had to be melted over a lamp to provide water for the development process. At the end of one arduous day the triumphant little army descended with three photographs—two of them good—and returned to the French border town of Chamonix, where their success was celebrated with a fireworks display. Soon Louis Auguste and his brother, Auguste Rosalie, were selling thousands of their Alpine panoramas. Bisson *frères* became so famous that Napoleon III invited them to record his ascent of the Alps. Perhaps the Emperor's choice arose as much out of an interest in his hobby as in historical record: Napoleon had become an amateur photographer, and had himself ordered a fast lens from England. It was mounted in silver and engraved with the imperial arms.

Later Alpine photographers even took along models on their ascents. When a 19th Century German photographer, Theodor Wundt, climbed the Alps in 1893, he was accompanied by a young lady mountain-climber who posed demurely beside the frightening precipices. Her name was Jeanne Immink, and she described her experience as follows: "He was standing right next to a vertical drop and wanted to photograph me. My God, you should have seen him. The ledge where he was standing was only a foot wide, but he didn't give it a thought. In an instant he had opened his tripod and ducked behind his black cloth. 'The left hand a bit higher, please, still higher. Good. Put your left foot forward. Fine.' You had to be there to see how he twisted and turned in order not to knock the camera over the cliff. The whole thing was unbelievably dangerous and could easily have ended

in disaster, but he shouted, *'Achtung!* Now, please, smile and look down into the abyss.' "

In America photographers had discovered a landscape as wild as any in Europe. In 1853 the daguerreotypist S. N. Carvalho wrote to the editor of America's *Photographic Art Journal:* "I succeeded beyond my utmost expectation . . . on the summits of the highest peaks of the Rocky Mountains with the thermometer at times from twenty degrees to thirty degrees below zero, often standing to my waist in snow, buffing, coating, and mercurializing plates in the open air." There spoke the ultimate nature photographer —slightly mad, full of enthusiasm and standing in snow up to his waist. Most of Carvalho's friends—and the editor of the *Journal*—told him he was courting failure; but Carvalho replied, "I am happy to state that I found no such word in my vocabulary."

Landscape photography made a major advance when the wet-plate process came into general use in the 1850s. The new process had many advantages over the daguerreotype. A photograph could be looked at from any angle, whereas a daguerreotype had to be held exactly so to catch the light. Moreover, a wet-plate negative could produce countless positives, while the daguerreotype *was* the picture. Still, wet plates required that the photographer take a darkroom with him everywhere. One journeying cameraman, Charles Savage, fitted out a huge wagon for his tour through the West in 1866. He described it as "about nine feet long and six feet high in the dark room, leaving three feet of space in front for carrying a seat and provisions. The sides are fitted with grooved drawers for the different sized negatives, and proper receptacles for the different cameras, chemicals, etc." Thus equipped, he took the first photographs of such scenic wonders in Wyoming as South Pass, Devil's Gate and Independence Rock.

After the Civil War scores of photographers poured into the West to take pictures of the region's mountains, rivers, falls, deserts, canyons and unusual flora and fauna. Many of them accompanied geological surveys that were backed by the government or the Smithsonian Institution. Some of these photographers, like Alexander Gardner, worked alongside crews laying track for the transcontinental railroad, producing pictures with such imaginative captions as "View embracing twelve miles of prairie" or "The extreme distance is five miles off." Others took off on their own and never returned. One brief newspaper account in 1866 read: "Mr. Ridgway Glover was killed near Fort Phil Kearney on the 14th of September by the Sioux Indians. He and a companion had left the Fort to take some views. They were found scalped, killed and horribly mutilated."

There were less lethal but still annoying enemies of the early adventur-

ers. Timothy O'Sullivan, one of the most famous photographers of the West, made an expedition to the Humboldt Sink of Nevada, and wrote: "It was a pretty location to work in, and *viewing* there was as pleasant work as could be desired; the only drawback was an unlimited number of the most voracious and particularly poisonous mosquitoes that we met with during our entire trip." Despite such harassments, more and more photographers entered the new territory. William Henry Jackson took the first pictures of Yellowstone in 1871. John K. Hillers photographed the Grand Canyon. L. A. Huffman recorded on film the last herds of buffalo that still roamed the open range. Today such names as Jackson Canyon in Wyoming and Mt. Hillers in Utah commemorate these pioneer photographers.

Other nature photographers were meanwhile pioneering in the somewhat less dangerous but equally adventurous field of photographing animals in the wild. By the 1890s even amateurs were taking pictures of birds on the wing and gazelles on the run. In the interval several important inventions had appeared. Dry gelatin plates had come onto the market in 1880. Unlike wet plates, they did not need to be prepared or developed on the spot, and they were so much more light sensitive that exposure time was reduced to less than one second. More important, roll film was soon being manufactured. Roll film could be loaded into small, hand-held cameras that were easily carried on field trips. Faster shooting was made possible when high-speed shutters were produced in 1890. Other innovations especially important for nature photographers were telephoto lenses, panchromatic "all color" film and lens filters with which black-and-white photographs could more accurately record the vast range of color in the natural world.

Technology not only gave nature photographers the equipment to take "instantaneous" pictures, as they were promptly called, but it also provided a process for widely reproducing the prints in books and magazines. By 1893, after nearly 40 years of experimentation and partial success, a method of cheap but accurate photographic illustration had been devised. It was the "half-tone process" (because the illustrations faithfully imitated the intermediate shades of gray in black-and-white pictures), and is still in general use. This process was an immediate boon to such pictorial journals as the *Illustrated London News, Illustrirte Zeitung* (Leipzig) and *L'Illustration* (Paris). In the United States general magazines like *Harper's Weekly,* as well as specialized ones like *Outing* that were devoted to nature and sports, began to print reproductions of photographs. At last photographers had found a mass market. It would shortly become even larger than the market developed by the fad for stereoscopic slides.

Armed with their new "instantaneous" cameras, nature photographers

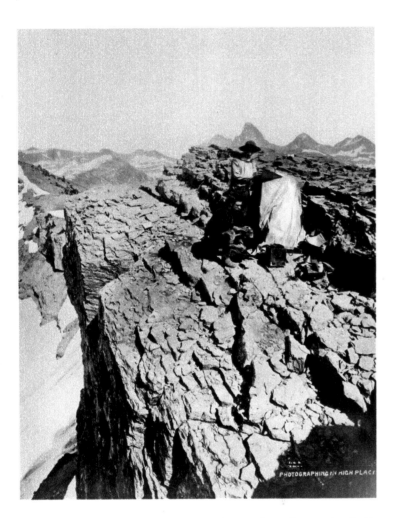

William Henry Jackson, shown on location in Wyoming's Grand Tetons in 1872, was one of the most famous among an enterprising and courageous band of frontier photographers. Their work, circulated mainly as stereoscopic views, familiarized Americans and Europeans with the splendors of the great American wilderness, luring sportsmen, adventurers and tourists into the wilds to see at first hand the grand vistas they had already viewed on film at home.

pursued wildlife with all the terrifying energy they and their predecessors had directed toward mountains and lakes. They set about studying the habits of their subjects. An article in *Outing* magazine, in 1900, printed photographs of a butterfly emerging from its chrysalis. The helpful accompanying text explained that the butterfly "rests quietly for about an hour to enable its tissues to harden preparatory to flight. . . . Place it where you will, and it will pose for you to your heart's content." The article also pointed out that wasps and bees rest quietly under flowers on rainy days, sometimes in such a dormant condition that they can be taken into the studio.

In the 1890s Mr. and Mrs. Allen G. Wallihan were so successful in catching animals in their natural surroundings in Colorado that they photographed a veritable portfolio of them, using the dry-plate process. This indefatigable couple hid for hours behind rocks and cedars beside deer trails. On one occasion, spotting deer while on horseback, they dismounted and, as Mr. Wallihan wrote, "The tripod is up quick as a wink, and the camera follows, the lens is attached, plate-holder inserted, and just as I draw the slide, they come out right in front of me, within twenty-five yards." On occasion, Mr. Wallihan could attract the animals' attention by whistling, breaking a stick or "bleating like a fawn."

The Wallihans' efforts led to excellent pictures but questionable zoological observations. On the subject of elks *(page 11),* Wallihan wrote, "I think they use their tusks or 'ivories' as a warning, by producing a squeaking sound with them." Evidently the elks did not squeak on one lucky day when the Wallihans were able to photograph a herd of 200 of them. ("The photo does not show near all, as they covered the plate, and quite a good many off at each end," he noted.)

By the 1890s the animals could not escape the photographers even at night. A Pennsylvania conservationist and congressman, George Shiras III, invented a gun that fired a magnesium flash, enabling him to illuminate his quarry in the dark. Shiras' nocturnal pictures of deer won first prize at the Paris World Exposition in 1900 and provoked a French aristocrat to exclaim, "How happy I would be to place these splendid pieces in my hunting castle." Soon Mr. and Mrs. Wallihan were hunting deer at night with a flash lamp, Mr. Wallihan remembering that after the blinding light was fired the deer scattered so wildly that "You laugh at their confusion until your sides ache."

Modern nature photographers know that birds are shy of strange movement but generally will continue their normal activities if human beings are out of sight, inside a canvas blind. Earlier photographers, however, felt they had to hide in fake trees or under piles of hay. One description of bird photography at the turn of the century was printed in a book titled *Wild Life at Home: How To Study and Photograph It,* by the English photographer Rich-

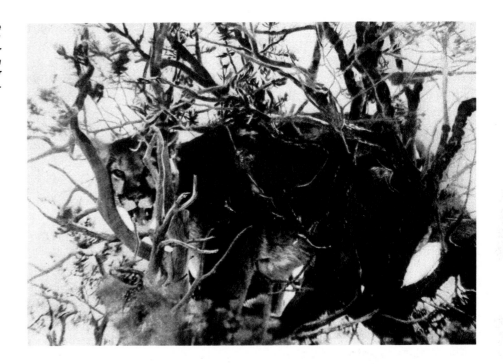

"An ugly customer," wrote A. G. Wallihan as the caption for this photograph of a cougar in his 1901 book Camera Shots at Big Game. "Too close for comfort" might have been more apt—for Wallihan had to shoot from a distance of only 25 feet after the cougar had been treed by two hunting dogs.

ard Kearton. Kearton made his blind by wrapping green cloth around a frame and arranging the top to represent a storm-snapped trunk. "My wife painted the whole to represent bark," he explained, "and when it was dry my brother glued small pieces of moss and lichen to it, and I fastened a number of pieces of strong thread to the wire inside and passed the ends through to the outside. With these we tied on a number of sprays of ivy, which we stripped from the trunks of trees. . . . The device, it is pleasant to relate, answered our highest expectations upon the very first trial."

Such undeniable advances in technology prompted armies of photographers to go to every corner of every land, and even underwater *(Chapter 4)*. The explorer and naval officer Robert E. Peary took a camera with him on an Arctic expedition; but he complained that the monotony of the Greenland ice cap provided little to photograph, and that "the interesting subjects for the camera figure down practically to the dogs."

The most celebrated photographers of nature went to Africa. Mr. Wallihan had predicted: "In the future, the literary hunter will tell you of his emotions while arranging his camera, how he felt as he looked into the eyes of the advancing animal . . . and prospected the chances of a good negative." Titled and untitled rich men traveled through the jungle with safaris of as many as 130 porters. Books were published with titles like *Camera Adventures in the*

African Wilds and *Flashlights in the Jungle.* Among the most famous nature photographers in Africa were Martin and Osa Johnson, an American husband-and-wife team who made a very good business of photographic safaris. On their 1933 trip to Africa they took along 50,000 dollars' worth of lenses, innumerable cameras and two airplanes, his and hers. The Johnsons wrote books about their trip and their text was frequently as colorful as their pictures. One book, *Over African Jungles,* describes a lion: "He was one of the handsomest lions I ever saw . . . and I can't think of a better way to describe him than to quote Osa. 'Why, Martin,' she whispered, still with her hand on my knee, 'he's a perfectly beautiful platinum blond.' " Their safaris were not without danger. Martin Johnson wrote of one instance in which he and Raymond Hook were photographing a female leopard from a blind: "Before I realized what was happening she sprang squarely through the too-large opening in the blind, and struck the camera behind which I was standing, sending it back against my face. That in itself half stunned me, but then, with such a crash in my right ear as made me think that the sky had fallen, Raymond's gun exploded in her very eyes. She was clutching at the camera not eighteen inches from me, and suddenly I felt her hot blood splash across my cheek. I still was too astounded to realize just what had happened, but then I saw her hold on the camera relax, and in another moment she fell limp, her head and body dangling down among the legs of the tripod of the camera . . . her hind legs supported by the lower edge of the opening in the blind."

Similarly an English author, Marius Maxwell, warned his readers in 1924 of the dangers of photographing wild elephants: "Face-to-face meetings are at all times nasty incidents, and particularly speculative at close quarters." Such confrontations could be avoided, he went on, by learning to decode elephant sounds. With a confident knowledge that might dismay a zoologist, Maxwell listed 11 different elephant sounds, including "a low squeaking sound" signifying "contentment or pleasure," and the elephant's danger signal, "a continued rumbling noise" indicating that "the members of a feeding herd are about to be alarmed." In dealing with a charging rhino, Maxwell warned, "a side-step in the nick of time is possible, but requires agility, and remains at all times a risky performance."

Today the nature photographer may still have to beware of the charging animal, but most of the technical photographic problems that bedeviled his predecessors have been solved. A few lenses, a 35mm camera equipped with a light meter, and high-speed film enable the modern photographer to become a lightly burdened explorer. He has superb underwater equipment at his disposal, strobes for better lighting outdoors and in the studio, and

even a motorized camera that can take as many as three frames a second of a bounding tiger or galloping zebra.

But although most of the technical problems may have been solved, the excitement has not gone out of nature photography. The photographer must still find his subjects. He must observe when flocks of migrating ducks descend on a pond each season or where a prairie dog is likely to pop up out of his hole. Even more challenging is the problem of taking a new picture of an animal or a landscape that has been photographed many times before.

That, of course, is the real problem: vision. In the Seventh and Eighth Centuries a Buddhist painter in China would stare at a flower or a monkey for days before lifting a brush. Finally he would dash off an ink drawing with a few strokes. The flower was not seen as an object of sentimentality; the monkey was not comical; for the first time a flower or a monkey had been focused on and fully *seen* on its own terms. The good nature photographers are in the same tradition: it is precisely this sort of clarity of vision that distinguishes their work at its best. —*Edmund White* ☐

The World of Nature

Nature photographers may jet to Africa for camera safaris, penetrate the wilderness to record on film the creatures that live there or dive into the ocean's depths to capture the eerie, beautiful life underwater. Or they may find equally dramatic nature pictures in more mundane settings: a bird on a city window sill or a snowflake on a hat —scenes as incontestably "natural" as a whale or Mount Everest. Whatever the subject, photographs open up nature's world and reveal with fascinating clarity phenomena that men seldom have the opportunity—or the patience—to observe for themselves. Nature photographs, as those on the following pages show, preserve for inspection the bustling, colorful complexity of all the different forms of life on our planet. And besides providing information and insights, nature photographs often have a special quality that lends them an importance in their own right.

Some of the most celebrated nature photographers have also been scientists. Eliot Porter abandoned a career as a bacteriologist to become a photographer (his pictures of Glen Canyon appear on pages 40-42). Field biologists go everywhere with cameras slung over their shoulders. Ornithologists in particular find photography useful, since their feathered specimens are eternally in flight or perched on a distant branch and thus difficult to study.

One of these distinguished scientist-photographers is Bradford Washburn, whose dramatic photograph of an Alaskan glacier appears at right. Washburn studied and taught at Harvard's Institute of Geographical Exploration; in 1936 he led the first photographic flight over Mount McKinley. In the following year he took pictures of thousands of miles of the Yukon that had never been photographed—or seen—before.

Not all, or even most, nature photographers, however, are scientists. Many are simply people from other walks of life who are eager to capture in their pictures the fleeting, the hidden or the awesome scenes that are everywhere available in the realm of nature.

The forbidding, stunning reaches of desolate ▶ Barnard Glacier in Alaska's Wrangell Mountains, near the Canadian border, were taken with an aerial camera by explorer-photographer Bradford Washburn. Besides their undeniable esthetic quality, the patterns of this photograph graphically reveal the inexorable march not only of the main glacier, but also of the many lesser ones that contribute to its massive size and flow.

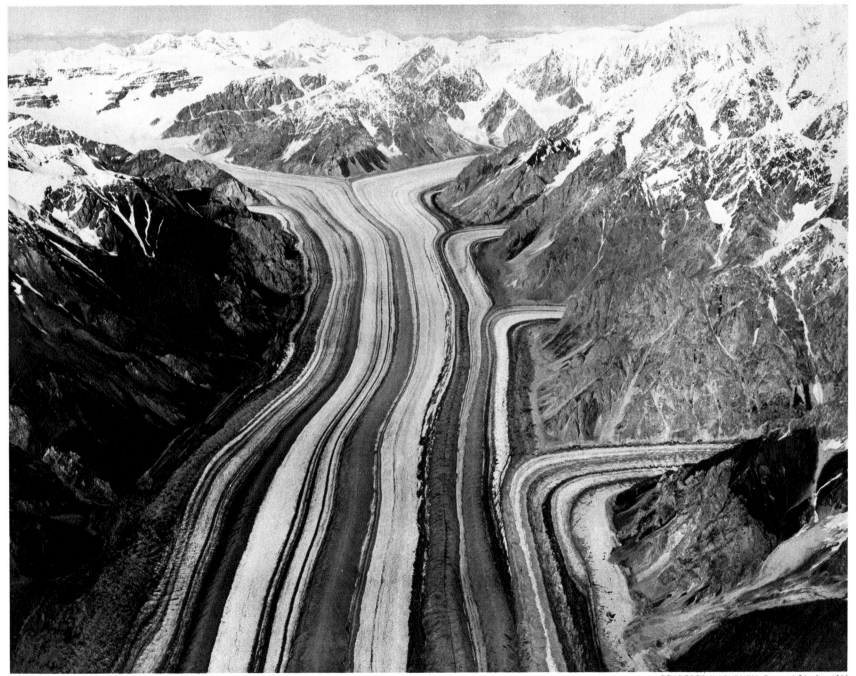

BRADFORD WASHBURN: *Barnard Glacier*, 1938

The Camera as Bird Watcher

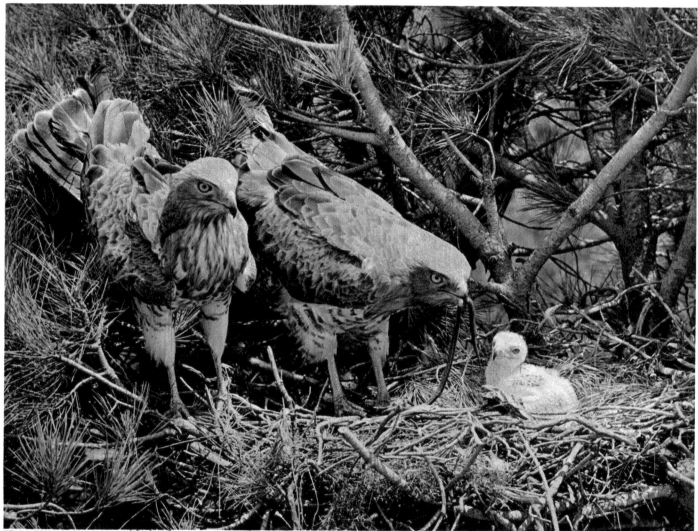

ERIC HOSKING: *Short-toed Eagles, 1957*

When naturalists undertook the complex project of identifying, counting and recording the birds of an isolated region in southwestern Spain, the camera played a key role in the venture. During three expeditions in 1952, 1956 and 1957, some 6,000 still pictures and 50,000 feet of motion-picture film were obtained. The chief photographer for the cataloguing project was Eric Hosking, who took the pictures shown here. As a result of all this camera work, several species of birds were photographed for the first time. More important, the extensive film record made by the naturalists helped to decipher the ways of the birds in the wild and to picture their living habits.

In the crown of a pine tree in Spain, a short-toed eagle chick is offered its dinner—a water snake —by its father. To take this picture, photographer Hosking perched atop a 28-foot pylon specially built for the purpose—19 feet from the nest.

Standing erect on its nest, a snow-white little egret ▶ displays the elegant plumage that was almost the species' undoing. So many egret feathers were used in women's hats that the fashion nearly caused the bird's extinction in the early 1900s. Now protected by law, the little egret is stalked only by bird watchers and nature photographers.

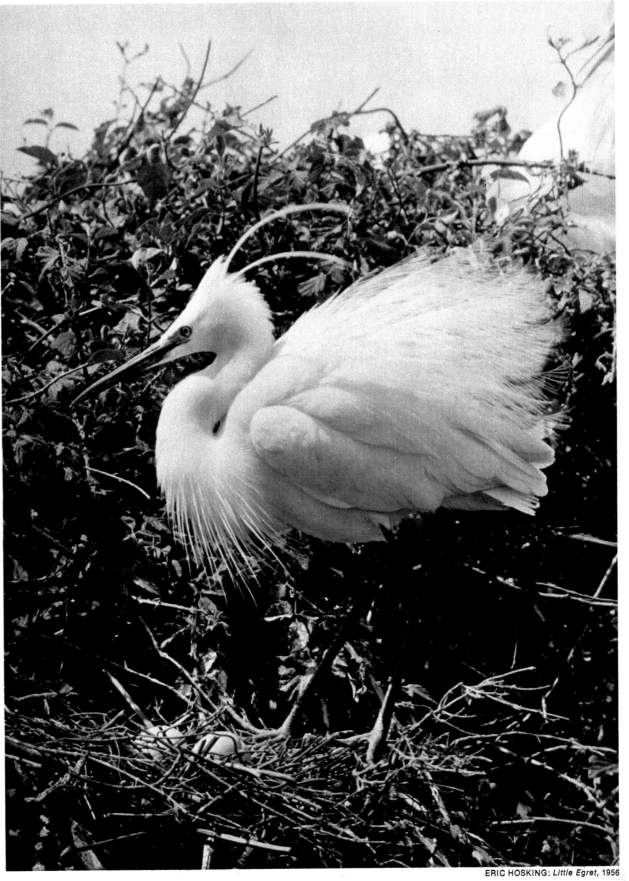

ERIC HOSKING: *Little Egret*, 1956

Split-Second Records of Motion

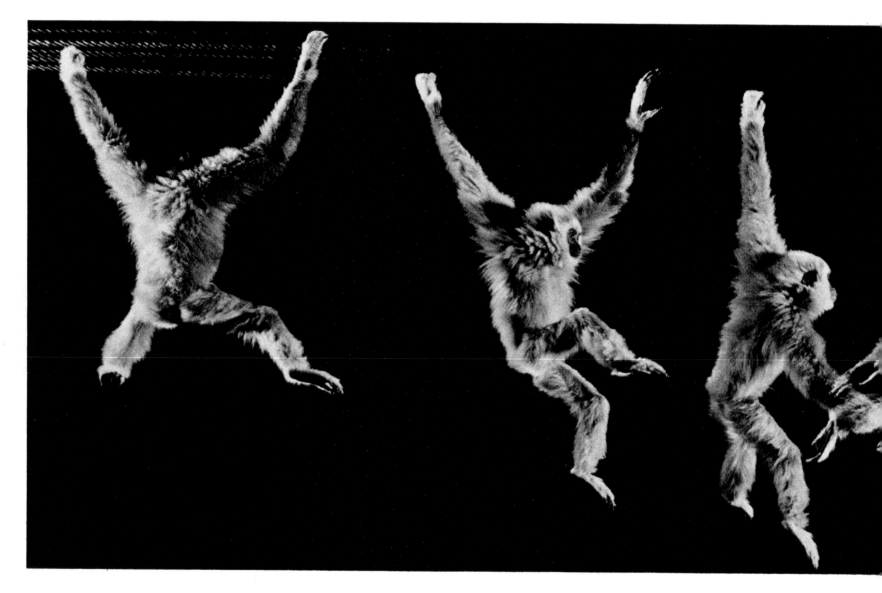

Although scientists have been recording animal locomotion with photographs since the 19th Century, today's sophisticated equipment produces pictures of such detail as earlier photographers never dared hope for. The multiple photograph above is of a gibbon brachiating (i.e., swinging hand over hand) along a rope in a studio, much as it would move from branch to branch in the jungle. This nimble mode of travel has always been intriguing to watch, yet before the advent of high-speed strobes, photographers could not reveal every detail of the gibbon's motions. Now, the sequence of split-second exposures shows exactly how a gibbon goes. Grasping the rope with its slender fingers, it brings its free arm rapidly forward to seize the rope, then it lets go with its back hand to start the process again. Through modern photography the moving gibbon becomes an informative frieze of animal action.

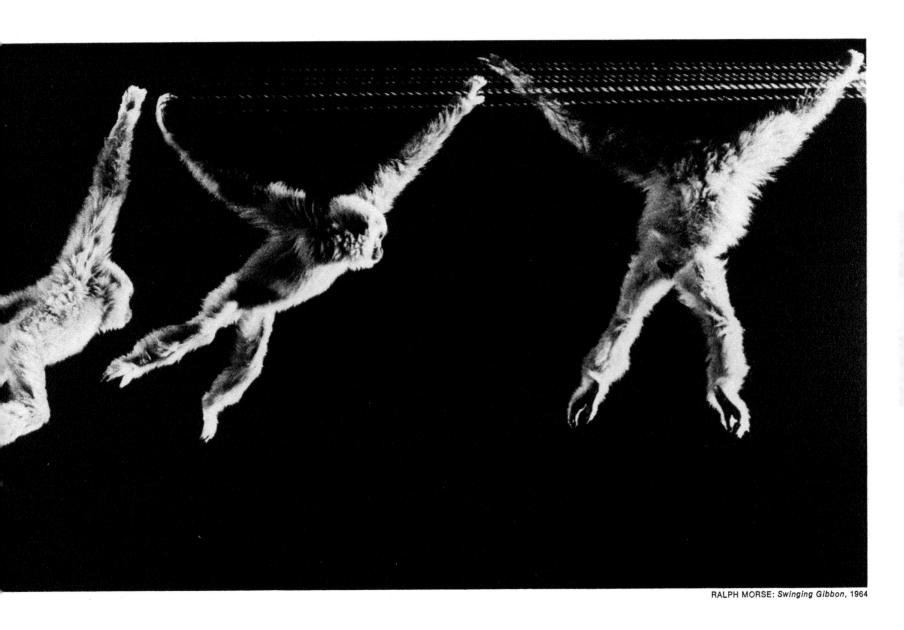

RALPH MORSE: *Swinging Gibbon, 1964*

A gracefully moving gibbon is caught in six
exposures made with strobes placed at either end
of the rope and set off by hand. The strobe
placement provided equal illumination along the
distance traveled and the exposure time in each
instance was the brief duration of the light.
The gibbon was lured along the rope by a bunch of
bananas held beyond camera range at right.

Revealing the Unfamiliar: Fire and Ice

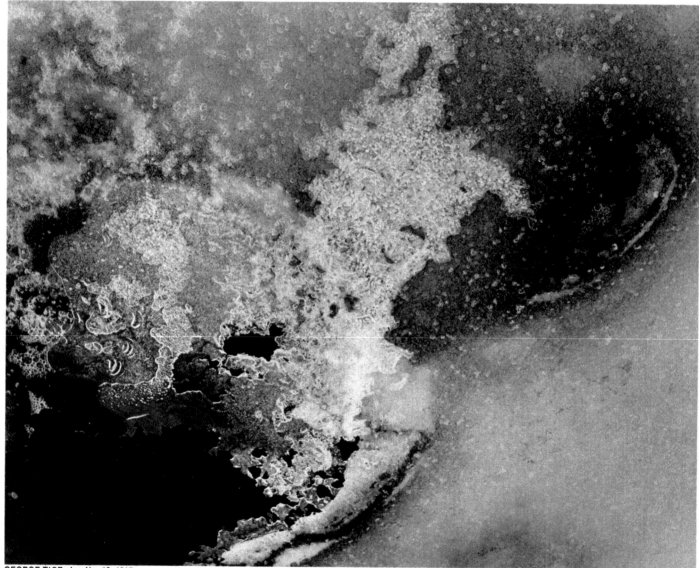

GEORGE TICE: *Ice No. 13*, 1967

The camera can often make the unknown known, whether it is photographed in an inaccessible corner of the world or in a back yard. Few people have stared into the crater of a volcano, but Franz Lazi, a freelance photographer, has brought to everyone the strange sight of mountaintop ice and snow surrounding a pool of molten lava at 2,000°F. By contrast, almost everyone has noticed ice covering a winter lake; yet photographer George Tice's view camera revealed this common sight in uncommonly sharp detail.

An unexceptional occurrence—ice covering the surface of water—provides a picture of haunting, crystalline beauty in this close-up taken with a view camera by George Tice. By focusing in and allowing the detail to create the picture, Tice has produced a stunning and unfamiliar nature study from an unexpected, though familiar, source.

Standing on a crust of earth just above a crater filled with glowing lava, Franz Lazi shot this picture on Mount Etna in Sicily. The crater, which had been erupting, was relatively inactive for this picture, shot at 1/50 second and f/11. By contrasting the molten lava with the blue ice-filigree at the crater's edge, Lazi emphasized the unearthly quality of this rare earthly phenomenon.

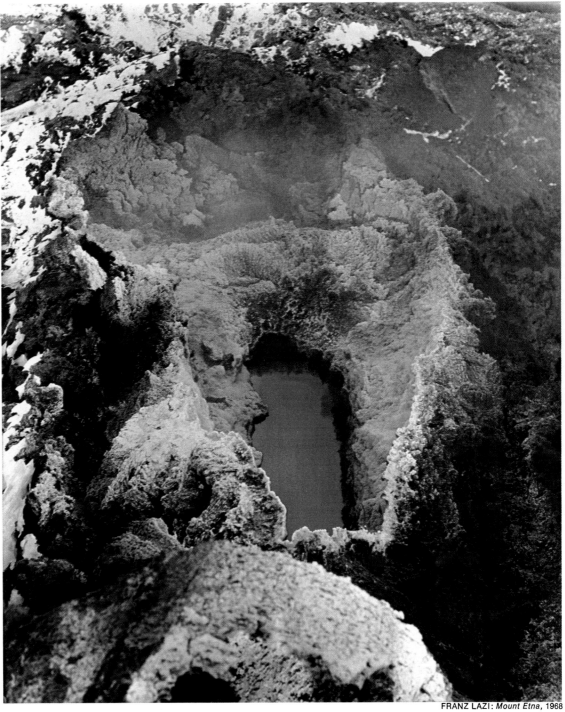

FRANZ LAZI: *Mount Etna*, 1968

Capturing the Spectacle of the Sky

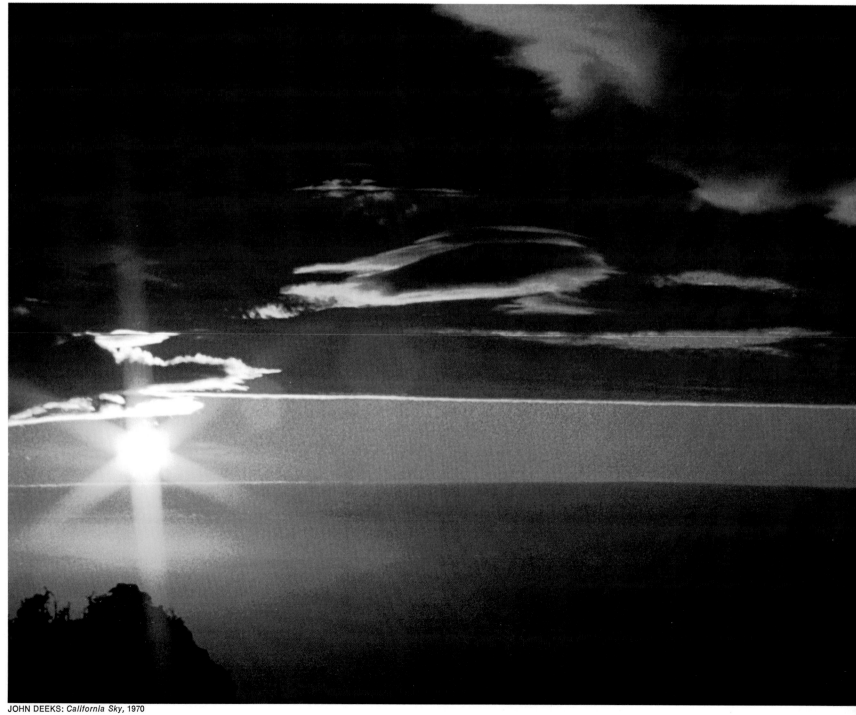

JOHN DEEKS: *California Sky*, 1970

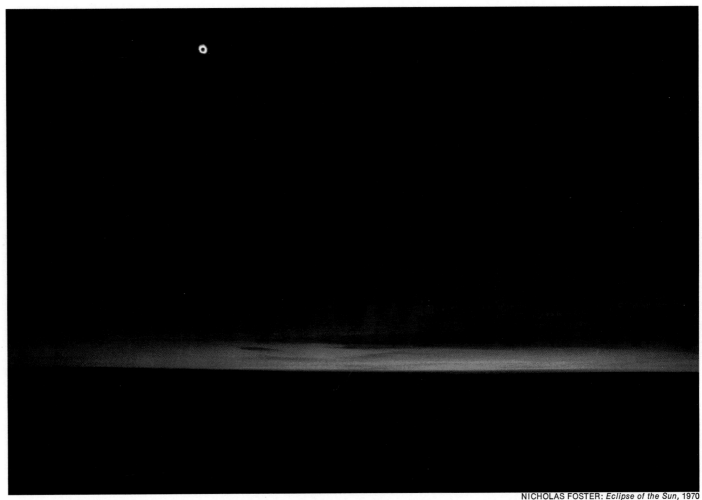

NICHOLAS FOSTER: *Eclipse of the Sun*, 1970

Taken from an airplane above Nantucket Island off Massachusetts, this picture of a total eclipse of the sun was shot with a 20mm wide-angle lens. The eclipse casts much of the earth below into darkness; but from the photographer's high vantage point, the wide-angle lens picks up a layer of light on the horizon just beyond the edge of the shadow cast by the eclipse.

◄ *A sunset shot from a Southern California mountaintop provides a panorama of sky patterns in this picture made with an SLR and a 35mm lens. The clouds form the top layer of the picture, while the setting sun is seen in the clear sky below them. What looks like the horizon beneath the sun is actually a thick layer of pollution.*

The biggest subject of all for the nature photographer is the sky. Astronomers have focused their telescopes on portions of the firmament to obtain pictures of the stars or to plot the paths of planets. But nature photographers too often ignore the sweep of the sky as a source of pictures. Once aware of its potential, some have found that the sky can produce pictures that are both beautiful and informative.

To capture one of nature's most dra-

matic occurrences, a total eclipse of the sun, photographer Nicholas Foster went up in an airplane for an unusual vantage point *(above)*. John Deeks, who took the picture at left, became entranced by the sky while he was a forest ranger stationed at a fire tower on a California mountain. The activity of the clouds, the odd effects of the sun's rays —even the layers of pollution—all contributed to this celestial spectacle of the earth's canopy at sunset.

Creatures in Ocean and Tank

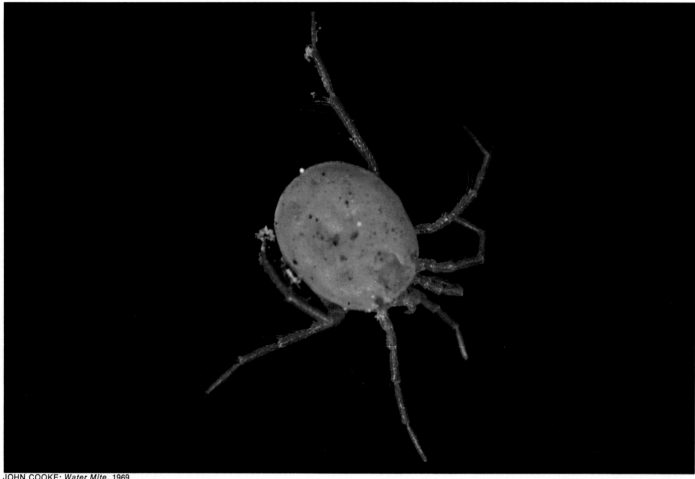

JOHN COOKE: *Water Mite,* 1969

Without photography the sea would remain *aqua incognita* to all but divers and marine biologists. But today the proliferation of underwater photographers—from tourists with snorkels to professionals like Douglas Faulkner *(pages 136-144)*—has made recognizable sights out of even such exotic sea creatures as the one at right.

Some creatures have to be brought into captivity before they can be photographed. The fresh-water mite above can barely be perceived by the naked eye. In order to take its picture, entomologist John Cooke placed it in a tiny tank of water. He then trapped it against the front of the tank with a glass slide that had a cavity in its surface. He used a 35mm camera with a four-inch extension tube to which a 40mm microscope lens was attached. The special lens provided clarity at short range—it was only two inches from the mite when the picture was taken—and the resultant photograph revealed every joint in the creature's almost microscopic legs.

Trapping a tiny water mite against the front of a tank, the entomologist-photographer mounted strobe lights on either side of it. He also set up adjustable mirrors that reflected the light at angles, adding dimension and texture to the mite's body with highlights and hints of shadows.

In the deep-blue water eight fathoms down off the ▶ coast of Japan, this 1⅓-inch-long jellyfish would seem a drab creature to the naked eye. But Douglas Faulkner, using a waterproof flash gun, elicited the tiny animal's bright colors.

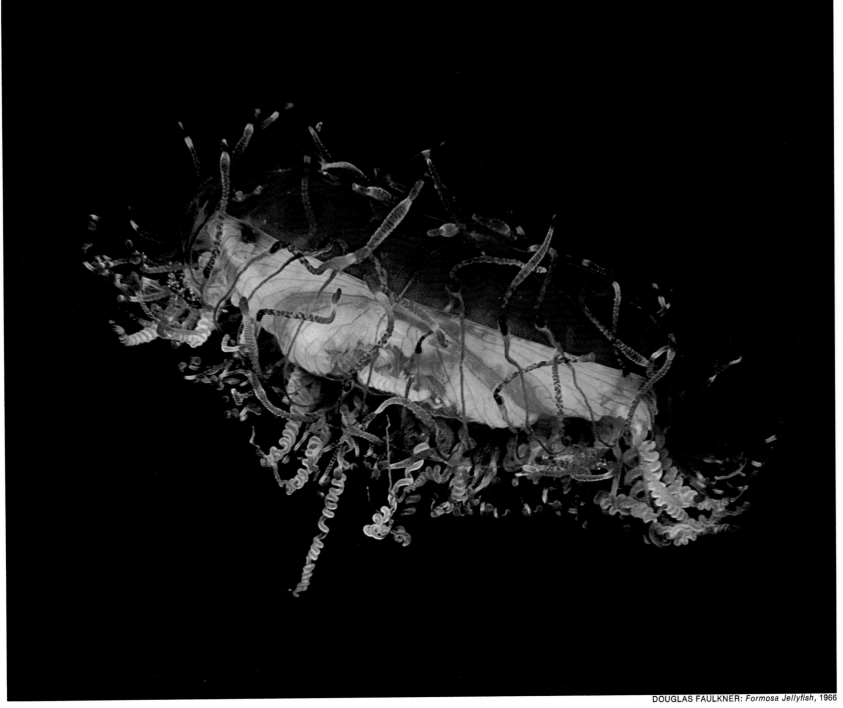

DOUGLAS FAULKNER: *Formosa Jellyfish*, 1966

Adding to the Colors of Nature

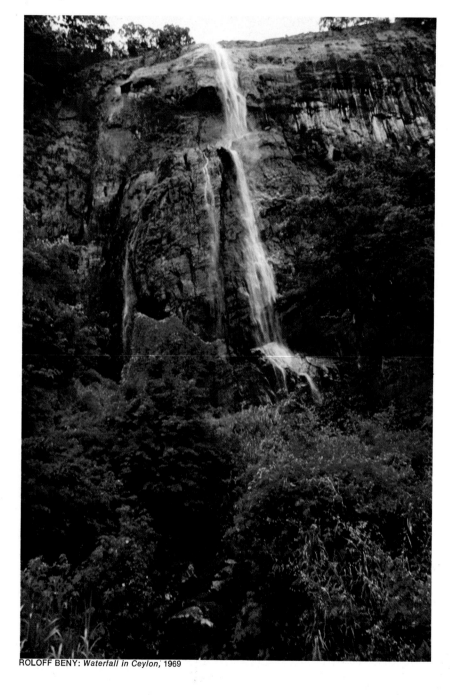

ROLOFF BENY: *Waterfall in Ceylon,* 1969

While photographic film generally has more limitations than the human eye, there are situations in which even ordinary color film can "see" more than the eye does. On a rainy day, when most photographers pack up their gear to await the return of the sun, more imaginative photographers use the rain itself to enhance the picture *(right).* The particles of rain water diffuse the light and soften the contrast. The water also reflects the blue light—characteristic of an overcast afternoon—onto the color film, which is more sensitive to blue than the human eye.

Infrared color goes a step farther. It is sensitive to colors that the eye does not detect at all. Thus an infrared photograph adds "false colors" to the waterfall at left, providing an artistic note for an otherwise familiar sight.

Infrared film shows this scene in Ceylon in "false colors": none of the colors are the way the human eye would see them because the film picks up both invisible infrared rays and visible rays. Thus the foliage appears red because its chlorophyll strongly reflects the infrared rays.

*In this picture of a forest grove at Yosemite ►
National Park, taken with regular color film by photographer Tom Tracy, the falling rain emphasizes the blue cast of a cloudy day. Everything seen in such weather conditions appears blue, almost as though it were being photographed—or viewed—under water.*

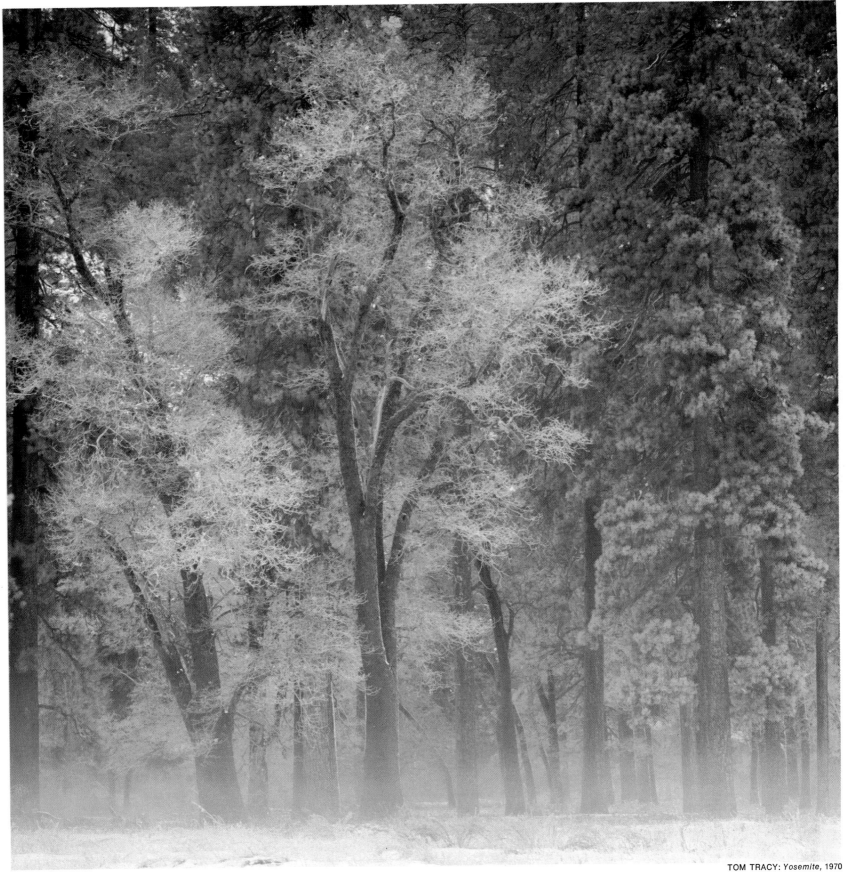

TOM TRACY: *Yosemite*, 1970

33

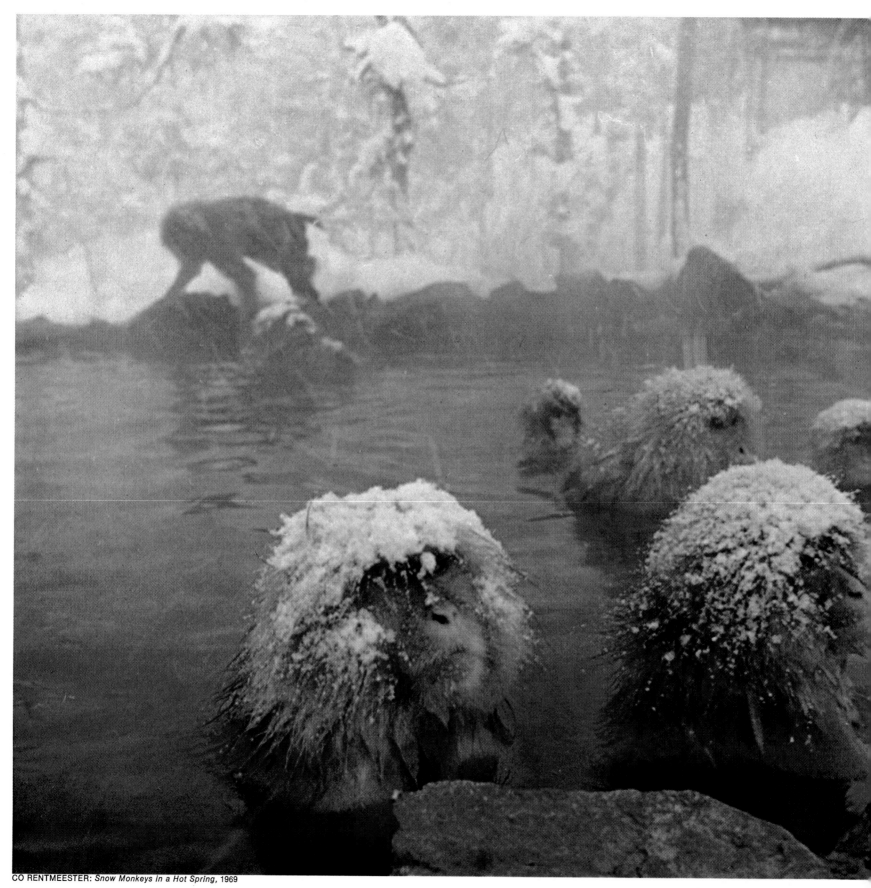

CO RENTMEESTER: *Snow Monkeys in a Hot Spring,* 1969

Catching the Unique Characteristic

In many studies of animal behavior, a camera is as necessary as a notebook. More than mere notes, the camera can record graphically the way animals live and act in their natural habitat for more careful study back in the laboratory.

In recording the curious snow monkeys of Japan, photographer Co Rentmeester prepared himself by visiting a primate expert at Kyoto University, where research on Japanese monkeys has been going on for two decades. There he learned that these unusual monkeys have adapted to life in the rugged Japanese Alps by foraging for food in bands, huddling together for warmth and even thawing out in the area's hot springs. Thus briefed, Rentmeester was able to get this appealing picture of the snow-capped monkeys squatting in the steaming waters of the hot springs and enjoying a brief respite in their struggle for survival.

In a natural hot spring, Japanese snow monkeys find their own relief from the cold weather. The photographer caught the moment of humorous incongruity when the monkeys warmed all but their snow-encrusted heads in the steamy water.

Setting up a Natural Situation

Sometimes the photographer has to move the natural habitat into an artificial—and more manageable—environment. The confrontation, at right, of an insect-eating South American marmosa (mouse-opossum) squared off against a tropical grasshopper its own size, was accomplished by transferring the two antagonists to a terrarium.

The result was not only a nature photograph that could not have been shot in the wild, but also a study that no artist could match. Only a photograph could convey the authenticity of the moment as the pugnacious little marmosa, with its bulging eyes and its anticipatory stance, realizes that it has met its match. (The grasshopper did prove too much of a challenge, and the marmosa backed off.)

While the camera is superior to the pen in capturing such fidelity to life, even less dramatic photographs serve as realistic evidence for the artist in his own work. And often the artist acts as his own photographer. The noted naturalist and illustrator Roger Tory Peterson has written, "In my studio, 35mm transparencies are projected on a Trans-Lux screen and then there is no question as to just how a duck holds its foot or how a leaf catches the light."

To make this picture of a showdown between an insect-eating marmosa and an insect its own size, an entomologist confined them in a 50-gallon terrarium that had been supplied with plants, sticks and rocks collected from the same spot in Panama as the animals. Using an SLR camera with a 50mm lens, the scientist-photographer lighted the scene with a strobe and reflector. Even in this small enclosure it was an hour before the two creatures met. But when they did, the photographer memorialized the scene on film.

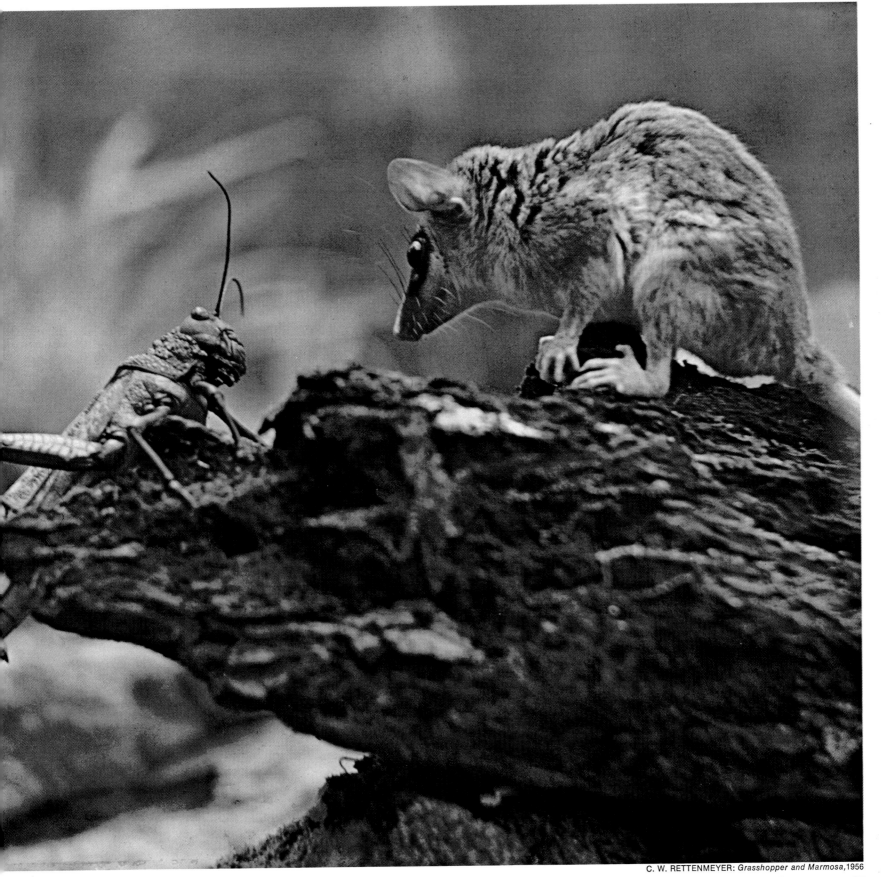

C. W. RETTENMEYER: *Grasshopper and Marmosa*,1956

Bagging a Photographic Trophy

More and more photographers have found hunting wild animals with a camera instead of a rifle more humane, and better sport. There are no closed seasons, no forbidden species and no "bag" limit. Furthermore, each hunter can achieve a different photographic interpretation of the same animal.

A photograph of a running cheetah, like the one at right, taken by John Dominis, reveals more of the cat's essential grace than any dead specimen could show. The cheetah is built to run, and its long legs, narrow waist and small head invariably make it appear awkward in repose.

Photographing an animal requires as much courage as hunting it with a gun. The photographer may have to stalk his quarry longer and at closer range than the conventional hunter does. But the animal that the photographer pursues may be shot time after time, and suffer no fate worse than overexposure.

To portray the speed of the cheetah, an explosive runner that has been clocked at 60 mph for bursts of a quarter of a mile, the photographer panned as the cat streaked past his camera. The blurred background and legs emphasize the sensation of swift motion. The photograph also reveals a secret of the cheetah's running style that the naked eye could not detect: at full tilt the animal touches the ground with only one paw at a time. To start the giant leaps by which it can cover 25 feet in a bound, the cheetah compresses its body, its feet tucked under it while a rear foot stretches forward—here the left hind foot is extended. When the rear foot touches the ground it is used to push off as the body uncoils and surges forward. The spring ends as a front paw lands and the body starts to compress again.

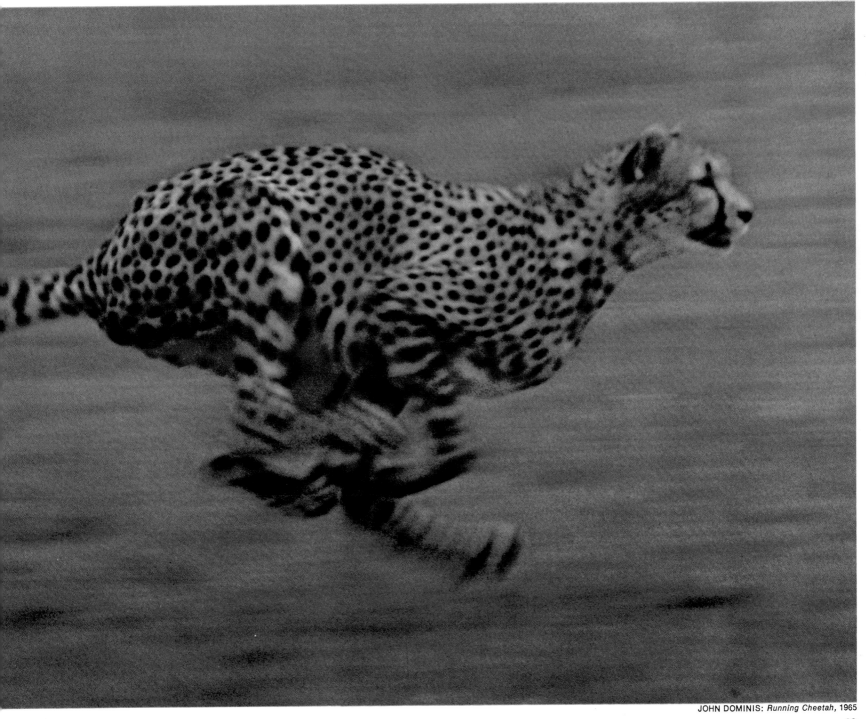

JOHN DOMINIS: *Running Cheetah*, 1965

Lasting Images of a Vanished Canyon

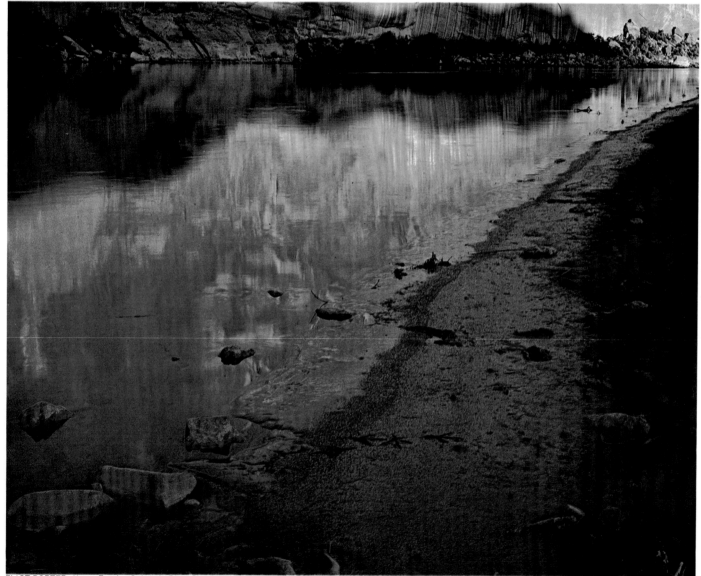

ELIOT PORTER: *Heron Tracks, Colorado River Shore,* 1961

Nature photography can provide an invaluable aid to history by preserving the look of scenic places doomed to disappear through human intervention.

In 1963 Glen Canyon, which extended 100 miles across the Utah-Arizona border, was flooded when the Colorado River was dammed as part of a hydroelectric and irrigation project. Before this scenic wonder disappeared from human view forever, Eliot Porter paid it a farewell visit with his camera. Porter's pictures, published by the Sierra Club as the book *The Place No One Knew,* acquainted the general public with the wonders of Glen Canyon for the first time—but only after it had been submerged. His pictorial record preserved forever the beauties of the canyon, which was soon to be drowned under a man-made reservoir. ☐

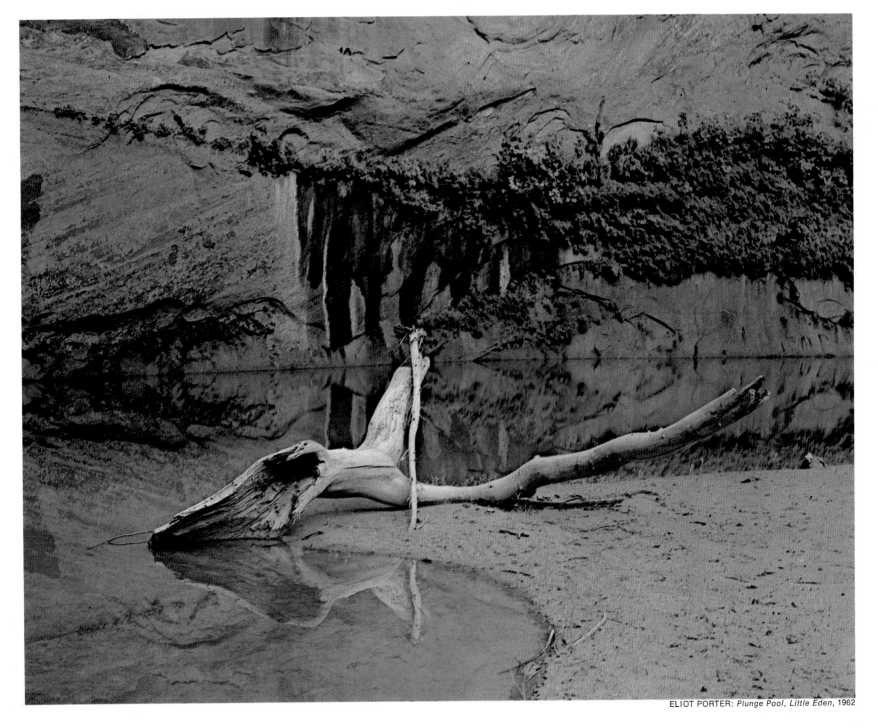

ELIOT PORTER: *Plunge Pool, Little Eden,* 1962

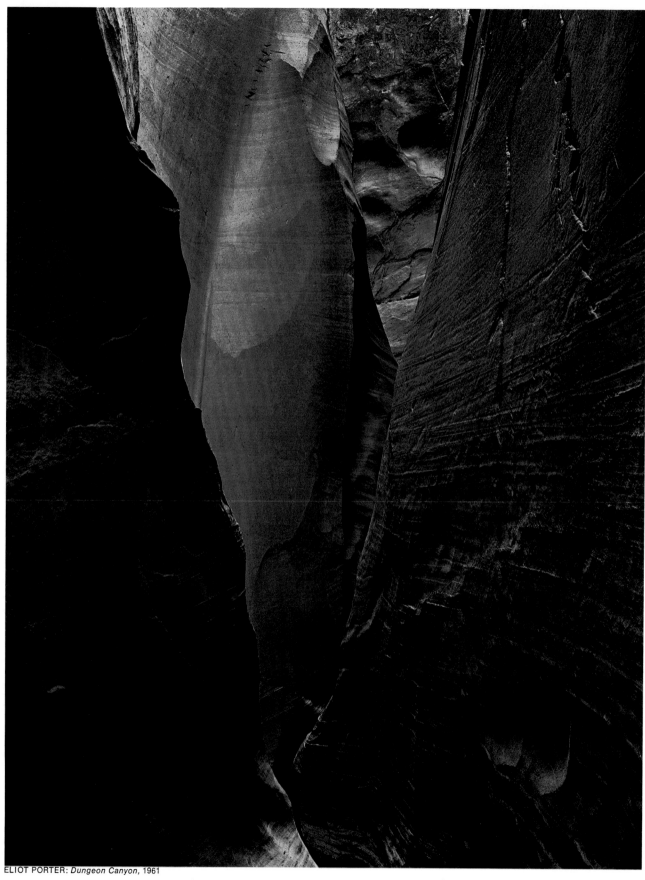

ELIOT PORTER: *Dungeon Canyon*, 1961

In the Field **2**

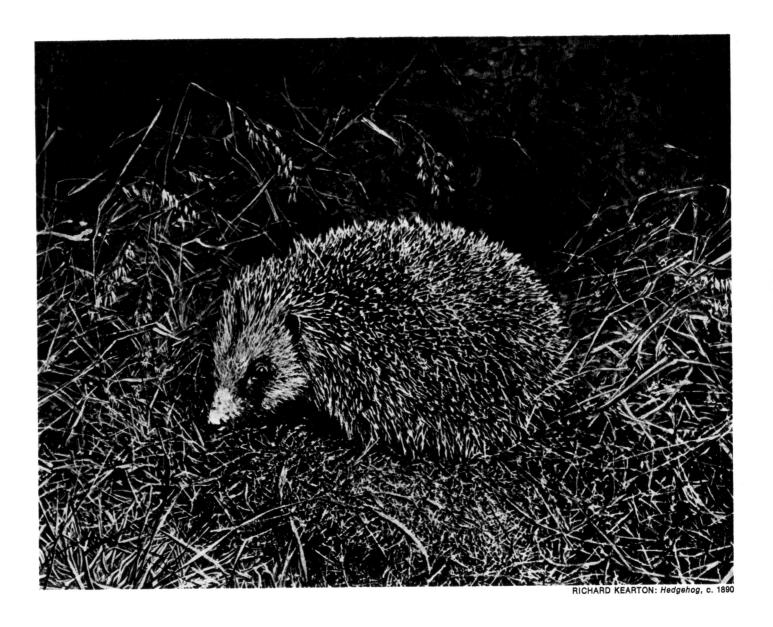

RICHARD KEARTON: *Hedgehog*, c. 1890

When to Go, Where to Go, What to Take Along

Outdoors is plainly the place for the nature photographer to spend most of his time: that is where his subjects are. And on his first or his hundredth trip to the field he will find pleasures offered by few other kinds of photography. Perhaps chief among these pleasures is the exhilaration of the hunt itself —the sheer joy of searching out subjects for pictures that will be in some measure unlike those anybody else has taken. A good example is the prickly portrait of a hedgehog on the previous page. The photographer may be sure of this variety because nothing in nature is completely predictable or subject to duplication. Few living creatures can be counted on to hold perfectly still. Many subjects in the field are so elusive as to be almost illusory. And the light is constantly changing, not only in amount and direction but in color as well. These variables are, to be sure, obstacles as well as opportunities. But the photographer who learns to cope with the caprices of nature will find an endless range of fresh and interesting pictures to take, and he may be sure that his excursions will never be boring.

Before venturing outdoors and into this world of infinite variety and challenge, the nature photographer must consider three basic matters: the best time to go out, where to look for his subjects, and what equipment to carry along with him. And if he will take the time to do a bit of homework on these questions beforehand, he will later find that his efforts have helped immeasurably to make any of his trips smoother and the pictures more successful.

When to go out depends to a great extent of course on what the photographer wants to photograph. He need not wait for a perfect summer's day if climate is not essential to the subject he is considering. The photographer of seascapes or sky will naturally welcome a brewing storm. The intricate structure of deciduous trees is most clearly delineated during the dead of winter, when the leaves are gone. Many small mammals are easiest to flash-photograph during their nocturnal foraging hours, if the photographer can determine ahead of time where to set his flash. The deeply saturated colors of wild flowers come out best on a bright but overcast day. In fact, many of the most striking and revealing nature pictures are those taken at the most unlikely-seeming moments.

There are, of course, limitations decreed by specific subjects. The man who wants to photograph honeybees, nesting birds or leaping salmon will have to fit his schedule to theirs. The timing and techniques for photographing some of these particular categories—birds, insects, flowers, big game animals, underwater life—will be discussed at some length in later sections of this book. But a good nature photographer soon finds himself developing the true naturalist's all-encompassing interest in the world around him, and thus he enlarges his expertise along with his repertoire.

Given this attitude, the nature photographer's "field" can extend from just outside his door to the farthest reaches of the wilds. There is, however, no question about where to begin: it is the nearest place that a plant can grow or a bird can perch. It may be a back yard or a nearby park or even, for a city apartment-dweller, a window box planted with wild flowers. Every photographer interested in nature can start by finding such an easily accessible place. Perhaps the most famous instance is that of Edward Steichen who, having taken pictures of just about everything everywhere else in the world, has devoted long and loving attention to a single shad-blow tree on his farm in Connecticut, recording its aspect in every season, in every light and in every stage of bloom and dormancy. For the amateur even more, there is no better way to become familiar with the subtleties of nature, and to learn the capabilities of his camera equipment as well, than by concentrating in this way on one convenient and familiar subject.

This sort of close study will pay further dividends as the photographer begins to move around within the confines of his own small nature preserve. Even a modest yard offers an astonishing variety of subjects: flowers, natural grasses, vines, mosses. The plants attract insects, and these in turn bring birds and perhaps a frog or a snake. The enterprising photographer can help nature along with the judicious application of flower seeds or a bird feeder, being careful to let his handiwork show as little as possible.

If the convenience of the back-yard nature setting is intruded on by civilization—in the form of manicured lawns, fences or telephone wires—the photographer then can move a relatively short distance farther afield: to the wood lot of an accommodating farmer or to a weekend retreat in the country. Even churchyards and ancient cemeteries in the middle of cities can be quiet places to work; many of them have beautiful trees and wild flowers that can be photographed—with or without their surroundings. Once again convenience and accessibility should be the prime considerations, since there is much to be gained by going back time and again to the same locale. All of the pictures on pages 71-76, for example, were taken over an 11-year period by freelance photographer Thomas Martin in a relatively small section of Palisades Interstate Park, which is a mini-wilderness located just across the Hudson River from the skyscrapers of Manhattan.

With his powers of observation and his technical prowess tested on familiar ground, the nature photographer is ready to extend his field still farther abroad. Many of the state and national forests, parks or seashores are within reasonable traveling distance of nearly any home. A number of them have been set up expressly to preserve particularly interesting forms of plant or animal life or geological formations. Sanctuaries for wildlife exist not only in distant Africa but in practically every country, particularly the United

States. There are preserves for alligators in the Florida Everglades, for whooping cranes on the South Texas coast, for bison in New Mexico, for mountain goats in Montana, and for migrating waterfowl all along the flyways from Canada to the Bahamas and Mexico. Special permission for taking pictures is required in some of these preserves, but it can usually be obtained. In fact, wildlife, in surprisingly natural surroundings, is as near as the nearest zoo. As the pictures on pages 175-186 demonstrate, superb pictures can be taken of exotic birds and animals under controlled conditions in habitats quite similar to those in the wild. Similar pictures can be taken in aquariums and in botanical gardens and arboretums; all offer the opportunity to observe and photograph rare specimens that would be impossible to find, much less photograph, in the wild.

The best camera for most field photography is the 35mm single-lens reflex with interchangeable lenses. In the relatively short time the SLR has been widely available, it has become by far the most popular and widely used camera for nature photography. It is not, of course, the only good camera for field work. Some of the other types (which will be discussed in turn) are more useful in certain circumstances. But for an all-around, reliable and practical nature camera, most photographers prefer the SLR.

The reputation of the SLR for this sort of work is based first of all on the camera's through-the-lens viewing and focusing system, which permits the photographer to see exactly what the camera sees. This is helpful when focusing on subjects at normal distances of a few feet or a few yards, at close-up range or for long-distance scenes when the subject is too far away to be seen clearly without the magnified view provided by a telephoto lens.

The SLR's versatility is enhanced by a broad range of special-purpose lenses, any of which can be easily and quickly attached or removed. For close-ups there are macro lenses specifically designed for this kind of work; alternatively, regular lenses can be used with the simple addition of a bellows attachment or extension tubes *(pages 82-83).* For broad views of subjects like trees, large animals or landscapes there is a complete range of wide-angle lenses, extending all the way to the 180° fisheye lens. The long focal length of the telephoto lens makes it possible to magnify distant (or dangerous) subjects like animals *(Chapter 5),* to close in on one small portion of a nearby subject, or to blur out distracting backgrounds such as bars in a zoo cage or a fence behind a flower bed. Telephoto lenses extend from about 90mm (with a magnifying power of about twice that of a normal 50mm lens), up to about 600mm (with a power about 12 times normal). There are more powerful lenses, but they are heavy and unwieldy; the 600mm is about the practical limit for normal field work.

A major advantage of the 35mm SLR in the field is its portability. A typical SLR with normal lens weighs about two pounds, and its narrow, rectangular shape allows it to be carried easily on a neck strap or to be stowed in a gadget bag or hiking pack. Finally, it uses the lightest and least expensive film of any camera: a dozen rolls of 35mm color weigh but a single pound and yield over 400 separate pictures, at less than a quarter per frame.

While the compactness of the 35mm camera is one of its chief attractions, some photographers prefer a larger film size, especially for landscapes, and are willing to sacrifice some convenience to get it. They have some excellent alternatives in a group of cameras that use 120 film (they take pictures 2¼ x 2¼ or 2¼ x 2¾ inches in size) but retain most or all of the SLR features. One version looks just like an overgrown 35mm SLR; it is taller and wider and roughly twice as heavy—nearly four pounds—but otherwise it is very similar, having the same eye-level prism viewing system, interchangeable lenses and the handy controls of its smaller-sized brother. A second large-format SLR is shaped more like the familiar box camera—but the resemblance ends there. This type has interchangeable lenses but uses a simpler viewing system. The image comes through the single lens as usual, but is viewed on a ground-glass screen rather than through an eye-level prism finder. The ground glass affords a flat, same-sized display of the exact area the exposed film will include, and so helps in composing the scene, especially with the use of a tripod.

Where careful composition and extra-fine detail are of prime importance, and the subjects are reasonably stationary—as in a pattern photograph of wild flowers or a scenic vista—this type of large-format SLR may well be the best camera. However, since the image is reflected in a single mirror before being thrown on the screen, it is a mirror image, i.e., reversed from left to right. This can be perplexing in some kinds of field work, particularly with active subjects: they appear to move in the wrong direction on the screen. If the subject is moving left on the ground glass, the photographer must pan to the right to keep it in view. An accessory prism viewer, which turns the image back to normal, is available for many models; but it is not included as standard equipment.

The 35mm rangefinder camera opened the modern era of nature photography. It is the immediate ancestor of the 35mm SLR and the better ones have most of the SLR's best features—interchangeable lenses, a wide range of shutter speeds and other versatile controls, and the convenient 35mm film size. The only substantial difference is in the viewing-focusing system. Instead of seeing the subject through the lens, as with the SLR, the photog-

rapher looks through a separate window, which is coupled by a mirror arrangement with another window. This produces overlapping images of the subject seen from two slightly different perspectives. When the focusing knob is turned, the two images come together until the subject is in focus. The difference in perspective between the lens and the viewfinder is automatically corrected at normal distances, as with the twin-lens camera.

In certain respects the rangefinder has some advantages over the SLR, and many photographers carry both, one to supplement the other. The basic rangefinder is less intricate, lighter and more compact. It emits a discreet click rather than the more audible clunk caused by the SLR's swing-away mirror, and is therefore more desirable when the camera is used by remote control or in a blind very close to nesting birds or timid animals. Also, its quick, simple focusing is helpful in photographing such subjects as fast-moving animals. Because the viewing window is entirely independent of the lens it is equally bright and sharp for all lenses. But because it is separate, it is useless for framing with a very long or short lens—that is, the viewing window does not show the magnification or other perspective of the added lens. For extreme close-ups or long-distance photographs, an accessory viewfinder can cope with this problem. It is inserted between the camera and the lens; this in effect converts the rangefinder camera into an SLR, but it is a relatively cumbersome arrangement.

Even rangefinder cameras that come only with fixed lenses have many desirable features, and those with good optics will produce marvelous nature pictures within normal viewing ranges. The fixed-lens rangefinder camera does, however, lack the versatility of a camera with interchangeable lenses, and tends to limit the field photographer's subjects.

The twin-lens reflex camera was long a favorite with nearly every professional nature photographer, and it is still fondly regarded by those who specialize in medium-range landscape photographs and portrait-type pictures of plants and animals—all of which it takes superbly. It provides 2¼ x 2¼ -inch pictures with the attendant advantage of a large negative; and it also has a ground-glass viewing system—with its attendant disadvantage of the reversed image. (For the photographer who can never get used to this, an accessory prism viewfinder is available to turn the subject around.) The subject is not seen through the camera lens as with an SLR, but through a twin lens of the same focal length just above it, and this means that the viewing-lens and taking-lens viewpoints are not precisely the same, thus introducing the problem of parallax error. Better twin-lens cameras adjust for this difference automatically at normal viewing distances, but framing extremely near or faraway subjects becomes largely a matter of guesswork. Also, no

matter what aperture is chosen for the taking lens, the viewing lens remains wide open and the photographer is unable to preview the depth of field at his selected f-stop. Another disadvantage for the versatile photographer is that twin-lens cameras, with few exceptions, do not have interchangeable lenses.

The view camera is the biggest gun of the photographic arsenal, with built-in advantages and disadvantages. For spectacular landscape pictures like those taken by Ansel Adams *(page 189)* or exquisitely detailed compositions *(pages 209-211),* the view camera has no peer. It has another invaluable asset, especially useful in taking landscape pictures: its flexible controls permit the photographer to rearrange the scenery. The view camera also has a large ground-glass viewing screen and equally large film sizes (from 2¼ x 3¼ inches to 8 x 10 inches). But even the most portable view cameras are cumbersome compared with an SLR, and the view camera's controls require a good deal of adjustment. This camera is regarded as a special-purpose instrument, and is not generally used in field photography.

What to take along with the camera or cameras you choose? A good selection of field photography equipment is listed on page 55. But at the very least, even for the simplest daylight photography with no extra lighting, you need a selection of long and wide-angle lenses and filters, a light meter (even if there is one on your camera), a tripod and a lens cleaner.

The uses of various lenses for nature photography are described in the appropriate chapters. Each lens should be provided with a skylight filter to reduce haze and to protect the lens.

Your camera may have a built-in light meter system, but still it is wise to have an extra light meter on hand. The range of some built-in meters is comparatively limited. And an extra light meter is good insurance in case the built-in one should fail.

A tripod is essential for getting pictures under difficult lighting conditions, where long exposures call for steady support, and to aid in careful framing of stationary subjects like flowers and bird nests. The tripod also permits steady panning on a moving subject like a running deer. The tripod should have a double-jointed head that allows the camera to be pointed in any direction, and the center post should be reversible so the camera can be mounted underneath when you photograph objects close to the ground. If weight and size are primary considerations, as they might be on a long hiking trip, a small table tripod plus a ball-and-socket head (both shown on pages 82-83) can be an acceptable substitute. This so-called lowpod is designed for low-level shooting. But when the camera is very close to the ground the prism viewer becomes useless. A waist-level viewer or special at-

tachment that throws the image up at an angle is necessary for ground-level pictures. As always when a camera is mounted on a tripod, the shutter should be snapped with a cable release to avoid the slightest jar; otherwise the steadying effect of the tripod will be nullified.

The most often overlooked item for the field kit is something with which to clean the lens. Dust and grime are facts of life in the field, and nothing is more detrimental to a fine lens than trying to clean it with an already grimy handkerchief or shirttail. Gritty particles should first be whisked from the lens with a fine brush, and the lens polished with lint-free paper. Distilled water is the safest cleansing liquid, especially for color-coated lenses. In the field a convenient source of distilled water is condensed moisture from the breath. Extreme care must be taken not to get the slightest speck of saliva on a lens; it may contain harmful bacteria, enzymes or food particles. The lens should be held above the mouth with the head tilted upward, and the breath exhaled slowly and softly onto the glass surfaces.

Another useful and lightweight piece of equipment is a light-proof changing bag. It can be stuffed into the equipment case, and used in the field for changing film. Not only will it protect the innards of the camera from being invaded by airborne dust and dirt during the film-changing process, but the changing bag is essential for extricating a jammed film roll without sacrificing the pictures you have taken before the accident.

The above items comprise the basic kit for the field photographer who wants to travel light. And such a photographer is understandably disinclined to take lighting equipment along with the rest of his gear. Yet extra illumination often can be nearly as helpful in daytime as at night. It can provide fill-in light, or add the necessary brightness for a shutter speed that can stop the motion of birds' wings or the nodding of wild flowers in a strong breeze. And there are new electronic-flash units that can be a godsend for the field photographer. There is a reliable strobe that weighs but a few ounces, is smaller than a 35mm camera and gives a flash so brief that most animals do not even notice it. The illumination is truly packaged sunlight—the color of the sun at high noon—so no special filters or films are needed. With careful aiming of this unit, quite natural-looking pictures can be obtained.

Another piece of special equipment not in every field kit is an air-pressure shutter release, a simple and inexpensive device that enables the photographer to take close-ups of skittish subjects from a discreet distance. It consists of a long plastic tube with a squeeze bulb at one end and a plunger that presses the pre-cocked shutter button at the other end. For use when you need to get still farther away, electronic and even radio-controlled shutter releases are available. For complete remote control, a battery-operated mo-

tor can be added to some cameras; it advances the film and cocks the shutter automatically each time a picture is taken. And if *this* isn't discreet enough, the whole motorized camera can be enclosed in a soundproof housing called a blimp; this rig—SLR camera, motor and housing—does, however, cost about 500 dollars. Not many photographers will want or need to get quite so elaborate; but for those who do, the hardware to handle nearly any situation can be bought or specially built.

As important as the equipment is how to get it there. The items in the checklist on page 55 weigh less than 25 pounds; except for the tripod, all of the equipment can be stowed easily in a medium-sized shoulder-strap bag. The tripod can be carried across the other shoulder as a counterweight; or for long treks in rough terrain the lowpod, which can be carried in the bag, can serve. For most makes of cameras there are specially fitted bags that have compartments for the camera and accessories and built-in sockets to hold extra lenses. These are handy but tend to be bulky. Most photographers prefer to use an unfitted bag, working out their own most convenient stowage plan. Conventional camera gadget-bags are for sale everywhere, but equally good and often less expensive types of rugged field packs are available in sporting-goods and surplus stores. With any of these unfitted bags small slabs of foam rubber in different shapes and sizes can be used to cushion and separate the larger pieces of equipment.

For additional equipment, such as an extra camera body, special-purpose lenses and perhaps a complete line of close-up accessories, nothing can beat an aluminum carrying case. It resembles a small suitcase and is carried by a handle. Most of these carrying cases come packed with layers of foam rubber that the purchaser, using a knife provided with the case, carves into pockets for each piece of equipment. A good aluminum case is waterproof and dustproof, gives excellent insulation (important in the field) and provides quick access to each item. Many photographers prefer this kind of case for all their equipment; it is undoubtedly the best bet for anyone who expects to take most of his pictures in a relatively confined area and does not have to walk too far to get there.

A small corner should be reserved in every carrying case for a handful of plastic bags—the kind sold in grocery stores for sandwiches. They are invaluable for protecting equipment from dust and lint inside the case, for covering cameras and lenses while working in snow or rain, for keeping film dry and for countless other uses. Also a sheet of thick plastic or rubberized material should be carried for kneeling on damp or dusty ground; this ground cover can be folded inside the carrying case or wrapped around a leg of the tripod and secured with rubber bands.

Modern camera equipment, when used knowledgeably, can refine the actual taking of a picture to an almost mechanical operation. The nature photographer should take full advantage of this fact because he needs to devote as much attention as possible to his subjects. Acquiring a good understanding of how—and why—the equipment works is the basic step. Dry runs at home and experience in the field will increase his prowess, and along the way he can pick up many profitable shortcuts in technique.

It also goes without saying that the nature photographer should be something of a naturalist. He should read every nature book he can find that describes the flora and fauna of the places he plans to visit. There are excellent field guides that tell where to find nesting birds, how to identify the various kinds of animals, trees and flowers, and generally what to look for in any particular locale. Classroom botany and biology text books contain a great deal of good basic information. Many national parks produce detailed manuals that describe the plants and wildlife to be found within their boundaries. For recommendations on clothing and other personal gear in the field, the photographer can make good use of the field guides that are published for hunters and for fishermen. One important note of caution, however: if the photographer plans to stalk the same quarry as the hunter, he would do well to wait until the hunting season is over; a camouflaged photographer creeping through the underbrush after a deer can be mistaken for the deer itself, with dire results.

Once afield, the novice photographer is tempted to snap away at everything in sight. The urge must be resisted. A great nature picture demands concentrated effort; hours or even days may be needed to get all the elements of a picture to come together—good lighting, an appropriate background, artistic composition, an interesting action or aspect of the subject. So it is necessary to stick to one subject at a time. By the same token, if a subject is worth so much effort it is worth spending some extra film to make sure of getting the picture. Each exposure should be bracketed: half a stop above and below the meter reading for color film, and a full stop in each direction for black and white. Finally, a careful record should be kept of each significant exposure: the subject and the date; the lens used; any attachments such as extension tubes and filters; the f-number and shutter speed. Only with such data can the subject be adequately described and the camera technique studied and improved.

Patience and perseverance are clearly two of the nature photographer's prime requirements. It is equally clear that he needs a good grounding in his subject matter and a certain amount of special equipment. Most of all, he must have abiding interest in all aspects of nature. Only then will he feel truly at ease taking pictures in the outdoors. □

A Checklist of Equipment for the Field

Equipment for general nature photography in the field can be divided into the three groups listed below. The basic equipment will give pictures of what the eye normally sees, plus moderate long-distance and moderate close-up pictures. The second group of items augments the flexibility of the basic list and adds the capability of auxiliary lighting. The third group includes accessories, mostly for further convenience. (Specialized equipment for close-ups and underwater photography is discussed in the chapters devoted to those topics.)

group 1: basic equipment

single-lens reflex camera with normal lens, and case

longer focal length lens *(text)*

front and rear caps and protective skylight filter for each lens

light meter

tripod

cable release

extension tubes for close-up pictures

film

changing bag

carrying case

group 2: supplementary equipment

table tripod ("lowpod")

ball-and-socket tripod head

ground-level viewer

electronic-flash unit

filter set *(page 204)*

air-pressure shutter release

group 3: accessories

pistol grip for lenses above 200mm

shoulder pod for photographing birds

extra camera body

accessory motor or motorized body

kneeling mat or ground cover

plastic food-storage bags

notebook

carrying case for additional equipment

The Flighty Subject

Of all nature subjects, birds are among the most tantalizing—and satisfying—for the field photographer. Their habitats range from back yards to remote ice caps. Some birds are exotically colored, others drab; some are relatively tame and approachable, others so elusive that they can be captured on film only with high-speed cameras and powerful lenses. All birds, however, have a common characteristic that endears them to the nature photographer: they are creatures of habit.

Birds tend to do the same things over and over again in recognizable patterns. A given species may be depended on to perch or posture or soar in a certain way; feeding techniques seldom vary; nesting takes place at the same time every year and in predictable places. A knowledge of these repetitive activity patterns enables the photographer to find the bird he is after, to get within camera range and to show his subject behaving naturally.

Acquiring this knowledge is not a formidable task. The basic information on any species can be found in any good field guide. Further information can come from on-the-spot observation. To get the picture of gannets at right, Roger Tory Peterson used such a mixture of knowledge and observation. Peter-

son knew where to find the nesting site and exactly when to go there (gannets spend most of their time out at sea, even sleeping on the water, and come ashore only once a year to breed and rear their young). Arriving on the scene, Peterson judged how close he could get without disrupting the colony—a humane as well as a practical consideration, since many birds will leave their nests unprotected or abandon them entirely if disturbed too much. Finally, to add to his familiarity with this particular species, he observed the birds to detect some characteristic behavior that would give him not just a picture but a portrait with meaning.

Roger Tory Peterson is one of the world's most distinguished ornithologists, and his knowledge and experience give him an advantage over most bird photographers. But he is the first to insist that anyone can pick up the few basic facts that are needed in the field. After that, keen observation and camera technique are what count most, as the pictures by other photographers on pages 58-61 amply demonstrate.

The kind of camera equipment that is best for bird photography depends mainly on how much the subjects move around. Any reasonably portable camera can be used for pictures at nests

since the camera is set up close to the subject, pre-focused and arranged so the shutter can be tripped from a distance with a long cable release. Twin-lens reflex and rangefinder cameras, being quiet and compact, are good for this work. Even electronic-flash units can be used; the birds soon get used to them. And if the photographer wants to avoid returning to the camera to wind the film and reset the shutter for each new picture, he can use a motorized SLR camera (its mirror should, however, be locked up if possible in order to make it quieter).

The SLR is also the best camera for virtually every other kind of bird picture, whether the subject is perching, roosting or on the wing. The quick framing and focusing system of this camera is helpful at all times, even with lethargic birds like sleepy owls *(page 59);* it is indispensable for fleeting species like hummingbirds and wheeling gulls *(pages 62-63).* Long lenses are generally needed to secure a large enough image on the film because most birds are small and must be photographed from a distance.

In whatever habitat and with whatever equipment the wild bird is photographed, it can produce rewarding pictures for any nature photographer.

At their breeding site on the coast of South Africa, two adult gannets (foreground) stand guard in front of the dark-feathered young birds of the nesting colony. Because the area is near a guano mining operation, the gannets were accustomed to the sight of men. The photographer, a famous ornithologist, was able to come within five feet without disturbing them. This made it possible for him to use a 35mm SLR camera with a 35mm lens. The wide-angle view and great depth of field of this lens brought out the detail of the nearest birds without losing the shapes of the other birds or even the cliff in the background.

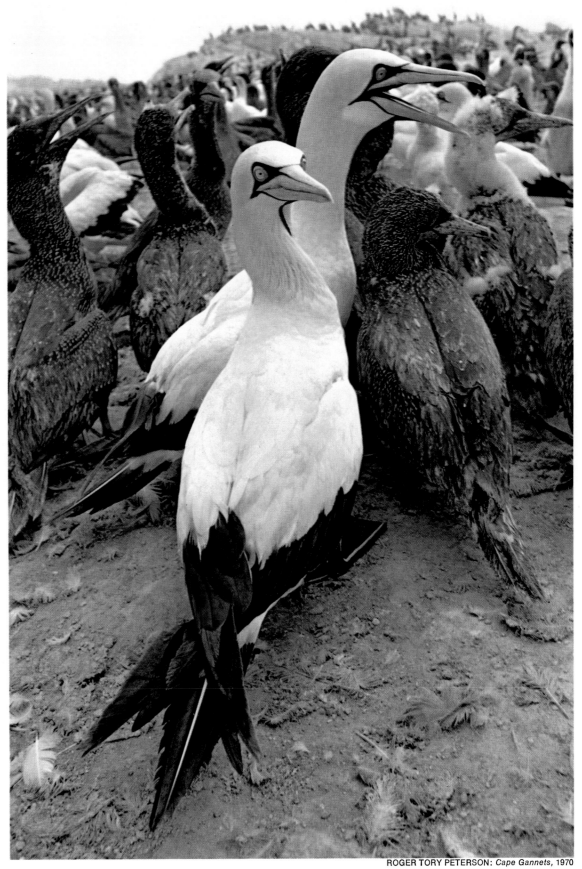

ROGER TORY PETERSON: *Cape Gannets*, 1970

MARJORIE PICKENS: *Cardinal*, 1970

Perched in a Norway spruce on a winter day, a cardinal is softly illuminated by sunlight reflected from snow underneath the tree. The bird and its mate were attracted by birdseed on the ground. While one bird was feeding, the other kept watch, always from the same limb. The picture was taken from a window 15 feet away with an SLR camera and a 300mm lens with an extension ring.

Two effective ways of getting close to perching birds are to attract them with food or to seek them out, carefully and silently, in their nesting or roosting place *(right)*. The best place for a feeding station is a semiopen spot that provides plenty of light but is near a low-limbed tree or bush where the birds will feel secure. If liberal amounts of birdseed are scattered on the ground, many different species will be attracted to the area in a day or so. Then a bird feeder can be hung near a well-lighted spot, and the photographer can focus on a place where the birds perch before or after coming to the feeder *(left)*. The camera should be kept out of sight, in a blind or other shelter, but if hiding the camera is impracticable it can be set up in the open by moving quietly as close as the birds will tolerate.

Special field guides describing the nesting and roosting habits of birds can aid in finding them on their home grounds. Knowing a bird's mating and migratory cycles and its distinctive voice are additional aids, and these are described in any of the regular bird guides. Sound recordings of many familiar birds are available in most record shops and sporting-goods stores.

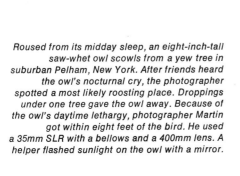

Roused from its midday sleep, an eight-inch-tall saw-whet owl scowls from a yew tree in suburban Pelham, New York. After friends heard the owl's nocturnal cry, the photographer spotted a most likely roosting place. Droppings under one tree gave the owl away. Because of the owl's daytime lethargy, photographer Martin got within eight feet of the bird. He used a 35mm SLR with a bellows and a 400mm lens. A helper flashed sunlight on the owl with a mirror.

THOMAS W. MARTIN: *Saw-whet Owl,* 1968

JOHN COOKE: *Jamaican Tody,* 1967

With a caterpillar dangling from its beak, a pert tody—a Jamaican relative of the kingfisher —perches on a tropical branch. After checking to see if the coast is clear it will deliver the morsel to its young in their burrow in a nearby bank. (What looks like a nest on the limb is a clump of moss.) The bird perched in this spot time and again until it caught the attention of an Oxford photographer-entomologist who was making a movie on Jamaican wildlife. Switching from movies to a 35mm SLR, he edged closer to the perching place each time the bird flew off. After three hours he was close enough—and the tody was evidently so accustomed to his presence—to be able to take this picture from only three feet away, using a 135mm lens with an extension tube.

Often a photographer in the field will come across a bird that is completely unfamiliar to him. But even without knowing anything about its habits he may be able to get a good picture simply by keeping still and observing how the bird behaves. Then he can anticipate the bird's movements and decide where to aim the camera.

The picture at left was made this way. The bird is a tody that lives only in Jamaica and it was discovered accidentally by photographer John Cooke. Dr. Cooke is a zoologist but not a bird specialist. Nevertheless patience and perception, the main requirements for this kind of work, paid off: after hours of observing and slowly inching closer to the bird, Dr. Cooke got a picture that is both beautiful and informative.

When stalking or observing any kind of bird it is a good idea to dress for the job. Avoid flashy garments, shiny buttons and jingling buckles that might startle the quarry. If possible, cover the bright parts of tripods and other equipment with black masking tape. To approach particularly skittish species, camouflage may be necessary. It need not be elaborate: a blanket or a bed sheet draped over the head and shoulders, and held so it does not flap in the wind, is usually sufficient. Even better is mosquito netting, available in sporting goods stores, or military camouflage netting, which can sometimes be bought cheaply in G.I. surplus stores. Either kind of netting is lightweight, easy to see through—and apparently reassuring to most birds.

Flying birds put the field photographer to the ultimate test. Aiming, focusing and finding the right exposure in the split second of a mid-flight picture take a degree of skill and dexterity that comes only with practice. But the promise of getting pictures like the one at right is worth all the practice.

A good way for the beginner to start is by taking pictures of birds flying to and from an accustomed place, such as a nest, a birdbath or a feeder. At first the camera can be mounted on a tripod, and aimed and focused at one point in the bird's flight path. With aperture and shutter speed preset, full concentration can be given to tripping the shutter at the split second a bird appears in the viewer. Next, if only one leg of the tripod is extended (making it effectively a unipod), the camera can be swung in an arc to follow the bird as it flies by. The shutter is then snapped when the bird comes into focus. When the photographer really gets the feel of his equipment, he can keep refocusing the camera while both it and the bird are moving. Ultimately the tripod is dispensed with and the camera is entirely hand held, making possible full freedom of movement.

A 35mm SLR, with its fast controls and maneuverability, is the best camera for this kind of work. Telephoto lenses are almost invariably needed to obtain reasonably large images. Lenses ranging from 200mm to 400mm are most often used. But experts like Roger Tory Peterson, who took this sea gull picture, recommend using the shortest focal length that will give a satisfactory image. The shorter a lens is, the lighter it can be and the greater its depth of field—making focusing that much easier. When using any of the longer lenses, however, a pistol-grip accessory (sometimes with an additional shoulder brace) is helpful for steadying hand-held shots.

High shutter speeds, usually 1/500 or 1/1000 second, are needed for flying birds. Even these speeds will not stop the wing movements of many species. That, however, can be an asset of a sort: if the rest of the bird is recorded in sharp focus, some blurring of the wings can add realism to the picture.

Bird aerodynamics are complex, but the photographer can count on basic flight characteristics that will help him anticipate a picture. Chickadees flit; hummingbirds hover like helicopters; and sea gulls—as Peterson well knows —like to soar in updrafts. As with all bird photography, keen observation of such habits is the final key to success.

Its wings and tail outstretched to ride the wind, a swallowtail gull soars gracefully over its native Galápagos Islands. Observing that the gull was gliding on an updraft of air caused by a high cliff, the photographer stood on the cliff, anticipated the bird's flight path and panned his camera as the gull swooped past him. He hand held a 35mm SLR with a 300mm lens, and set his shutter at a speed of 1/500 second for the picture at right.

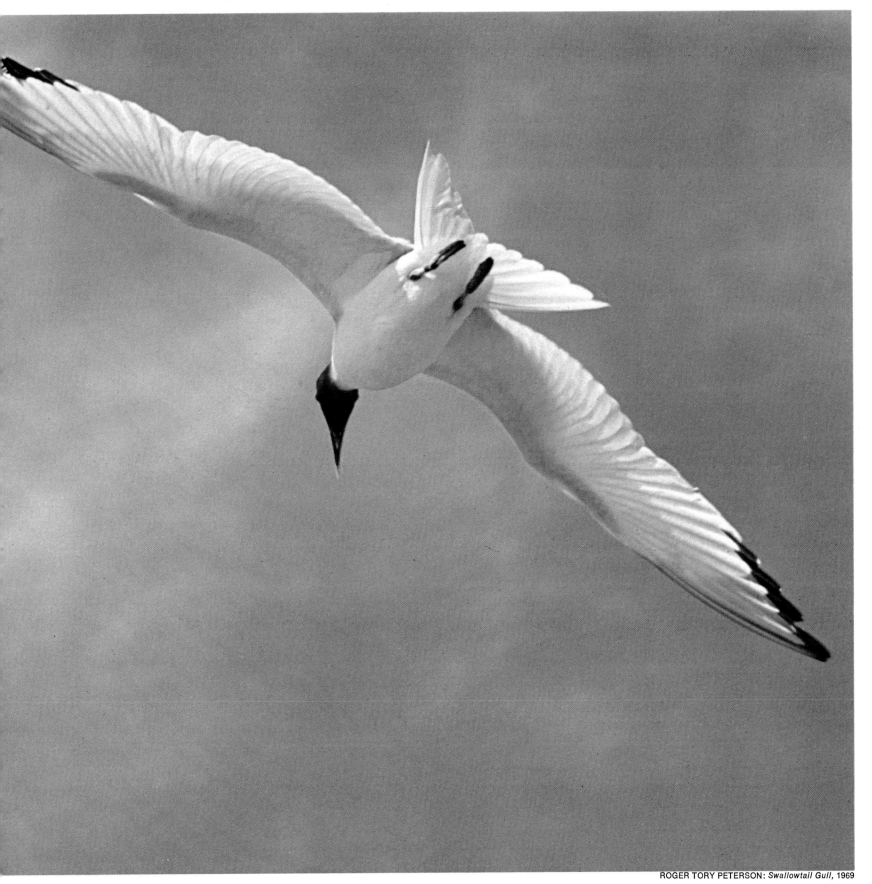

ROGER TORY PETERSON: *Swallowtail Gull,* 1969

Odd Objects in Swampy Waters

With so many high, dry and comfortable places from which to take pictures, why would anyone bother to look for a frog in a bog? The answer is staring out at you from the picture at the right: many superb pictures can be taken in the shallow waters of swamps, ponds and at the seashore. This is an environment unlike either dry land or deeper water, and some of its inhabitants can be found nowhere else.

The fact that many photographers are afraid of getting their feet—or their equipment—wet is actually a good reason for going to these places: there is less competition. And it is possible to protect equipment as well as feet. Waterproof shoes for the shallows, or fishermen's hip boots for deeper water, are the only extra protection the photographer needs. Camera gear can be protected from moisture, mud and sand if it is enclosed in wire-tied plastic food-storage bags, which are available in rolls at any grocery store.

When shooting close to the water or when the wind is kicking up spray or sand, the photographer should keep the plastic bag on the camera, with only the tip of the lens uncovered; the controls can be seen and operated through the plastic. Most tripods are made of materials that are resistant to rust and corrosion, but the tripod should be cleaned thoroughly after each trip, with special care taken to remove grit from the fine threads of the telescoping legs.

Locating animals is seldom more difficult in the shallows than elsewhere. Reading up on habits and habitats is, as always, the essential first step. Many creatures leave ample signs of their presence; beavers gnaw down trees and erect dams and lodges in the water; muskrats build burrows in the sides of pools and streams; otters construct mudslides down river banks; alligators build waterside nests that are all but impossible to miss—they may be six feet wide and a yard high. To find smaller animals, such as the frogs and marsh birds that live in thick swamp grass or reeds, it is best to rely on sound. This is easiest if two people are along. Standing perhaps 30 feet apart, each person silently points to where he thinks the animal's sound is coming from. Then both move, slowly and quietly, a few feet closer and point again, keeping this up until they are close enough to catch sight of the quarry.

The smallest forms of shallow-water life are, paradoxically, the easiest to find. Swamps, mudbanks and sandy beaches teem with tiny crawling, swimming or stationary animals. The photographer need only bend over and scoop them up. Moreover, it is possible to take these creatures home and still get natural-looking pictures: just scoop up a bucketful of environment along with the animals.

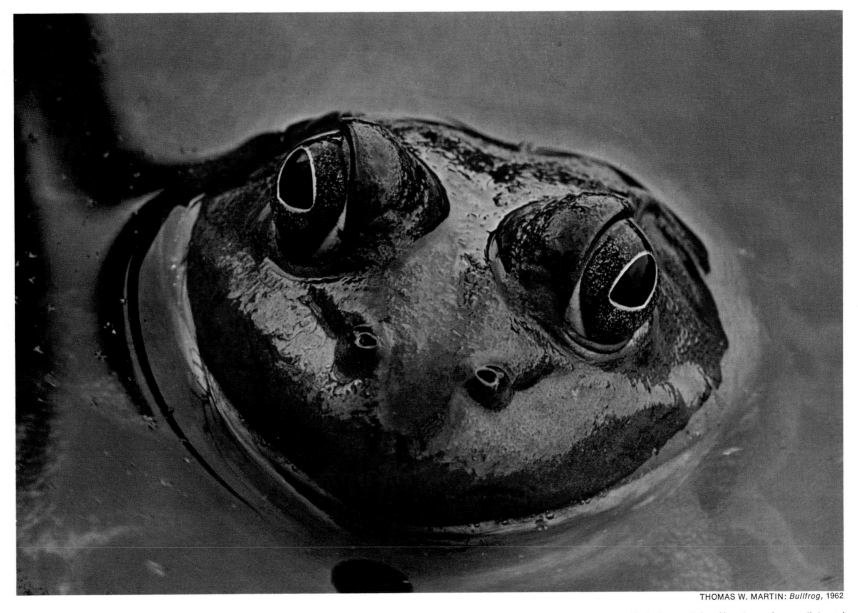

THOMAS W. MARTIN: *Bullfrog,* 1962

Up to its mouth in a New Jersey bog, a glint-eyed
bullfrog waits for an unwary insect to fly too close.
When one does, the frog, whose hind feet are
touching the bottom, will spring up and grab it.
Bullfrogs are generally complacent subjects if the
photographer avoids sudden movements. This
one was coaxed into position with the stem of a
bullrush, and the picture was taken with
a 135mm lens and bellows on a 35mm camera.

Farther Afield: The Need for a Guide

When a photographer journeys to a distant and unfamiliar place, he usually has a limited amount of time; so he may need more than knowledge and keen eyesight if he is to make the most of his excursion. At such times the help of an experienced guide is invaluable. This is true of any strange environment but especially so of swampy terrain where travel may be laborious and many picture subjects are difficult to locate.

A case in point was LIFE photographer Dmitri Kessel's assignment to record the wildlife of Brazil's heartland for a magazine series that later became the book *The Wonders of Life on Earth.* In barely two weeks, before moving on to other areas, Kessel had to find and photograph a long list of subjects in the enormous wilderness called the Mato Grosso—and this during the rainy season when the normally bone-dry area had turned into a labyrinth of lakes and waterways. Only by traveling on horseback with an expert who knew where to look and what to look for was Kessel able to locate elusive but fascinating little creatures like the tree frog at right.

Kessel and other LIFE staffers always seek the best guidance they can get when working in unfamiliar places. Any photographer will save time and effort—and probably money in the long run—by following their example.

Getting such help in the field is not difficult. The photographer need not consult the world's greatest expert on a particular plant or animal; his first job is simply to find the subject, and the best help usually comes from people who have lived in the area he is prospecting. Some of these natives may indeed be highly trained experts—curators of local zoos or museums, or biology teachers and researchers—who conduct field trips of their own and have a thorough knowledge of the flora and fauna of their areas. Park naturalists, foresters, conservationists and game wardens are extremely helpful—it is their job to know and dispense the kind of information the nature photographer needs. Oil exploration scientists know as much as anybody about geological formations. Or some useful clues may come from a trail guide, a rancher, even a sheepherder. Nearly all such people are experts on their home grounds. With any of them the photographer may be assured of finding an easy rapport, for they share his interest in nature—and they usually are delighted to meet someone hunting with a camera instead of a gun.

A tiny green tree frog, only one and a half inches long, does aerial acrobatics among the reeds and grass in central Brazil. Suction cups on each toe enable it to climb trees as well, and it spends most of its life swinging above the water searching for insects. The frog's green back blends into the vegetation when it is resting, making it hard to see from above. The photographer and a young Brazilian naturalist guide were able to spot it only by crouching low enough to glimpse its bright underside when it moved. The picture was then taken at close range with a 35mm camera and a 135mm lens.

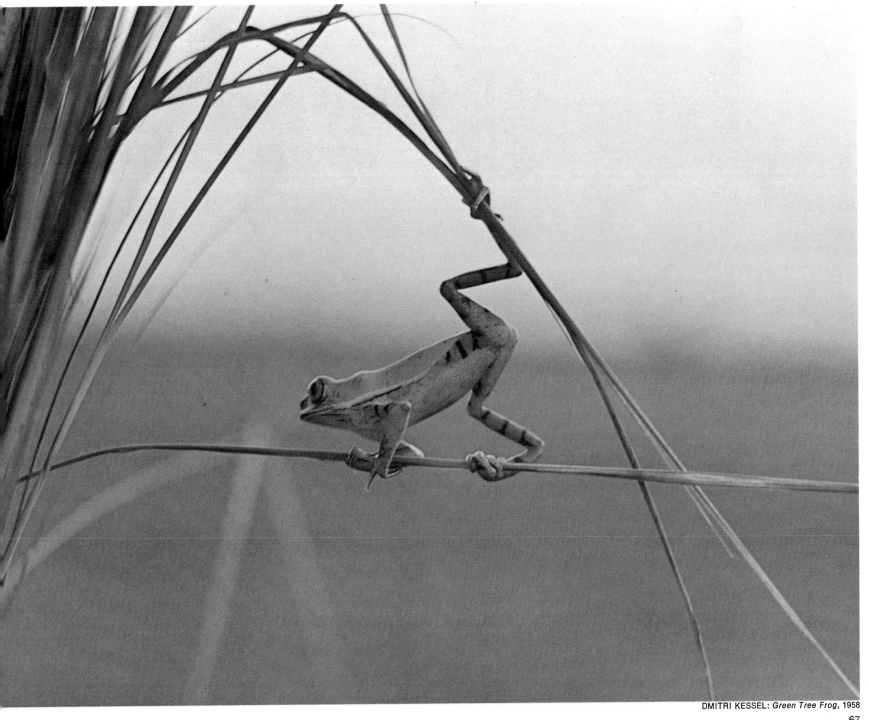

Creating a Portable Environment

ARTHUR SWOGER: *Sea Anemones,* 1970

The ocean shoreline, particularly that of sheltered inlets and bays, is one of nature's busiest environments, populated with countless varieties of plants and animals. Sometimes, when the water is clear and still, these species can be photographed where they are. More often, because of wind, waves, dirty water or the restlessness of the creatures, on-the-spot pictures are not possible. One solution is to bring the plants and animals, along with a portion of the soil and water, indoors—producing in effect a portable environment. In a glass container they may be photographed under controlled conditions.

This is how Arthur Swoger took the pictures shown here. Scooping up his specimens from Jamaica Bay on Long Island, New York, he carried each collection home in a bucket. There he transferred them to a small fish aquarium. After waiting for the water to clear (if it is very murky it can be filtered through cloth), he arranged his lights to shine through the top of the aquarium to simulate sunlight. Then he took his pictures through the glass sides. Besides giving clear and sharp pictures, this technique has an added advantage: it puts the camera on a level with the subject, thus adding to the realism of the photograph.

ARTHUR SWOGER: *Hermit Crabs,* 1970

◄ *A slice of life from Long Island's Jamaica Bay is transported to a home aquarium. The photographer collected a grass shrimp (top left), black-shelled barnacles and pallid sea anemones, then scooped up sand and water. He carefully observed the position of each creature in its habitat so he could re-create this scene.*

Thumbnail-sized hermit crabs, one of them out of its shell (above left), scramble over a cluster of barnacles. In their natural setting the crabs move too erratically for good pictorial composition, but in the aquarium their motion could be stopped with an electronic flash. Both of these pictures were taken with an SLR fitted with a 55mm lens.

A Natural Wonderland in the City's Back Yard

During the week Thomas W. Martin is a master diemaker who works and lives amidst the skyscrapers of Manhattan. On weekends and holidays he turns his full attention to nature photography —and he takes his pictures only an hour's ride out of New York.

All of the photographs on the six pages that follow were made in one relatively small but wondrously varied nature preserve atop the rocky Palisades that tower over the Hudson River in northern New Jersey. Called Greenbrook Sanctuary, the preserve covers 150 acres of streams (like the one at the right), woods, thickets, bogs and grassy glades. It is a semiprivate preserve available to anyone who applies—not unlike hundreds of other nature sanctuaries throughout the country.

Martin has made himself familiar with every plant and creature on every acre of Greenbrook. This knowledge enables him to plan each of his expeditions ahead of time so that there is no time lost in deciding where and what to photograph. Like all experienced field photographers, though, he keeps an open mind about his subjects. If, for example, he is planning to shoot wild flowers but the day suddenly becomes overcast, he switches to moss or mushrooms, which do not need bright sun.

Martin—with the help of his wife Irene—lugs a good deal of equipment along on every trip. For moving subjects like birds and small mammals he uses a 35mm SLR with a 400mm lens and bellows that will focus from infinity down to an image one-half life size. For extreme close-up shots he uses a 35mm rangefinder camera body with a through-the-lens reflex housing and bellows, mounted on a tripod. A 135mm lens is attached to the bellows for general close-up shooting.

The only piece of basic equipment Martin does not carry is an auxiliary lighting unit; a purist, he believes that outdoor pictures should be taken only with existing light, whether dim or bright. His single concession is the occasional use of a large rearview truck mirror on sunny days to concentrate a beam of sunlight on a shaded subject.

Although he is a part-time photographer, Thomas Martin is no amateur. His work is praised by wildlife and photographic experts alike and has been published in many books and magazines. He still derives his greatest satisfaction from the shows he gives to camera clubs, and he feels an obligation to tell other people of the pleasures he has found. "I know it sounds corny," he says, "but when I look through my camera lens I can imagine how a violinist feels as he takes up his bow. The beauties of nature that I see are surely akin to great music."

Dappled by a spring sun filtering through overhanging foliage, the stream that gives New Jersey's Greenbrook Sanctuary its name flows over the mossy rocks. The stream meanders through the wildlife preserve, forms a pond, then continues to the rocky cliffs of the Palisades, where it tumbles 300 feet into the Hudson River. For this medium close-up a 135mm lens was used.

Greenbrook, June 1967

Greenbrook in Spring and Summer

Buttonbush Flower, July 1961

Swallowtail Butterfly Wing, August 1966

Bullfrog, July 1962

Wild Grass with Raindrops, May 1966

From April through August, Greenbrook Sanctuary offers its widest variety, and photographer Martin is at his busiest. He sometimes concentrates on a single subject for a day or more until sure of the picture he wants. All these subjects were taken with a 135mm lens and bellows except for two pictures: that of the butterfly wing (top, second from left), for which Martin used a 35mm lens and bellows to magnify a section of the wing nine times life size; and that of the red squirrel (bottom right), whose timidity required shooting from the slightly greater distance allowed by a 200mm lens.

Chanterelle Mushroom, July 1965

Orb Weaver Spiderweb, July 1967

Crab Spider, June 1956

Star Thistle, July 1961

Red Squirrel, April 1970

Greenbrook in Autumn

Catbrier Leaf, October 1964

Butterfly Weed, September 1964

With the coming of September Greenbrook takes on a crisp and brilliant aspect. Martin employs the lower angle of the autumn sun to backlight many of his subjects, like the three plants above. This illumination enhances details such as the vein structure of the translucent catbrier leaf (which was glossy green and nearly opaque in summer), the silky seed-bearing pappus of the butterfly weed and—a sign that another year's life cycle is complete—the stark, empty seed pods of the milkweed. For all three pictures he used a 135mm lens with a bellows.

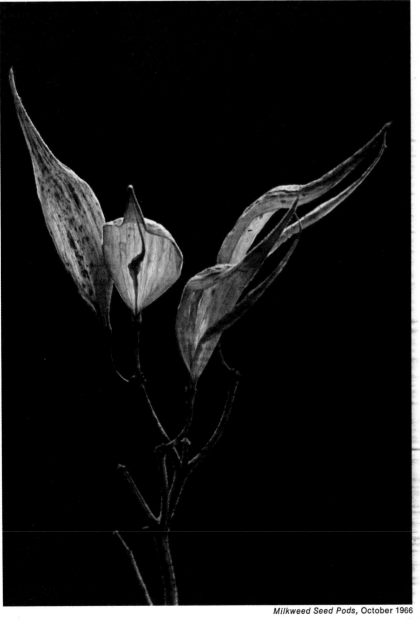

Milkweed Seed Pods, October 1966

Autumn Debris, October 1969

Leaves in Ice, November 1967

Its waters depleted by a dry summer and fall, a sluggish stream is glazed with algae and decaying plant matter (top right). The slow current has shaped the filmy mass into ripples around fallen leaves. Later, at the edge of a pond (bottom right), November ice has encased other leaves. To capture highlights and avoid clutter, Martin focused on selected areas, using a 200mm lens for the top picture and a 135mm for the lower one. Sharpness was maintained by aiming almost straight down so that the entire field of view lies in the same plane.

Greenbrook in Winter

Sculptured by gusts of wintry wind, the surface of Greenbrook Pond is transformed into crystalline whorls of ice. The ripples and circles are caused by pockets of air caught under the water as it freezes. Undaunted by the cold or by the snow that often blankets the ground, Thomas Martin visits the wildlife sanctuary all winter, filling out his photographic record of the changes wrought by each of the seasons.

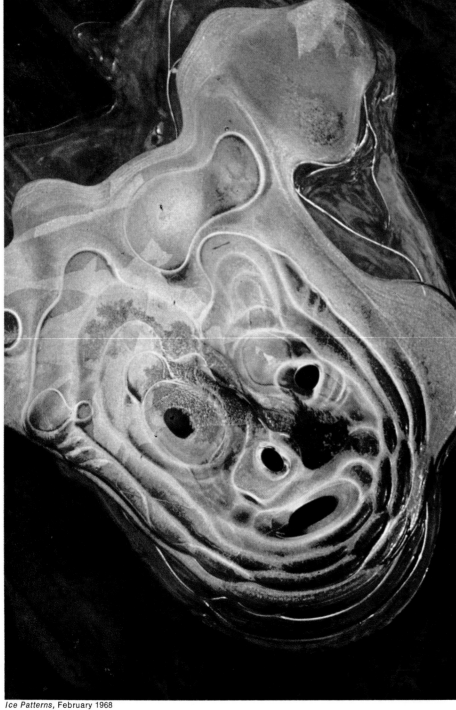

Ice Patterns, February 1968

The Intimate World of Close-ups

3

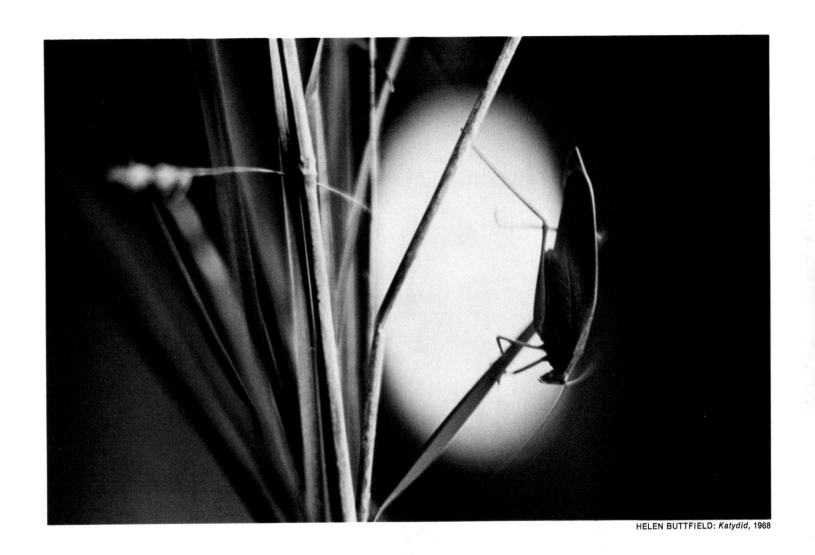

HELEN BUTTFIELD: *Katydid*, 1968

Tools and Techniques of an Exacting Specialty

Nature is where you find it, and sometimes you find it in tiny samples. Then close-up photography is needed to get it on film. Taking close-up pictures can be one of the most fascinating enterprises in the whole field of nature photography—recording and clarifying everything from how a wasp flies to how a spider approaches its mate. And close-up photography can even make the ordinary subject more intriguing, by revealing the minuscule parts hitherto unseen by the unaided human eye. The photograph of a bird or an animal or a landscape is rarely a surprise unless, of course, it is a disappointment. The close-up photograph of the interior of a flower can be an unexpected revelation.

What is a close-up photograph? Technically speaking, it is a film image ranging from at least one tenth the actual size of the subject to about 10 times life size. Special equipment is needed for this kind of photography since to obtain these larger-than-normal image sizes, the subject must be nearer the lens than the normal camera mounting will allow. The size relationship is expressed as a multiple: 1x, for instance, means that the image on the film is life size; .10x means that the image is one tenth life size. Images that are smaller than life size are expressed as fractions, but they are still, in this photographic context, commonly called magnifications. Life-sized images (1x) and larger can be obtained with specially designed close-up lenses, or with regular lenses used with close-up attachments. A magnification of 10x is about the limit that can be obtained with regular close-up equipment. For larger images, it is more practical to attach the camera to a microscope.

There are several different types of close-up accessories. (A comprehensive selection is shown on pages 82-83.) One type is a specially designed "macro" lens, which without any extra attachments can produce either a normal photograph or can focus all the way down to a life-sized image. Another type consists of supplementary lenses that are simply attached to the front of the regular lens. A third method uses either a bellows or rigid tubes that are inserted between the camera body and the regular lens.

All of these methods operate according to a basic rule of optics: by decreasing the distance between the lens and the subject, the close-up systems increase the size of the image recorded on the film. The systems differ considerably in cost (from about three or four dollars for a single supplementary lens to 125 dollars or more for a bellows); in their complexity of use; in their optical quality and in degree of magnification. The principal methods, as well as their merits and limitations, are discussed separately on the following pages, so the photographer may determine which one of them will best serve his purposes.

Except for the supplementary lenses, which will work with any kind of camera, all of these close-up systems are designed for use with the single-

lens reflex camera that has interchangeable lenses. There is a good reason for this: the areas covered in close-ups are so small that the SLR's direct through-the-lens view is essential in getting a subject properly framed and the camera accurately focused. Alternatively, there are larger-format SLRs (such as the 2¼ x 2¼) that have a full range of close-up accessories, and there are also some 35mm rangefinder cameras that can be converted to reflex operation. Fixed-lens cameras, including 35mm rangefinders, twin-lens reflexes and even simple box cameras, can be used for close-ups—though at the expense of some convenience and usually some accuracy—when they are equipped with supplementary lenses and external viewing-focusing devices *(pages 100-101)*.

Because so many nature close-ups are taken outdoors, and because many of the subjects are alive, the photographer must cope with the omnipresent problems of changeable light and movement. In close-up work, moreover, these problems are literally magnified. Whenever an image is enlarged, any movement is increased proportionately; if a subject jumps or the camera jiggles, the picture will be blurred unless extraordinary precautions are taken. Among the best preventives are a rock-steady tripod, a cable release and a fast shutter speed. In some situations it may be helpful to use the self-timer and the mirror lockup. In difficult cases an electronic flash, which provides the effect of a shutter speed of 1/1000 second or higher, can be used to stop motion *(page 98)*.

Light is a special problem not only because it is erratic outdoors, but also because close-up accessories (with the exception of front-mounted supplementary lenses) diminish the amount of light that reaches the film. This means that the f-stops engraved on the lens are no longer accurate indicators for exposure computation. When the lens is extended from the camera by close-up equipment, formulas must be used to correct the exposure reading given by a hand-held meter. (A through-the-lens metering system may not make the necessary compensation, since not all of them measure the light reaching the film. So the performance of any meter should be checked by the methods described in this chapter.) The formulas for correcting exposures are given on pages 92-95. The arithmetic involved is relatively simple, but it may take more time than a busy photographer can afford, especially if he is working in the field. The solution is to use the basic formulas to compile a simple chart, or guide, whose figures will apply specifically to the individual photographer's close-up equipment. A method for doing this will be found on page 95. As with any phase of nature photography, getting some of the brainwork out of the way beforehand will allow full concentration on the subject and will pay handsome dividends in better pictures in a field of nature photography that is a novel world of its own. □

An Arsenal of Accessories

The equipment shown at right is neither a basic kit nor a collection of every accessory available for nature close-up photography. Some photographers will need only a few of these items, while others will want special-purpose equipment not included here. However, this assortment should cover the vast majority of close-up situations most photographers are likely to encounter.

The camera, lenses and extension devices should all be from the same manufacturer. This is because close-up accessories are designed to work with specific cameras as parts of an integrated system, thus ensuring the best optical performance and permitting the retention of most of the camera's automatic controls. At the heart of these systems is a 35mm single-lens reflex camera. For most close-ups, the camera is used with regular lenses of any focal length, along with attachments that permit closer focusing distances than is normally possible. Flexibility is provided by having one normal lens, such as the 50mm that comes with most cameras, and one of moderate magnification such as a 105mm or 135mm.

Supplementary lenses are added to the front of the regular lens; extension tubes and bellows fit between the camera body and the lens. In a special category are macro lenses, which are designed to provide excellent performance in the close-up range. The 55mm macro lens shown here (3) has an extended focusing range for normal distances as well as close-ups.

A vertical viewfinder (11) is handy for looking down into a camera when photographing objects close to the ground. A hand-held light meter is often needed to extend the limited range of the built-in meters on most SLRs. It should, like the one shown here (12), be adaptable for measuring very small areas.

The lightweight but sturdy tripod (16), essential for most close-ups, should have a reversible center post so the camera can be suspended underneath for very low pictures. Alternatively, a tabletop tripod can be used for such purposes. Since these tripods are not adjustable, a ball-and-socket head (17) is used with them. When conditions in the field preclude the use of a tripod, and the camera must be hand-held for close-ups, a combination pistol-grip/shoulder support (19) will be helpful for steadying the equipment.

Lightweight stands (23) can be used for careful positioning of light units or reflectors. The reflectors selected here are ordinary black-and-white poster boards, obtainable at art supply stores. The photographer should make sure, however, that the boards do not contain extraneous colors that could be reflected onto the subject.

1 | **35mm camera with 50mm lens and lens hood**
2 | **105mm lens with lens hood**
3 | **55mm macro lens**
4 | **cable release**
5 | **supplementary lenses**
6 | **variable-focus supplementary lens**
7 | **single extension ring**
8 | **set of extension rings (combined)**
9 | **adapter ring for reversing lens** *(page 86)*
10 | **bellows**
11 | **vertical viewfinder**
12 | **light meter**
13 | **ringlight for macro lens**
14 | **ringlight for 105mm lens**
15 | **electronic-flash gun**
16 | **tripod**
17 | **ball-and-socket tripod head**
18 | **tabletop tripod**
19 | **pistol-grip/shoulder mount**
20 | **tape measure**
21 | **clips for holding reflectors**
22 | **two-way clamp and rod (for rigging reflectors)**
23 | **stands for lights or reflectors**
24 | **white and black cardboard reflectors**

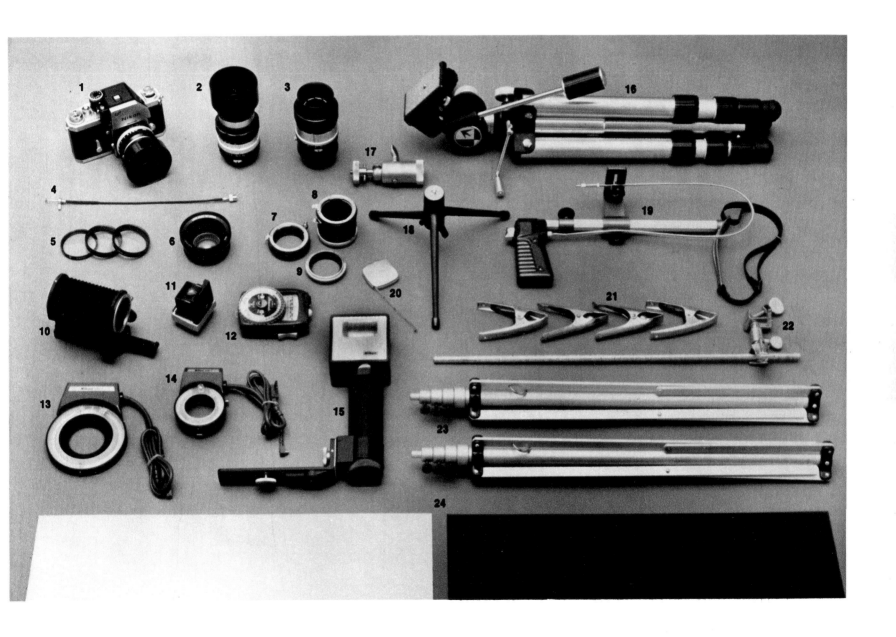

How to Use Supplementary Lenses

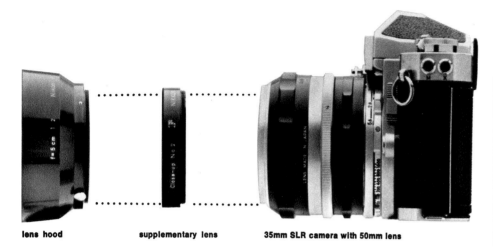

lens hood **supplementary lens** **35mm SLR camera with 50mm lens**

50mm lens alone

50mm lens and +1.5 diopter supplementary lens

50mm lens and +4.5 diopter supplementary lens

The simplest devices for making close-ups are supplementary lenses. They are magnifying glasses of varying powers, and are attached to the front of regular lenses. Supplementary lenses enlarge an image in two ways: they add their own power to that of the regular lens, and they change the focusing distance of the regular lens so that it can actually move closer to an object than it normally would.

The power of a supplementary lens is expressed in diopters, an optical term used to describe both the focal length and the magnifying power of the lens. Thus a 1-diopter lens (expressed as +1) will focus on a subject one meter (1,000mm) away. A +2 diopter focuses at half that distance (500mm) and magnifies twice as much; a +3 diopter focuses at 333mm and magnifies three times as much, and so on. Lenses of varying diopters can be added to each other in order to provide greater magnification, as long as the stronger lens is attached to the camera first.

As the chart at right shows, when a supplementary lens is affixed to a camera lens set at infinity, the new focusing distance will be the focal length of the supplementary lens. This is true no mat-ter which camera lens is being used. For example, a +2 lens will always focus on a subject 500mm (19½ inches) away with a 50mm lens, a 135mm lens or any other lens—provided that the regular lenses are set at infinity. The ultimate image size, however, still depends on the focal length of the camera lens. This is because the degree of enlargement is determined by the diopter of the supplementary lens plus the magnifying power of the regular lens. Thus a +2 diopter gives a bigger image with a 135mm lens than with a 50mm lens. Also, as the chart shows, a supplementary lens will give varying degrees of enlargement depending on the camera setting of the lens.

Advantages: Supplementary lenses do not change exposure readings. They are small, inexpensive and can be used with any kind of camera, including rangefinder models *(page 100).*

Disadvantages: Because of their design, the lenses can provide acceptable sharpness only when used with small apertures. Their surfaces, not bonded to the regular lens, may cause reflections and other aberrations. And overall sharpness of focus decreases at +5 diopters or stronger.

How supplementary lenses enlarge: The top picture shows a cluster of petunias as seen by a 35mm SLR with a 50mm lens. The lens, set at its closest focusing distance (about 18 inches) produces an image on the film about one tenth (.10x) life size. (The pictures here are enlarged slightly above actual film size.) With a +1.5 diopter supplementary lens (center) camera-to-subject distance is reduced to 15 inches for a larger image, about .20x life size. With a +4.5 diopter lens the distance is 10 inches and the image of one blossom is enlarged to about .33x life size.

Data for Use with Supplementary Lenses

supplementary lens	camera setting (feet)	subject distance (inches)	approximate image reduction using 50mm lens	approximate area covered (inches) using 50mm lens	approximate depth of field (inches) at f/8
+1 diopter (1 m. focal length)	infinity	39	.05x	19 x 28	9
	20	34	.06x	16 x 24	6½
	10	30	.07x	14 x 21	5
	5	23¾	.08x	11 x 16½	3
	3	18¾	.11x	8½ x 12¾	2
	2	14¾	.14x	6½ x 10	1
+2 diopters (500mm focal length)	infinity	19½	.10x	9½ x 14	2½
	20	18¼	.11x	8¾ x 13	2
	10	17	.12x	8 x 12	1¾
	5	15	.14x	7 x 10½	1¼
	3	12½	.16x	5¾ x 8½	¾
	2	10½	.20x	4¾ x 7	½
+3 diopters (333mm focal length)	infinity	13	.15x	6 x 9	1
	20	12½	.15x	6 x 9	1
	10	12	.16x	5¾ x 8½	¾
	5	10¾	.18x	5 x 7¼	¾
	3	9½	.22x	4¼ x 6¼	½
	2	8¼	.26x	3¾ x 5½	⅜
+4 diopters (250mm focal length)	infinity	9½	.20x	4½ x 7	½
	10	9	.22x	4¼ x 6¼	½
	5	8½	.24x	4 x 6	½
	2	7	.30x	3½ x 4¾	¼
+5 diopters (200mm focal length)	infinity	8	.25x	3¾ x 5	⅜
	5	7	.30x	3¼ x 4¾	⅜
	2	6½	.33x	3 x 4½	¼
+6 diopters (167mm focal length)	infinity	6½	.30x	3¼ x 4¾	¼
	2	5¼	.38x	2¼ x 3½	⅛

This chart shows how supplementary lenses can be used. The columns showing image reduction and area covered apply only to a 50mm lens (or any lenses from 45 to 55mm used on a 35mm camera). The other columns are valid for camera lenses of any focal length. The chart is particularly applicable for rangefinder and twin-lens cameras (page 100). Since the focusing mechanisms of these cameras cannot be used accurately at close distances, the "subject distance" must be measured physically. The figures refer to the precise distance between the subject and the front face of the supplementary lens. The image reduction column indicates the relation between the size of the image on the film and life size; thus the number .10x means that the image on the film is one tenth life size. The depth of field is given for an aperture set at f/8. Accordingly, at an aperture of f/4, divide each figure in half; at f/16, double each figure.

How to Use Extension Tubes and Bellows

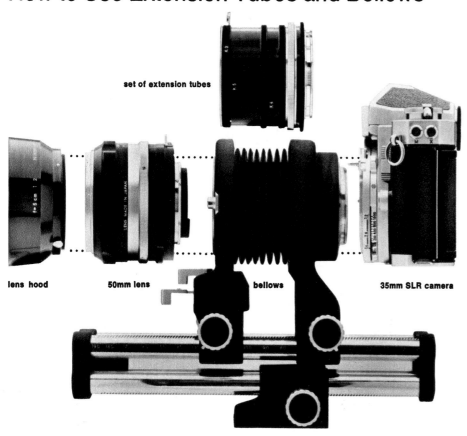

set of extension tubes

lens hood 50mm lens bellows 35mm SLR camera

50mm lens alone

50mm lens and full extension-tube set

50mm lens reversed and extension tubes

50mm lens and fully extended bellows

Extension tubes and bellows help the photographer make close-up pictures in essentially the same manner. Either accessory is mounted between camera body and lens, extending the lens nearer to the subject and farther from the film. This has a magnifying effect because the lens is now focused on a smaller portion of the subject but projects the image of the smaller portion onto the same area of film. The farther a lens is extended, the larger the image size on the film.

The only major difference between extension tubes and bellows is the degree of versatility they offer in providing varying amounts of magnification. Tubes are rigid rings of metal that extend the lens in predetermined, graduated steps depending on the length of each ring and on how many of them are used. Tubes are lightweight and relatively inexpensive; a typical set that will give a life-sized image with a normal lens costs about 20 dollars.

Bellows are made of a flexible material and provide continuously variable magnifications over their entire extendable range. They are precision instruments and a good quality one costs from about 25 dollars to 125 dollars.

Advantages: By permitting the use of regular lenses, tubes or bellows maintain the optical quality of the camera system. They provide a wide range of magnifications and are the only attachments that will produce high-quality, larger than life-sized images.

Disadvantages: Since they require through-the-lens focusing, tubes and bellows must be used with SLR cameras. They reduce the amount of light reaching the film, so exposures must be readjusted. Bellows and long tubes may be unwieldy, and usually need to be mounted on a tripod.

Some different degrees of magnification obtainable with extension tubes and bellows are shown in the pictures at left. At the top is a view of some petunias taken with a 50mm lens alone. The image on the film is about one tenth (.10x) the actual size of the flowers. (The pictures here are enlarged slightly above the film size.) Next is a view taken with a basic set of extension tubes: a life-sized image (1x) of part of a single blossom is produced. Greater or lesser magnification could be obtained by changing the number of rings used in the tube set. The next picture was taken with the same basic extension-tube set but with the 50mm lens reversed: the front end of the lens instead of the back was attached (with a special ring) to the extension tube. Because of the optical design of the lens (page 99), this gives a somewhat greater magnification (here 1.5x) without any further extension of the lens from the camera. The bottom picture was taken with the 50mm lens, in its regular position, attached to a fully extended bellows. This shows the center of a single flower, magnified to 5x life size.

The focal length of a lens determines how far it must be extended for a certain degree of magnification. The focal length also determines the "working distance" between lens and subject. Thus a 50mm lens requires a 75mm bellows extension (above) for a 1.5x life-sized image of a cicada (right). Lens-to-subject distance is about 3½ inches. The shorter the focal length, the smaller this distance.

With a 135mm lens the bellows must be extended to its farthest limit (about 190mm) for the same magnification. But the working distance increases to about nine inches. Also, the longer lens improves the perspective, with less foreshortening of the cicada, particularly of its swept-back wings. Thus long lenses (90mm to 135mm) are preferable with tubes or bellows, if they will provide enough magnification.

Lighting from Different Angles for Different Effects

The direction from which light falls on a close-up subject is as important as the amount that hits it. For some subjects there may be only one suitable lighting angle. But with others, like the leaf in the pictures at right, the direction of the light may be varied to achieve a special effect or to emphasize certain details of shape, texture or structure.

A photograph is also affected by whether the light comes from a broad source, which throws wide, evenly diffused beams, or from a point source, which throws straight, narrow beams. A broad source is essential for even illumination in extreme close-ups. A point source will produce shadows and sharp edges. The narrow beam of an electronic flash becomes a broad source if placed very near the subject, while the sun, normally considered the broadest source of all, is actually a point source because it is so distant.

The examples of lighting arrangements shown here were made with a small electronic flash and a floodlight. The principles involved apply to natural lighting as well, because sunlight hits outdoor objects from different angles depending on the time of day and the position of the camera.

With an electronic-flash unit mounted on the camera, the subject, a basswood leaf, is illuminated with straight-on, frontal lighting (below). All parts of the leaf receive substantially the same amount of light, so there are almost no highlights or shadows and no particular emphasis on form or texture (photograph above).

With the light aimed at the leaf from the right side (below), a sharp contrast is produced between shadow areas and highlights (above). This lighting gives a clear modeling of the main structural parts and gives the picture of the leaf a three-dimensional quality. Some of the leaf's texture is lost, however, in the shadow areas.

 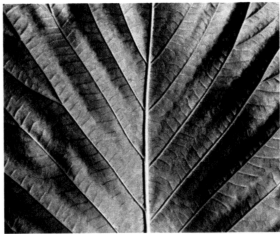 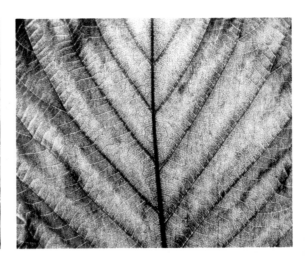

When the light is aimed from the right side and a white reflector card is held on the opposite side and near the subject (below), some of the light is bounced back into the shadow areas. This lessens the extreme contrast between the light and dark parts of the picture (above). Although modeling is not so vivid, the texture of the leaf is more visible.

A floodlight in a large reflector, aimed from one side (below), gives a broad and even illumination with good modeling of the structure but without strong contrasts between light and dark areas (above). This kind of lighting is especially effective when used with color film, which has a comparatively narrow range of contrast.

With the flash unit behind the subject (below), the light comes through the translucent leaf and reveals its intricate vein structure (above). If the subject were opaque, a light placed in this position would produce a silhouette. Technically all five of these pictures are well lighted; the choice depends on the photographer's taste.

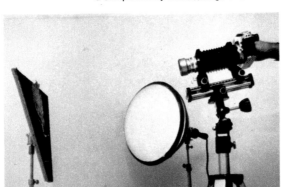 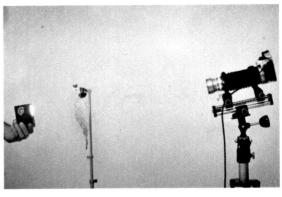

Controlling Reflections at Close Range

Lighting difficulties. which are enough of a problem under normal circumstances, are aggravated in close-up photography. The problems are particularly acute with flash equipment. Yet most of them can be avoided by knowing ahead of time the effects of different lighting techniques when the camera is close to the subject.

Ringlights, for example, produce an even frontal lighting of the subject by fitting right over the lens. So they permit the camera to come very close to the subject. But as the example at right shows, a ringlight aimed at a shiny subject may leave errant images of itself in the picture. The best solution is not to use them at all with subjects that have highly reflective surfaces.

The best light sources are those that can be moved about so as to avoid undesirable reflections. Some flash units have diffusing lenses that can be used instead of the regular one; or a piece of diffusing material can be taped over the unit (thin white cloth will do). An excellent alternative to this method is to place a light-diffusing "tent" over the subject itself, as shown at far right.

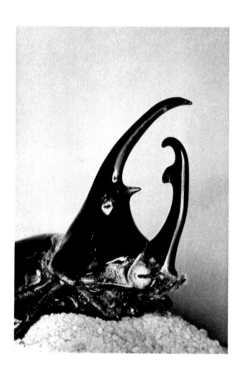

A beetle, with its mirrorlike surfaces, is a poor subject for ringlight illumination. The picture below shows the beetle being photographed with the ringlight, which is fitted around the lens and draws its power from an electronic-flash unit. The beetle's surfaces reflect the direct flash of the ringlight as hot spots (above), canceling out the device's ability to produce evenly distributed light, and failing to provide definition of the beetle's curves and facets.

A good subject for ringlighting is the shell above, whose surface is relatively nonreflective. The object can be light or dark, as long as it is not too shiny. A dark background promotes contrast for light-colored objects like the shell. The reverse would be true with a darker subject.

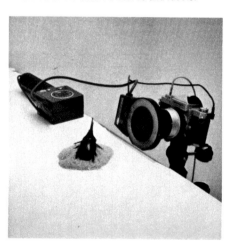

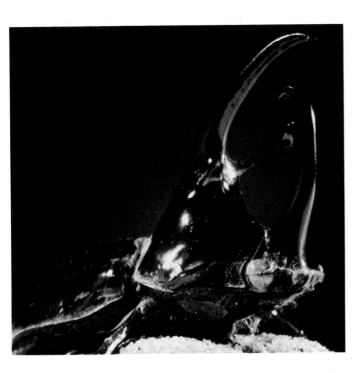

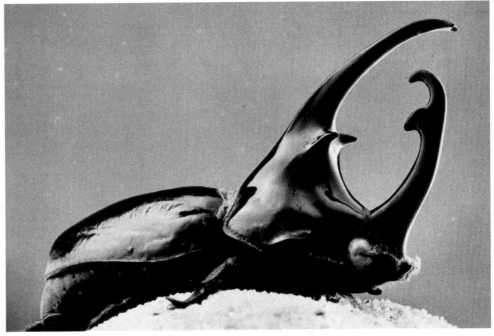

Regular electronic-flash units (below) produce uneven illumination and distracting bright spots when their direct beams try to illuminate the beetle (above). The two units are correctly positioned for best rendition of shape and detail. But the different angles and distances of the units distribute the light unevenly, and the beetle is both badly lit and marred by reflections.

The setup below is the same as the one at left except that a curved piece of plastic has been placed over the beetle to diffuse the light coming from the two flash units. The unit angled from the left of and above the subject gives broad overall illumination while the other provides strong, even sidelighting to define the edges. Thus the picture shows the beetle's shiny surface without distracting reflections.

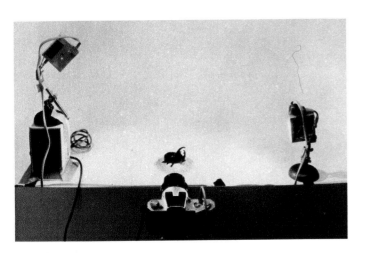

Formulas for Computing Magnification

In close-up photography it is essential to know the exact relationship between the size of the image on the film and the actual size of the subject itself. This relationship usually ranges from film images reduced to one tenth life size (.10x) to images that are magnified to 10 times life size (10x). These figures —including the reductions—are commonly referred to as "magnifications." Accordingly, before a picture is taken the photographer needs to know how to set the camera properly in order to obtain the desired magnification.

In the example on this page the problem is to find the lens extension that will best provide the desired close-up. This is done by measuring the dimension intended to fill the frame *(top, near right)* and dividing the result into the film size.

One frame of 35mm film measures 24mm on the narrow side and 36mm on the long side. In the example shown here, the film size (24mm) divided by subject size (60mm) gives a magnification of four tenths life size (.4x).

This figure can now be used to determine how far a particular lens must be extended to achieve this degree of magnification. The formula is: Ext = (Mag + 1) × Focal L. − Focal L. In this example, with a 105mm lens, the figures are as follows: the magnification (.4) plus 1 is 1.4. This figure, multiplied by the focal length of the lens (105), gives 147, from which the focal length (105) is subtracted. The result is 42—which means that the bellows (or the tubes if they are being used) have to be extended 42mm in order to achieve the desired amount of magnification. This formula can also be used to maintain the same image magnification when using lenses of different focal lengths.

To determine the lens extension required for a flower to fill a frame of film, hold a measuring tape against the portion of the subject to be photographed. Then divide the subject measurement (here 60mm) into the film width size (here 24mm) to calculate the exact degree of magnification that should be achieved.

After the desired magnification figure is computed it is used with the formula in the text at left to find how far the lens must be extended to produce that degree of magnification. The bellows should then be adjusted to this setting (in this case 63mm). If the bellows does not have a built-in scale (as shown above), a ruler can be used.

With the bellows already set at the desired extension, no further focusing of the lens is needed. Instead, the entire camera rig is positioned (above) so the subject is sharp. The predetermined magnification is now achieved automatically, producing the picture at right.

In close-up photography, the amount of light reaching the film is reduced to such an extent that the camera settings must be readjusted to get a proper exposure. To make these readjustments, the photographer must first determine the amount of change that will occur, either in the image size or in the physical distance the lens is moved. This can be done by making any of the three measurements demonstrated on this page. Only one of these measurements need be made; the results are then used with the chart on page 94 to find the corrected camera setting.

The two pictures at the top show how to measure the degree of image reduction or magnification. This figure can be used directly with the chart because it accounts for the effect of both the lens extension and the power of the lens that was used.

The bottom two pictures on this page show how to measure the lens-to-film distance *(left)* and the lens-to-subject distance *(near left)*. Before applying either of these measurements to the chart on the following page, however, they must be divided by the focal length of the lens being used. To minimize errors in computation it is always better to use the longer of the two measurements in any given situation.

To find out how much a subject is being magnified, hold a measuring tape in front of it (above) and look at the tape through the viewfinder (above right). Read the distance (75mm in this case) from one edge of the viewfinder to the other. Use this figure with the formula in the text on page 92 to compute the magnification,

dividing 75 into 36 (the long side of the film frame). The answer here is .48 times actual size, or approximately .5x. Turn to the chart on page 94; in the third column, under the heading "image reduction or magnification," find the entry for a reduction of .5x. Follow the instructions given with the chart to determine the correct exposure.

To find the lens-to-film distance, measure from back of the camera to the front of the lens. (It is not the precise optical distance, but close enough for practical purposes.) Divide this distance (300mm) by the lens's focal length (50mm); find the answer (6.0) in column one of the chart (page 94).

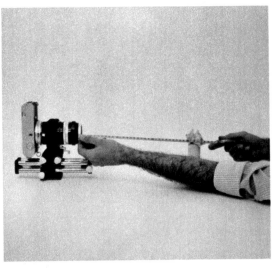

To find the lens-to-subject distance, measure from the front of the lens to the nearest edge of the subject. Divide this distance (300mm) by the focal length (50mm); find the result (6.0) in column two of the chart (page 94). Use this measurement when it is greater than the lens-to-film distance.

Handy Devices for Changing Exposures

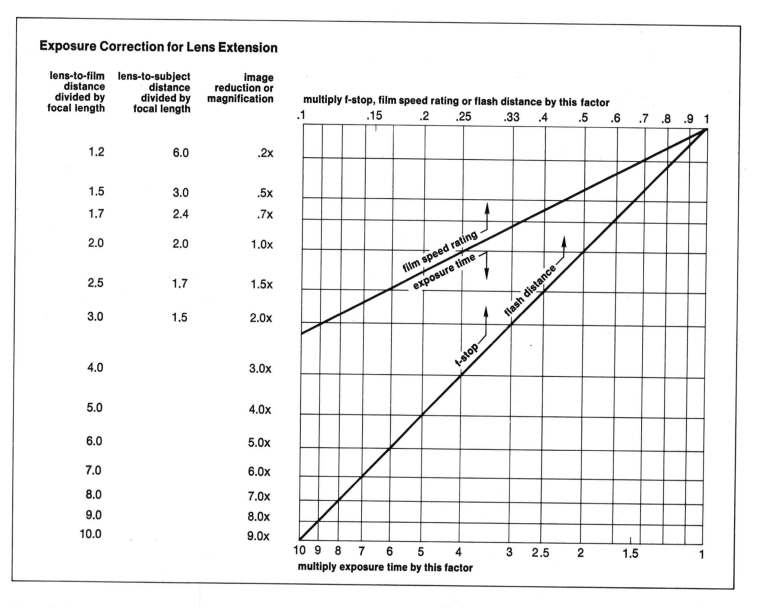

Exposure Correction for Lens Extension

lens-to-film distance divided by focal length	lens-to-subject distance divided by focal length	image reduction or magnification
1.2	6.0	.2x
1.5	3.0	.5x
1.7	2.4	.7x
2.0	2.0	1.0x
2.5	1.7	1.5x
3.0	1.5	2.0x
4.0		3.0x
5.0		4.0x
6.0		5.0x
7.0		6.0x
8.0		7.0x
9.0		8.0x
10.0		9.0x

multiply f-stop, film speed rating or flash distance by this factor

.1 .15 .2 .25 .33 .4 .5 .6 .7 .8 .9 1

film speed rating
exposure time
flash distance
f-stop

10 9 8 7 6 5 4 3 2.5 2 1.5 1

multiply exposure time by this factor

To use this chart, choose the most convenient measurement of the three in the columns at left. Make the measurement as shown on page 93, and find the figure in the appropriate column. Now decide which kind of exposure correction to make. The chart gives four choices: increase the exposure time; or uses a larger f-stop; or decrease the film speed; or decrease the distance between subject and flash. As the labels on the chart show, two of the corrective factors are found

by following the upper diagonal line, the others by following the lower diagonal line.

Having decided which factor to use, draw an imaginary line from your starting figure straight across into the chart until it hits the diagonal line that you want. From here follow the arrow that is next to the kind of correction you have chosen: go straight to the top of the chart and use the figure there if the arrow points up; go straight to the bottom if the arrow points down. These figures are

factors, not the final answer. Multiply the exposure setting (as given by a light meter), or the flash distance by these factors for the new setting.

Example: A light-meter reading indicates an aperture setting of f/16. The subject is to be photographed life size (1x). To find the corrected f-stop, start at the figure 1.0x (third column). Read across to the diagonal line labeled f-stop. Follow the arrow upward. The factor is .5. Now multiply f/16 by .5; the new setting is: f/8.

For making close-up photographs the chart at left and the measuring ruler below provide two methods for correcting the exposure settings that have been previously determined by a hand-held light meter. Light readings made with a through-the-lens metering system should also be verified by these methods, since such a system may not always give accurate exposure settings in close-up situations. The chart, like a road map, offers several starting points and several different routes for getting from one place to another—in this case from a normal exposure setting to one properly adjusted for making a close-up. A variety of starting points and routes can be chosen, but as the instructions below the chart explain, only one combination need be used for each picture situation.

The measuring ruler is a short-cut device that combines the several steps needed with the chart into a single step. It is not quite as detailed or as versatile

as the chart, but it can be useful for quick computations, especially when working in the field.

The chart provides not camera settings but factors—numbers that are used to determine the corrected exposure setting by simple multiplication. Since these factors can be applied in any situation, the photographer can work out his own list of specific corrections for every combination of lenses, magnifications, film speeds, f-stops, exposure times and other variables for the film and camera equipment he uses most often. Such a list of exposure corrections is essential for close-up work. Without it, the photographer is likely to spend more time making computations than taking pictures.

Alternatively, the same kind of data can be set down on a ruler similar to the one shown below. The figures then will actually be the corrected camera settings rather than factors for finding the settings, as in the chart.

To use the close-up correction scale shown below, transfer the lines and numbers to a piece of cardboard or other stiff material. After a picture is in focus, hold this scale parallel to the film plane and directly on the subject. Adjust the scale so the left-hand edge is lined up with the left side of the viewfinder. Read the numbers nearest to the right side of the viewfinder. To correct exposure by changing shutter speed, multiply the exposure time from the light meter by the upper number on the scale. (Here the upper number is 2.25. If the present shutter speed is 1/100 second, then 2.25 x 1/100 gives a new speed of about 1/50.) To change the f-stop, open up the aperture the number of stops shown by the lower numbers. (Here the nearest lower number is 1. If the present f-stop is f/16, open up the aperture one stop, to f/11.)

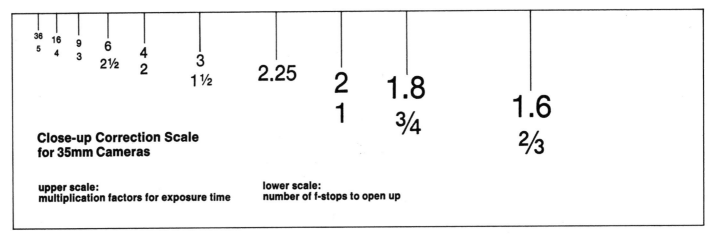

Close-up Correction Scale for 35mm Cameras

36
5 16
 4 9
 3 6
 2½ 4
 2 3
 1½ 2.25 2
 1 1.8
 ¾ 1.6
 ⅔

upper scale:
multiplication factors for exposure time

lower scale:
number of f-stops to open up

Coping with Three Exposure Problems at Once

In the field of close-up photography there are three factors affecting exposure time that must be considered. All of them have to do with the loss of light reaching the film and with the consequent effect on exposure.

First, the extension tube or bellows reduces the amount of light. Second, filters soak up light. Filters can be valuable in close-up situations: with black-and-white film, they can bring out texture—often crucial in close-ups— and improve the accurate rendition of gray tones *(page 204)*. With color film, a polarizing filter can cut down reflections *(page 107)* but, since the filters soak up some of the light in the process, exposure time must be increased. How much it should be increased can be calculated: multiply the exposure time by a "filter factor"—a corrective number supplied by the manufacturer for each filter.

But this extended exposure time still might not be enough, because of the third factor that must be accounted for. This is called reciprocity failure, which means that a film emulsion reacts more slowly than expected when the light forming the image is weak. Therefore the exposure time, already increased to compensate for the close-up attachments and the filter, may have to be extended still further. A chart giving the extended exposure times necessary to compensate for reciprocity failure is on the right-hand page.

Since each of the three exposure corrections has a cumulative effect, they must be made in the proper order. First make the correction for the lens extension; then for any filter being used; and finally, if necessary, add exposure time for reciprocity failure.

This picture of a mushroom was taken with a 50mm lens and a bellows to produce a one-half life-sized image. A medium-yellow filter was added to enhance texture. An exposure reading with a hand-held meter indicated an aperture setting of f/16 and an exposure time of 1/2 second. But the picture is too dark because no allowance was made for lens extension or filter factor.

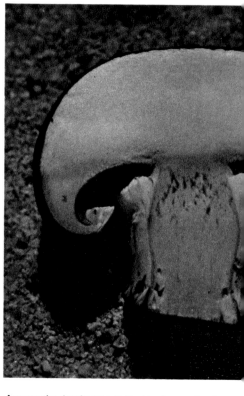

A correction for the lens extension, increasing the exposure time to 1¼ seconds, has lightened the picture somewhat. It is still too dark, however, because no correction has been made for the filter. The aperture is kept at f/16 throughout this series in order to maintain the depth of field.

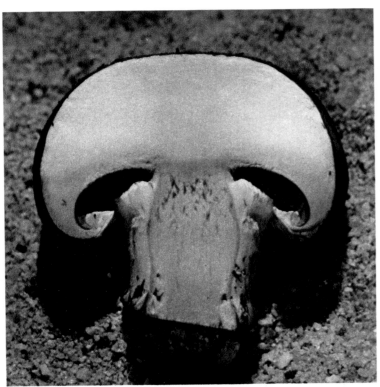

A further correction has now been made for the yellow filter: the exposure time has been extended from 1¼ seconds to two full seconds. This has lightened the picture a bit more, but even the increased exposure time is not enough, since the small amount of light reaching the film has caused reciprocity failure: the picture remains too dark.

A final correction has been made for reciprocity failure by extending the exposure time further with the aid of the chart below. The new time is three seconds, and the picture is now properly exposed.

Corrections for Reciprocity Failure

exposure indicated by meter (seconds)	corrected exposure (seconds) for negative films (approximate)	corrected exposure (seconds) for color-slide films (approximate)
1½	1½	2
2	3	2½
3	4½	4
4	6½	6
5	8½	7½
6	11	9½
7	13	11
8	16	13
9	19	15
10	22	17½
12	27	22
15	35	30
18	43	36
20	50	42

Calculating Exposures with Flash

When a close-up picture is taken with a flash unit the exposure must be corrected for any extension of the lens just as if natural light were being used. The correction can be made in two ways: by changing the aperture setting or by changing the distance from the flash to the subject. The latter method, which is demonstrated at right, is usually preferable for close-ups because most photographers like to keep the aperture closed down to obtain as much depth of field as possible.

The first step is to position the camera for the close-up picture. Then focus to get the desired degree of magnification and set the aperture at the appropriate f-stop. Now refer to the table of guide numbers that the manufacturer furnishes with the flash unit. These numbers are not camera or distance settings in themselves, but are factors indicating the light output of the unit when used with various film speeds. Find the guide number for the film you are using and then divide this number by the f-stop. This gives the distance in feet and inches at which the flash must be placed from the subject for a normal picture. The close-up exposure corrections can now be made, matching the desired image magnification with the flash distance factor as shown on the chart on page 94.

If the aperture is to be changed, rather than the flash-to-subject distance, follow the same procedure as that used for taking a normal picture. Then, by making any one of the measurements that are described on page 93, use it in connection with the chart on page 94 in order to find the corrected f-stop.

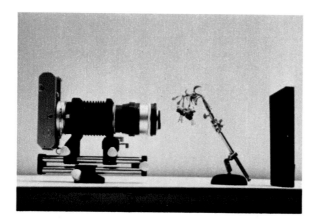

Ready to take a close-up picture of a flower, a 35mm camera is set up with a bellows attachment to extend a 55mm macro lens to get a 1.5x magnification. The aperture setting is at f/22. The desired composition is made, and the camera is focused; it will not have to be moved again.

COLOR		B&W	FILM			
ASA	10	16	25	50	64	80
GUIDE NO	18	22	28	39	45	49
ASA	100	125	200	400	500	800
GUIDE NO	56	61	79	112	123	158

Flash-guide numbers for film speeds (ASA numbers) are found on the flash (above) or in its instruction book. The film used here is ASA 125, so the number is 61. This number divided by the f-stop (f/22) gives flash-to-subject distance (three feet)—but without allowing for lens extension.

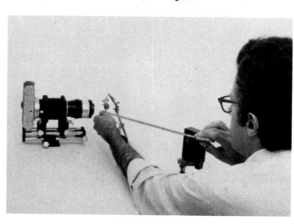

Because the lens has been extended to obtain a 1.5x magnification, the amount of light reaching the film is decreased. To get more light without changing the f-stop, the flash must be moved nearer to the subject. To find the proper flash-to-subject distance, refer to the chart on page 94 and use the diagonal line labeled flash distance. For a magnification of 1.5x, the flash-distance factor is .4. The original distance, calculated with the guide number above right but not allowing for lens extension, was 3 feet. This "normal" distance is now multiplied by .4 to give the new flash-to-subject distance: 1.2 feet, about 15 inches. The result: a perfect exposure of fuchsia stamens.

Lens Designs That Change Performance

On an asymmetrical lens like the 105mm at right, the front and rear aperture sizes seem different. For correct close-up exposures, determine the ratio of the apparent apertures. Set the diaphragm wide open and hold the lens at arm's length. Using one eye, measure with a ruler (a metric ruler is shown here) the diameters of both front and rear apparent apertures. The front (near right) is 31mm and the rear (far right) 19mm. Divide the rear measurement by the front for the "pupillary magnification factor," or PM —.6. Now divide the image magnification (page 93) by this figure, add 1 and square the result. Multiply this answer by the shutter-speed setting given by a light-meter reading for a corrected shutter-speed setting. The adjustment matters only if the PM factor is below .8 or over 1.2.

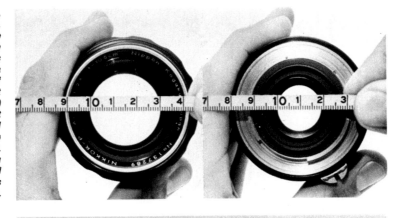

The basic designs of symmetrical and asymmetrical lenses are shown in these three diagrams. A symmetrical lens (top) has similar convex elements on both sides of the diaphragm aperture. This arrangement produces a focal length that is substantially the same as the distance from the lens to the film. Asymmetrical lenses have convex elements on one side of the aperture and concave elements on the other. A telephoto lens (center) has its concave elements behind the aperture, making its focal length longer than the lens-to-film distance. A retrofocus lens (bottom) is a wide-angle lens with concave elements in front of the aperture, making its focal length shorter than the lens-to-film distance. When extended for close-up use, the telephoto dims the image more than a symmetrical lens would, while the retrofocus dims it less.

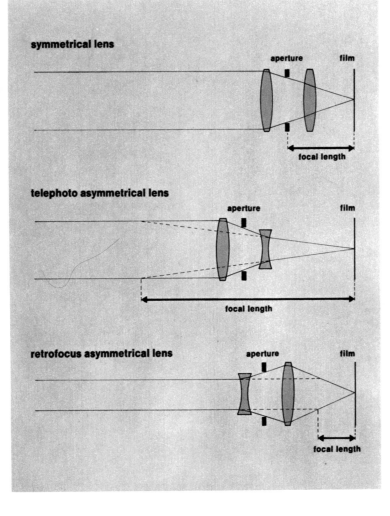

symmetrical lens

aperture · film · focal length

telephoto asymmetrical lens

aperture · film · focal length

retrofocus asymmetrical lens

aperture · film · focal length

The design of a lens may have unexpected effects on focus and exposure in extreme close-ups. The problems arise if it is asymmetrical: the elements in front of the diaphragm opening are optically different from those behind —a design used for telephoto lenses and retrofocus wide-angle lenses.

These lenses are made asymmetrical by concave lens elements to alter the usual relationship between lens-to-film distance and focal length. The focal length of a telephoto, for instance, is greater than its lens-to-film distance —not equal to that distance, as is the case with a symmetrical lens. This trick gives a long focal length in a conveniently smaller size, but it complicates exposure when the telephoto is extended for close-ups. The magnification obtained by extension depends on focal length, not on lens-to-film distance, so the asymmetrical telephoto must be extended relatively farther than a symmetrical lens for the same magnification. At this relatively greater distance from the film, the light from the lens spreads over a greater area—and the image is dimmer. For this reason, the exposure-correction factors used with a symmetrical lens *(page 94)* are not accurate for a markedly asymmetrical lens. The correction must be adjusted as shown at left above.

Even the slightly asymmetrical lens may introduce a focus problem, failing to give uniform sharpness in close-ups. Reversing the lens may remedy this defect. The elements that give uniform sharpness work best at short range, and so they will normally be close to the film. With the lens extended, they still work best at short range—i.e., close to the subject, or reversed.

Adapting Rangefinder Cameras

Any 35mm rangefinder camera can be used for close-ups by adding supplementary lenses. The rangefinder mechanism will not focus at very close distances, however, nor will the viewfinder show the exact area being photographed. Therefore, some external device must be used to position the camera at the correct distance from the subject, and to make sure that the picture is properly composed.

A simple way to position the camera is to cut a piece of cardboard *(right)* to the proportions of lens-to-subject distance and the area that will be covered. The measurements are in the chart at right, below. They vary according to the focal length of the regular lens and the diopter power *(page 84)* of the supplementary lens. The center line on the card is the distance from lens to subject (ab on the chart); the diagonal lines show the width (dc) of the area.

A wire frame *(second right)* is more accurate and convenient. To make one, determine the length of wire by referring to the diagrams and chart. For example, with a 50mm lens and a +2 supplementary lens, the measurements are: ab, 19½ inches; bc, 9½ inches; cd, 14 inches; bc again (opposite side of frame), 9½ inches; and ab, 19½ inches. The total is 72 inches. Add three inches to each end for attaching the frame to a piece of board. Bend the wire into the shape shown, drill two holes in the board and insert the ends of the frame. Drill another hole in the bottom of the board and use a tripod mounting screw to attach board and frame to the camera, making sure the lens-to-subject distance equals ab on the chart. These measurements assume that the camera lens is set at infinity.

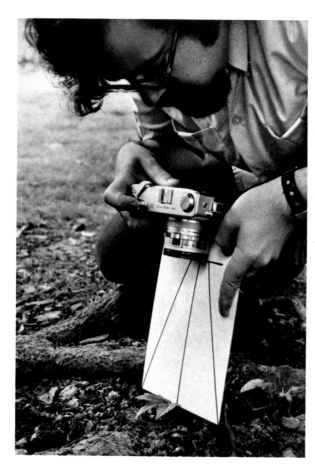

To take a close-up, a rangefinder camera with a supplementary lens is held against a cardboard cut to the proper lens-to-subject distance and width of the subject area. The card is removed from the field of view before the picture is made.

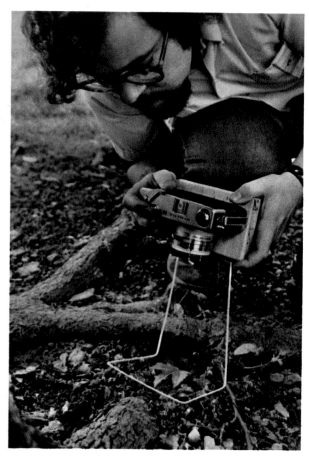

A wire frame, which is easier to use than the marked card at left and is simple to construct (details in text), conveniently outlines the subject area. Since the wire frame surrounds the area seen by the lens, it will not appear in the picture.

Dimensions (inches) of Close-up Focusing Frames for 35mm Rangefinder Cameras

close-up lenses	ab	camera lens 50mm bc	cd	44-46mm bc	cd	38-40mm bc	cd
+2	19½	9½	14	10	15	11½	17
+3	13	6	9	6¾	10	7¼	10¾
+4	9½	4½	7	5	7½	5½	7¾
+5	8	3¾	5	4	6	4¼	6¼
+6	6½	3¼	4¾	3½	5	3½	5

Close-up pictures are difficult to take with twin-lens cameras because the perspective of the viewing lens is set for normal distances; at close-up distances it overshoots the field of view seen by the taking lens. There are two ways of dealing with this problem, both methods retaining the use of the camera's regular viewing and focusing system so that no external measuring devices are needed.

One method consists of placing a supplementary lens over the viewing lens and composing and focusing on the subject. Then the camera is raised until the taking lens is at the level where the viewing lens was focused. The supplementary lens is then moved from the viewing to the taking lens, so that the already-focused picture can be made through the close-up lens. The two pictures at left, above, demonstrate how this is done. The drawback, of course, is that the camera must be lowered and raised each time it is focused on a different subject.

A more convenient method is to use a special pair of supplementary lenses that automatically correct the perspective for viewing and taking close-ups, as shown at left, below. These supplementary lenses come in various diopters and cost from five to 25 dollars.

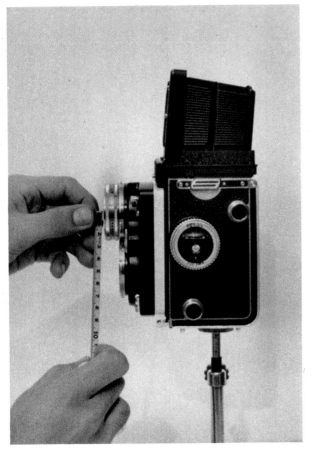

For a close-up with a twin-lens camera, a supplementary lens is placed on the viewing lens (above). The picture is composed and focused. The camera's position on the tripod is marked with tape, and the distance between the centers of the viewing and taking lenses is measured.

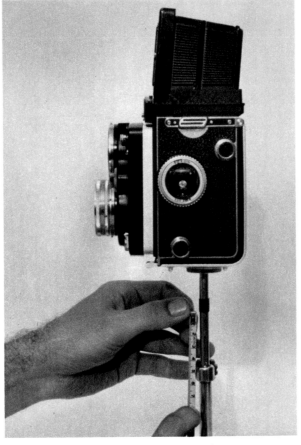

The camera is raised the height of the distance between the centers of the viewing and taking lenses (above) so the taking lens focuses on the subject just as the viewing lens did. The supplementary lens is moved from the viewing lens to the taking lens, and the picture made.

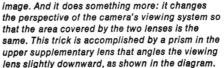

A different method from the one above utilizes twin supplementary lenses that fit over the two regular lenses of the camera (left). The lower, or taking, supplementary lens magnifies the image of the subject in the usual way. The upper, or viewing, supplementary lens also magnifies the image. And it does something more: it changes the perspective of the camera's viewing system so that the area covered by the two lenses is the same. This trick is accomplished by a prism in the upper supplementary lens that angles the viewing lens slightly downward, as shown in the diagram.

Bringing Out the Inner Beauty

Flowers are among the most popular, plentiful and readily accessible of all nature subjects. Yet too many pictures of them turn out trite and disappointing. The fault is not that of the flower, nor entirely that of the photographer. It comes from inherent differences between the way an object appears to the viewer and the way the camera records its image. The photographer sees a flower with stereoscopic, or three-dimensional, vision that separates it from its surroundings, while the mind's eye compensates for such things as motion and subtle changes in color and lighting. The camera, by contrast, has monocular, or two-dimensional, vision and tends to place equal emphasis on everything in its one-eyed field of view. Thus a rose that stands out clearly when a photographer looks at it will be lost amidst the other flowers and nearby objects if he takes a picture of it from a normal viewing distance.

The solution to this problem is to regard flowers, almost without exception, as subjects for close-up photography. With close-up techniques a single blossom or a cluster of blossoms can be emphasized so that the background either does not show or is reduced to an undistracting blur. The contrast of colors further separates the flower from the background or in extreme close-ups enhances the view of its structure. This technique provides an automatic dividend: details are enlarged so that they can be seen more clearly, as in the picture at right.

Along with the merits of close-up photography come the limitations that are discussed earlier in this chapter. But the resourceful photographer can overcome these and even make virtues of some of them. The shallow depth of field when working up close, for example, is the very characteristic that permits a sharp separation of a flower from its surroundings. And in extreme close-ups, such as that on page 105, it can be used to concentrate attention on a single part of a flower.

When lenses are extended in close-up photography, less light falls on the film. Longer exposures are required. Fast lenses, high-speed film, reflectors and fill-in flash can help with the exposure problem. But the photographer should realize that lighting is an esthetic as well as a technical consideration. Broad sunlight is not always necessary or desirable, for natural-looking pictures can be taken in shadows and hazy weather *(pages 110-111)*, and even when the sun is nearly gone from the sky *(page 113)*.

Perhaps the toughest challenge that flowers present is the least expected one: that of motion. Flowers are not the docile subjects they seem, but sway and twitch and flutter incessantly, often for no perceptible reason. The slightest movement, moreover, is exaggerated by the magnifying effect of close-up equipment. The best motion stopper is a fast shutter speed. If a low light level does not permit the use of a fast shutter, the photographer must find a way to keep the flower from moving. He can erect a windbreak (any handy material will do as long as it does not reflect its own color on the flower). Or he can tie long-stemmed flowers to a stake, carefully placed so as not to show in the picture. If all else fails, he can move the flower bodily to a sheltered place, in which case it is wise to dig it up, and replant it after the picture has been taken.

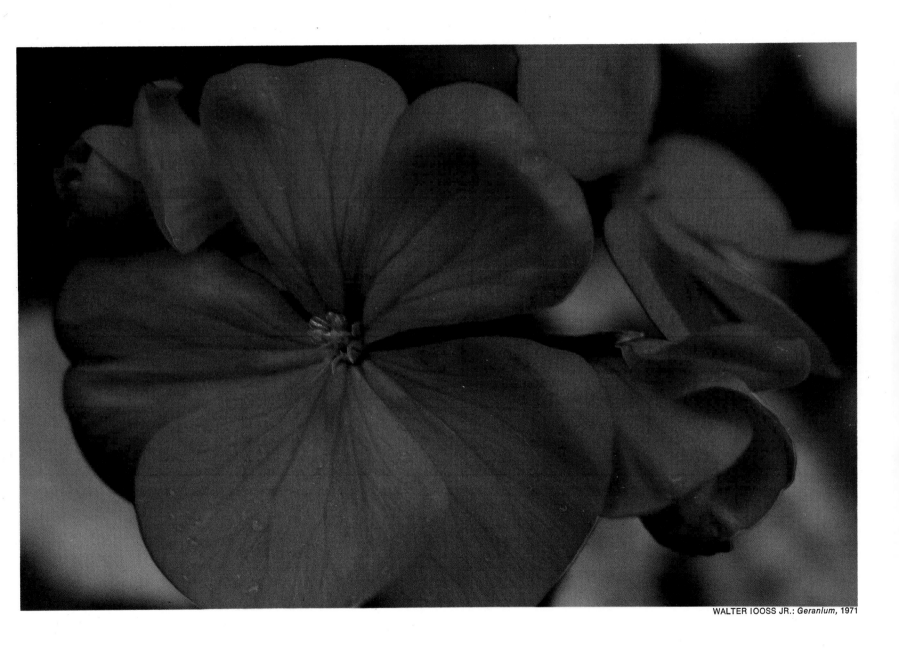

WALTER IOOSS JR.: *Geranium,* 1971

Sprinkled with tiny raindrops that might have been barely visible to the naked eye, a geranium blossom was photographed with an SLR fitted with a macro lens, producing a life-sized image on the 35mm film. During the printing process it was enlarged to about six times life size.

Coping with Depth of Field

Technically speaking, a lens focuses sharply only across a given plane; yet the eye will accept objects just in front of and just behind this plane as being in focus. This zone in which everything seems to be in focus is called the depth of field. At a moderate or extreme distance from the camera the depth of field is great. But the closer the subject is to the lens, the shallower the depth of field becomes. In close-up photography the depth of field may be only a few millimeters. Therefore, in taking pictures at extremely close range the thickness or roundness of an object has a great deal to do with how sharply it will be reproduced in the resultant photograph.

A flat object like the leaf at right is no problem because it has virtually no depth to contend with. But the curvature of the orchid at far right causes it to extend through a much greater depth of field—so great, in fact, that a lens close to it can bring only a small portion of the flower into focus. The photographer must decide, as Nicholas Foster has done here, which part of the plant is most interesting and photogenic, and then concentrate on reproducing that area in focus.

In such situations there are only two ways to obtain greater depth of field. One method is to settle for a smaller film image, either by using less powerful close-up equipment or by moving the camera farther away from the object and refocusing the lens. The other way is to stop the aperture down as far as possible. This method, however, reduces the amount of light reaching the film: so the picture must be taken either with a slower shutter speed or with additional light; the latter can be provided by a reflector or a flash unit.

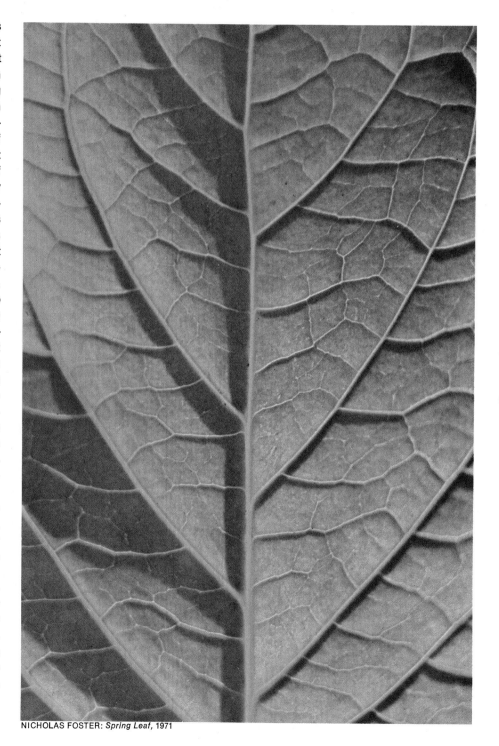

NICHOLAS FOSTER: *Spring Leaf*, 1971

◀ *Because this leaf has a relatively smooth surface and lies flat with no folds or bunching, the photographer could obtain uniform sharpness by focusing his 35mm camera with 50mm lens on any part of it. Even the ribs of the leaf, which rise high enough to cast shadows, are not thick enough to extend past the lens's depth of field, thus remaining in focus throughout the picture. Here the leaf is about five times life size.*

With the same equipment that he used for the leaf at left, the photographer took this life-sized image (here enlarged to about six times life size) of the underside of an orchid. It was possible to get only a small section of the picture in sharp focus because the orchid extends beyond the shallow depth of field that is available at this close range. Even with the 50mm lens stopped down to an aperture of f/16, the depth of field is only two millimeters. This was enough, though, to give a clear view of a glistening dewdrop, clinging to the stem of the orchid just below the petals.

NICHOLAS FOSTER: *Orchid*, 1970

Focusing on the Delicate Detail

The shallow depth of field that presents such a problem in close-up photography *(previous pages)* can sometimes, when applied by an imaginative photographer, be converted into an asset. One case is shown here in photographs that examine the fragile and complex anatomy of flowers. Close-up photography can enlarge and delineate minute parts of a petal, a bud or a stamen. And in the process the shallow depth of field helps to emphasize the flower and separate it from its surroundings *(right)*, sharply focusing on the area of concentration while the rest of the picture is blurred. It can also help separate individual parts of the flower from the rest of the plant—the stamen detailed clearly while the petals are thrown out of focus *(far right)*.

To obtain the best close-up view, the camera can be set at odd angles to the flower. The photographer must make sure that the flower parts are shown in the correct position. The stamen of the hibiscus in these pictures, for example, stands upright. The close-up of it should not be taken at an angle that would distort this position.

After taking a close-up, it is a good idea to back off and get an overall shot of the entire plant, showing the placement of petals and leaves. This establishes the positions of all the flower's parts and ensures positive identification if there should later be any question about its species.

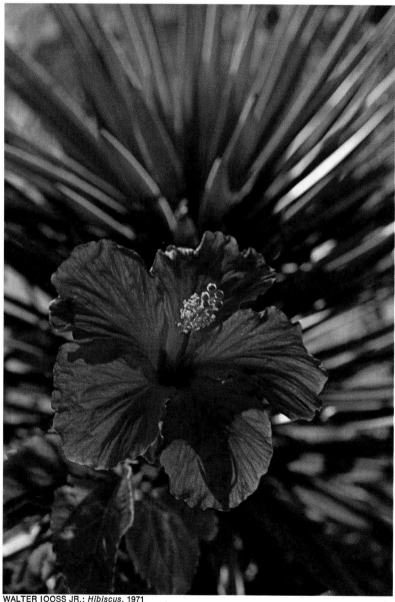

WALTER IOOSS JR.: *Hibiscus*, 1971

Photographed from nine inches away with a macro lens on a 35mm SLR, the entire blossom of this hibiscus stands out from the contrasting green foliage below it. An aperture of f/8 provided just enough depth of field to keep most of the flowers sharp while allowing the otherwise distracting background to go out of focus.

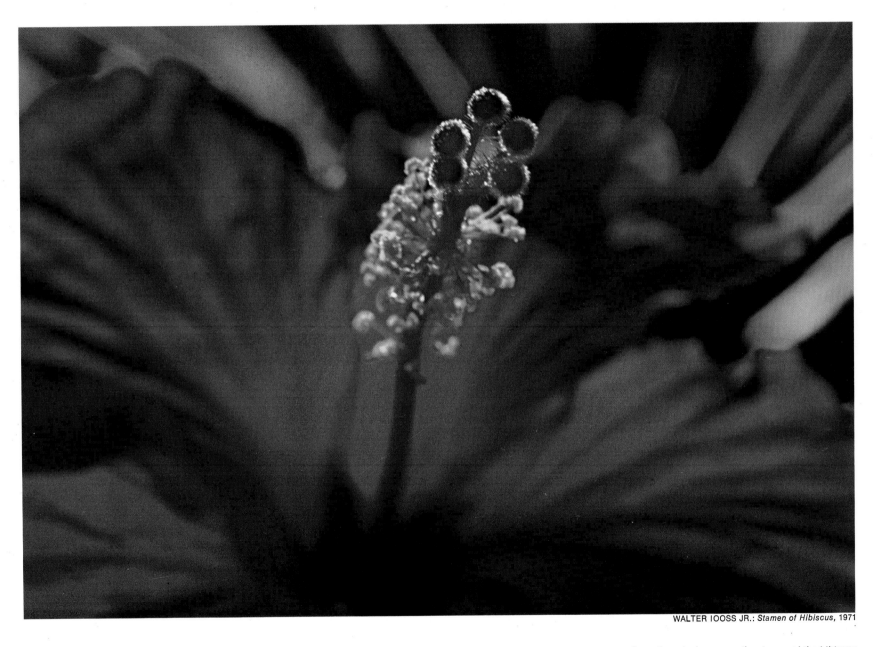

WALTER IOOSS JR.: *Stamen of Hibiscus,* 1971

*From three inches away, the stamen of the hibiscus
also shown in the picture at left is the center of
attention while the blossom itself makes a
soft-focus background. An f/8 aperture, as in the
other pictures, achieved the desired separation,
but a slower shutter speed gave the longer
exposure that was needed at the closer distance.*

107

Dramatic Effects with Directional Lighting

Not every plant benefits from full frontal illumination. The shapes and profiles of some, like the long-stemmed rose at the right, often show up to best advantage when strongly crosslighted from one side. Others are most attractive looking when the light comes from behind the plant, outlining rounded shapes with a bright halo or shining softly through leaves and petals if they are translucent. And there are special situations when side- or backlighting can turn an ordinary picture into an especially interesting one. What makes the photograph at far right striking, for example, is not just the ice on the plant; it is also the luminosity that backlighting gives to the ice.

The effectiveness of such crosslighting and backlighting depends largely on the abrupt contrasts that each produces between light and dark areas. The highlights on a plant make it stand out from the deeply shadowed areas, thereby lending the picture a dramatic three-dimensional quality. However, such drastic contrasts in brightness call for extra care in calculating exposures *(pages 94-95).* The secret of all lighting techniques is to position your camera until you get the desired angle between the light source, the subject and the lens. This may not be too difficult in the case of straightforward photographs. But for the more artistic and complicated kind of pictures involving side- and backlighting, the photographer may have to crawl around patiently until he can find the spot where his camera can catch the proper angle of the sun's rays. Or he may have to resort to the artificial lighting of flash units, positioning them in order to accomplish the desired effect.

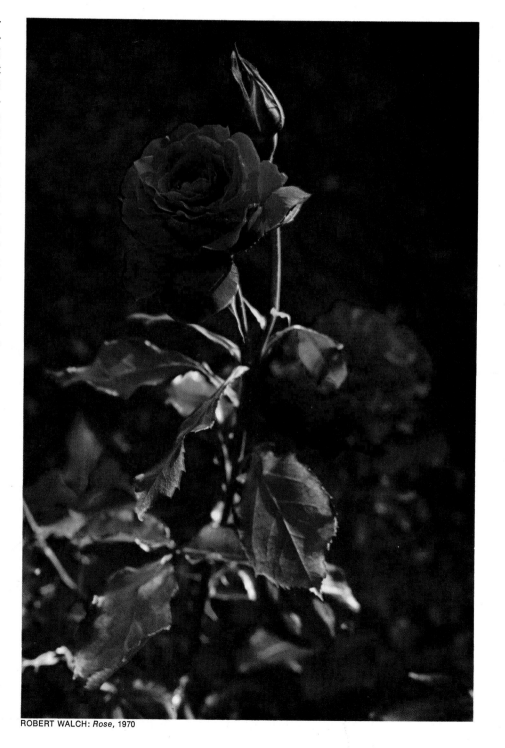

ROBERT WALCH: *Rose,* 1970

◄ Sidelighted by a late afternoon sun, the right side of a rosebush is sharply delineated while other parts are cast into shade. Because the background and the area opposite the sun are still more deeply shadowed, the rose stands out in bold relief from the rest of the picture. To get this view—and include all the plants—the photographer used a 35mm wide-angle lens on his 35mm SLR.

Backlighted by a low winter sun, the ice-encased seed pods of an ivy plant glow like polished glass. Photographer Green-Armytage, who took this picture near his home in southwestern England, calculated the exposure to catch only the transmitted light, some of which was refracted by the ice, illuminating the fronts of a few seeds and stems as well. To obtain a .20x life-sized image (here enlarged to 1.2x life size), he used a 35mm SLR with a 135mm lens and extension rings.

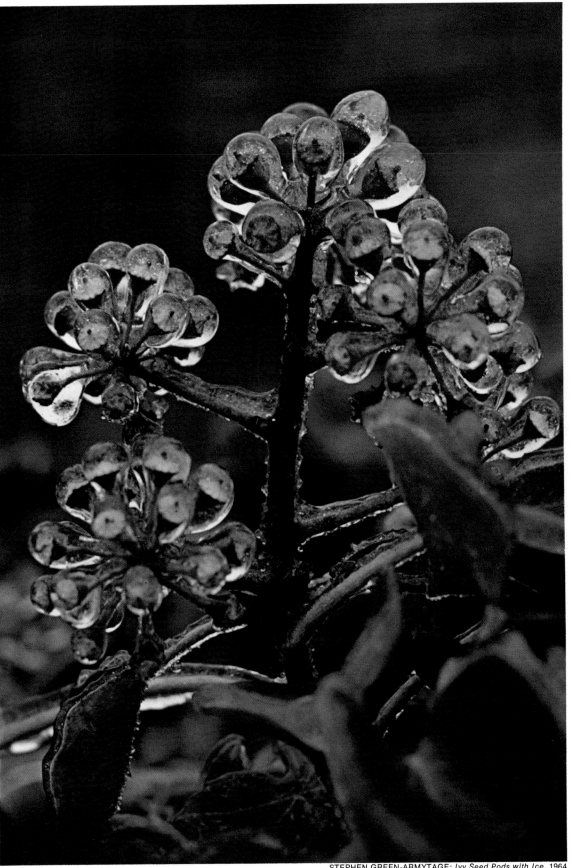

STEPHEN GREEN-ARMYTAGE: *Ivy Seed Pods with Ice*, 1964

The Changing Hues of a Tiger Lily

Which of the two pictures on these pages has the more accurate color? Both show the same tiger lily plant and were taken with the same kind of film and camera only a short time apart. Yet the picture at right has a subdued, bluish cast and the one at far right, taken closer up, shows the flower bright and without haze.

The colors in both pictures are perfectly accurate. What makes them look different is the atmosphere: the bluish quality of one is caused by sunlight filtering through haze left by a light rain. The haze had lifted by the time the picture at far right was taken, and the unfiltered sun struck the flower directly. Neither color is preferable to the other; the photographer's choice is purely that of esthetic consideration.

Light falling on a flower changes color not only with atmospheric conditions but with the time of day and year. When the sun is at a low angle, the colors are warmer. When it is high, the colors are "truer," that is, closer to what we regard as the exact hues. Light is also affected by the surroundings: sand, rocks or snow may reflect the blue of the sky; sunlight filtering through foliage will have a greenish cast.

We are accustomed to seeing flowers under changeable light conditions, and a certain amount of variation adds to the naturalness of a picture. But color film often shows flowers with colors that are not exactly what we remember seeing. The photographer may then wish to take a hand in obtaining the colors he wants in the picture. He can use haze filters to reduce blue, and reflectors or daylight strobes to correct the light. Or he can simply wait until the sun has reached a better angle.

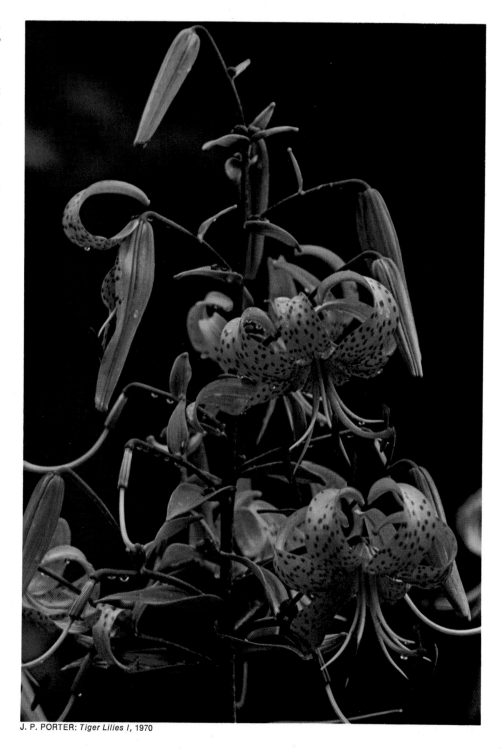

J. P. PORTER: *Tiger Lilies I*, 1970

◄ Enveloped in a soft haze, the tiger lilies at left were photographed a few moments after an early morning rain in the Adirondack Mountains in New York. The picture was taken with a 35mm SLR and a 135mm lens from eight feet away. The intervening distance permitted the hazy quality of the atmosphere to be registered on the film. This bluish cast was reduced somewhat, however, by taking a light reading directly on the blossoms and by using an ultraviolet-absorbing skylight filter to cut through some of the haze.

Two hours after the picture at left was taken, the sun had burned the haze away and illuminated the tiger lily with the strong rays of midmorning. To compose a picture that showed all the life stages of the lily—unopened buds, a full blossom and the dark bulblets on the stem—the photographer moved to within 30 inches of the flower and added a close-up bellows to the camera. A polarizing filter cut down reflections from the glossy leaves and petals, producing these fully saturated colors.

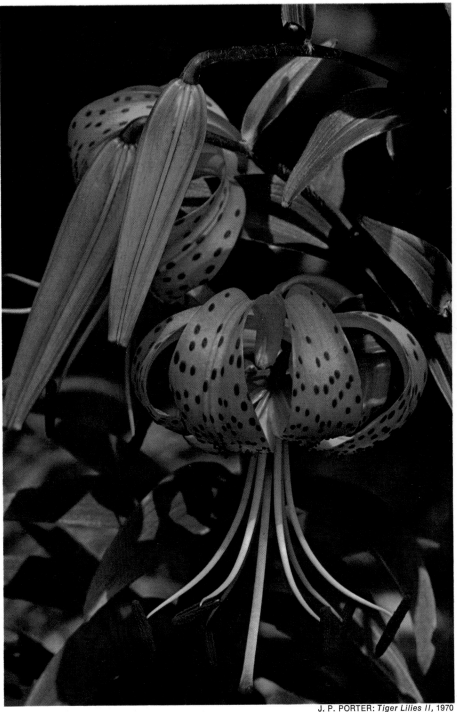

J. P. PORTER: *Tiger Lilies II*, 1970

Putting the Background to Work

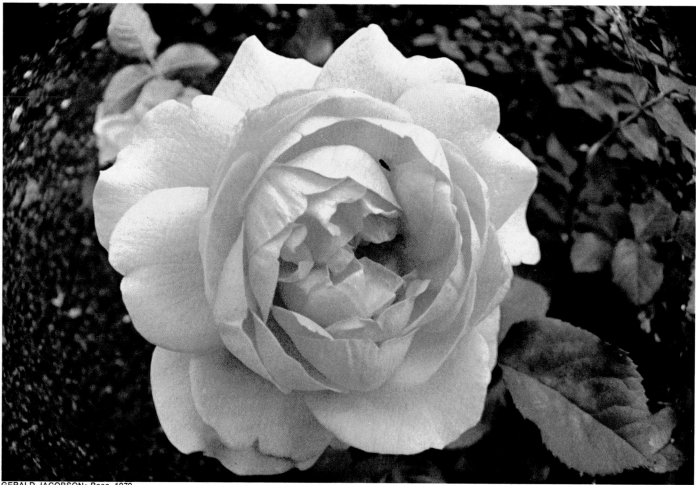

GERALD JACOBSON: *Rose,* 1970

Although backgrounds are frequently ignored or nonexistent in close-up photography, they can sometimes be included with dramatic effect. In the picture at right a telephoto lens has focused on a delicate cluster of flowers, but the photographer has also brought the sun and sky into the scene. They are out of focus, but their placement and presence contribute a sense of mood and place to the picture.

The single rose above was photo-graphed with a special wide-angle sup-plementary lens affixed to a macro lens. This more than doubled the angle of view and created the effect of unusual whorls in the background leaves. In this way the background is made to serve as a circular frame for the rose, and to enhance the composition. Besides gen-erating a compelling background that shows the rose to good advantage, the wide-angle lens emphasizes the full-ness of the blossom.

By adding a wide-angle supplementary lens to his 55mm macro lens, the photographer expanded the camera's view of a rose (above) from 45° to more than 100°. While the background curves, the rose's fullness is accented, and the petals show round and fluffy against the blurred leaves.

A 105mm lens was used to get this sharp view of ▶ fuchsia blossoms, set against the background spectacle of a setting sun. This blending of flower and sky gives the picture a depth and dimension that an ordinary close-up view would lack.

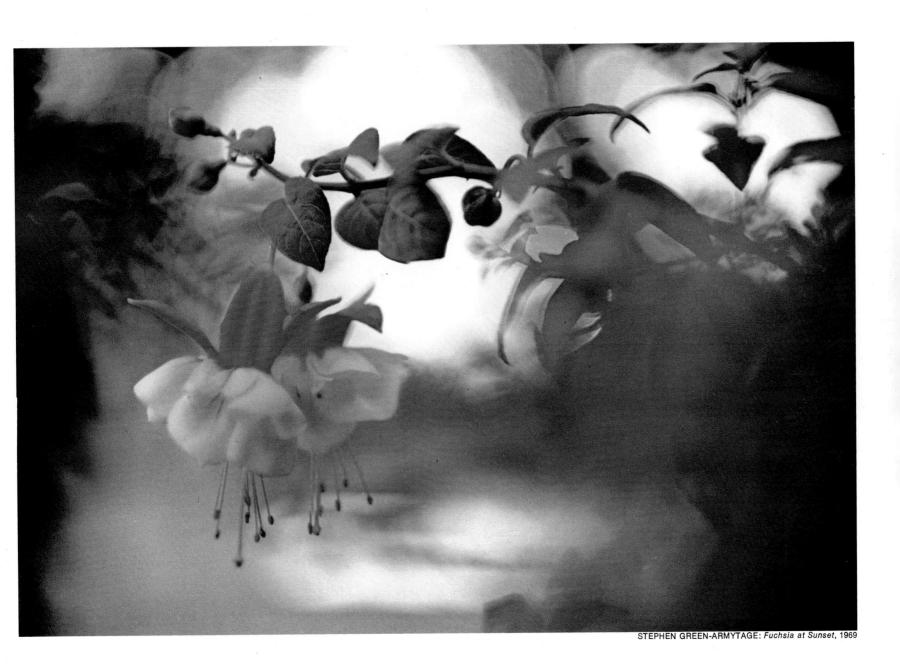

STEPHEN GREEN-ARMYTAGE: *Fuchsia at Sunset*, 1969

The Problems of Picturing Bugs

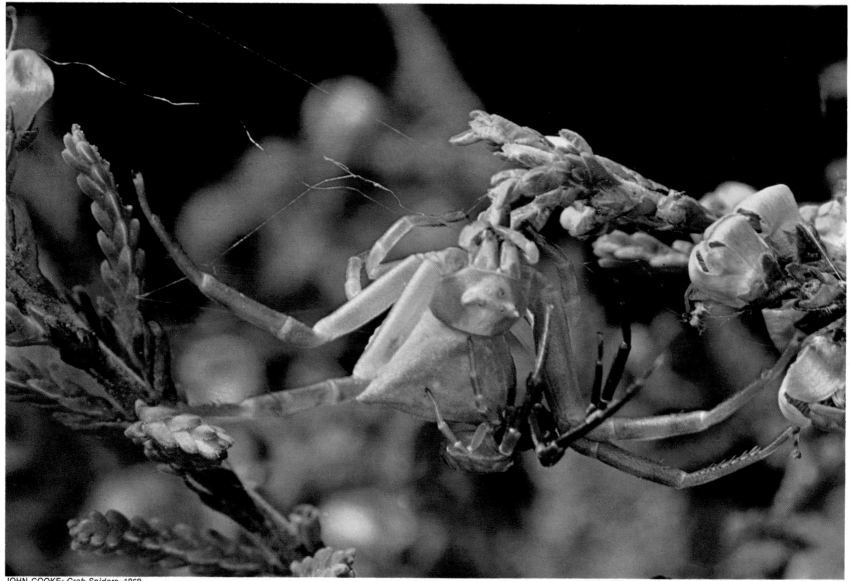

JOHN COOKE: *Crab Spiders*, 1969

In an instinctive gamble with death, a male crab spider climbs along the underside of the larger female and attempts to identify himself to her. If he does not do so quickly enough, the cannibalistic female may eat him before mating can take place. This picture was taken in daylight, but since the photographer stopped the aperture down to f/22 to gain depth of field, he had to use two flash units to provide the necessary additional light.

The neophyte in the field of nature photography might be excused for assuming that one of the most difficult camera subjects in the world is the bug. Its size ranges from small to infinitesimal. It is elusive; if it cannot move like lightning, it is a master of camouflage. Life size, it can be so tiny as to be indiscernible; magnified, it can be hideous. Besides, it may bite or sting.

Yet for the observant, understanding and, most of all, patient photographer, the bug can be a delight. There are bugs in almost unlimited supply. The arthropods, including insects, spiders and scorpions, are the most numerous of all living creatures; there are 300,000 kinds of beetles alone. The bug also offers a heady range of colors, behavior, habitat, facial expressions, eccentricities and sexual customs that have to be photographed to be believed.

For all their bizarre attraction, bugs do present some formidable technical problems for the photographer. Not the least of these problems is size; special equipment of all sorts is needed to look the horsefly in the eye, or to watch the understandably anxious male crab spider as he approaches his cannibalistic mate *(left)*. And many an insect subject cannot be induced to hold still. So the photographer, who has already sacrificed some of the necessary light by using his magnification equipment, frequently has to employ electronic flash —outdoors as well as in the studio.

Electronic flash can provide bright enough light at close distances to allow the camera aperture to be closed down, often to f/16 or f/22. This combination of added light and smaller aperture has two advantages: it gives an increased depth of field and, if the shooting is done during the day or in a lighted room, the small aperture excludes most of the light except that from the flash, preventing a double image.

Electronic flash has other valuable assets: its color closely matches that of sunlight at noon, so natural-looking pictures can usually be obtained without special films or filters; and it produces no evident heat that could annoy or harm an insect.

The price for such benefits is exceedingly careful attention in calculating the correct lens aperture and in measuring the proper distance from flash to subject *(page 98)*. And since it is impracticable, to say the least, to make these calculations each time an insect moves, the solution is to make a list beforehand of apertures and distance measurements for the particular close-up attachments used *(pages 92-95)*, to have ready for nearly every foreseeable situation.

For all these reasons, bugs can be difficult. But—for the reasons illustrated on these pages—the resulting pictures can be exotic and exciting.

The camera can record aspects of insect life that move as quickly as the wingbeat of a wasp or as slowly as the metamorphosis of a caterpillar. These different phenomena require different equipment, but both demand the same quality in the photographer: patience.

The remarkable picture sequence of a wasp in flight on these pages was made with an especially ingenious use of equipment. Dr. Roman Vishniac, a New York photographer who specializes in natural science pictures, took the sequence in his studio. First he focused a camera on one end of a tube. He then rigged an electric-eye device at the tube's end so that an interruption of its beam would trip the camera shutter and set off a high-speed electronic-flash unit. The electric-eye beam was aimed at the point where the camera was focused. When a wasp was forced into one end of the tube, it flew through the tube and out the other end, interrupting the electric-eye beam and taking its own picture. Many trips through the tube, and many pictures, were needed to get the full sequence of a wasp's wing positions as they are shown here.

There could hardly be a greater contrast between this elaborate project by Dr. Vishniac and that of Terence Shaw, who was 16 years old when he took the sequence of a caterpillar becoming a butterfly, shown at bottom right. Shaw's studio was the family living room, where he brought the monarch larvae to feed on potted milkweed plants. Then, using a 4 x 5 press camera and two electronic flash lamps, Shaw recorded all the stages of the gradual metamorphosis—with the same patience Dr. Vishniac used to catch the split-second flick of a wasp's wings.

In the sequence above, a cicada-killer wasp propels itself through the air by beating its wings 682 times a second. The wing motion was stopped with an electronic flash that produced an exposure speed of 1/75,000 second. Four of the many separate pictures are arranged to show one full cycle of the wasp's wing movement.

Stages in the development of a monarch butterfly are shown in this series. From left are the full-grown caterpillar, moulting caterpillar, pupa, completed metamorphosis, emerging butterfly and fully developed butterfly on the shell of the pupa. Careful observation was needed because some pictures had to be taken only hours apart, others days apart. The process took two weeks.

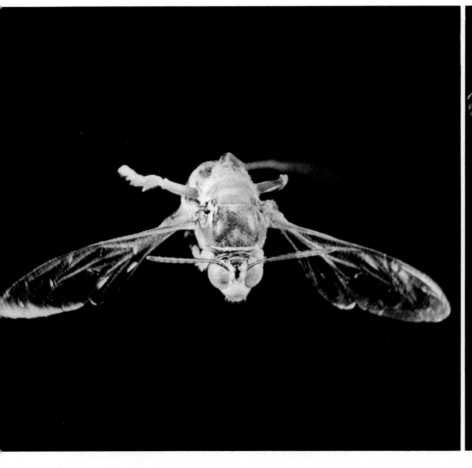
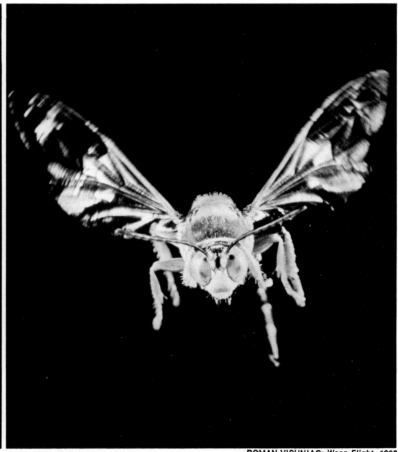

ROMAN VISHNIAC: *Wasp Flight*, 1962

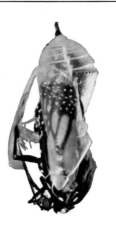
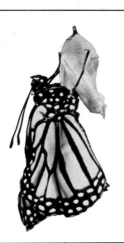

TERENCE SHAW: *Monarch Metamorphosis*, 1957

The shape as well as the size of an insect can influence the way its picture should be taken. Because the depth of field is extremely shallow with close-up equipment, elongated subjects like the caterpillar at right should be photographed from the side, or nearly so, if the entire insect is to be kept in focus. If photographed from the front, only the head of the caterpillar would be in focus and the remainder would be a blur. This shallow depth of field can, of course, be turned into a virtue. When the photographer wants to emphasize only part of a subject, the shallow depth of field will cause the rest of the picture to become indistinct.

This effect is inevitable with subjects that are magnified considerably larger than life size, as in the picture at far right. At this degree of magnification there is no appreciable depth of field, so the photographer must compose his picture to concentrate on objects that lie in a virtually flat plane. Thus Dr. Alexander Klots emphasized one eye of a horsefly; by so doing he obtained a more striking photograph than if the whole insect had been in sharp focus.

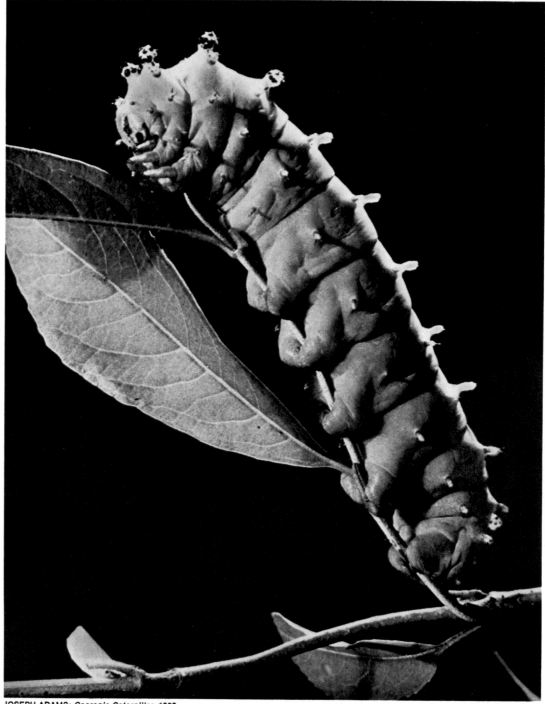

JOSEPH ADAMS: *Cecropia Caterpillar,* 1952

A broadside view of a cecropia caterpillar shows all of the insect in sharp focus. This is possible in part because the caterpillar is extended in a relatively flat plane in front of the camera. In addition a fairly extensive depth of field was available, since the picture was not taken as an extreme close-up. The caterpillar is reproduced in the photograph at left at 1.5x life size.

A head-on view of a female horsefly concentrates on the iridescent structure of a single eye, while purposely letting the rest of the picture fade gently out of focus. This shallow depth of field was obtained by photographing close to the subject, with a 35mm SLR, extension tubes and a 50mm lens stopped down to f/22. The subject was photographed at 1.5x life size on the film (here enlarged to about 12x life size), which permitted a zone of sharpness barely 1/12 inch deep.

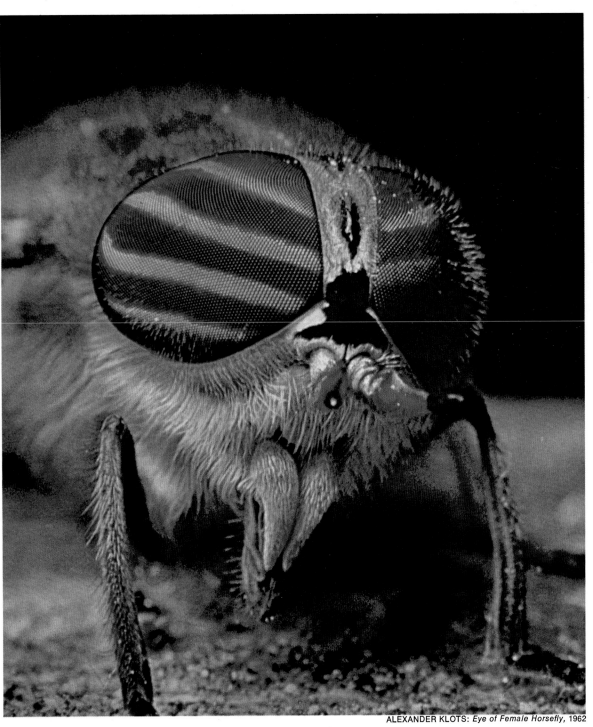

ALEXANDER KLOTS: *Eye of Female Horsefly*, 1962

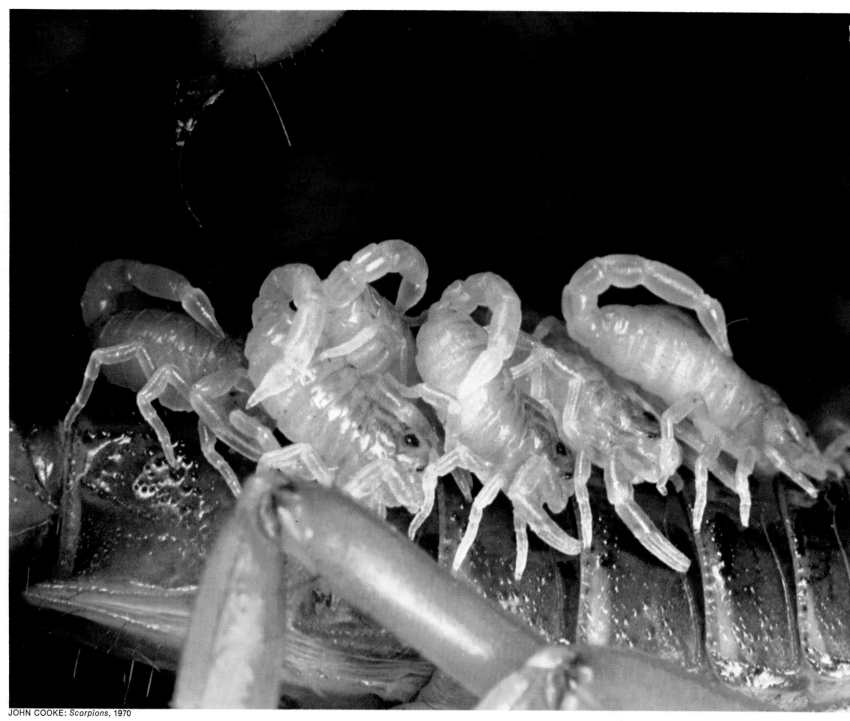

JOHN COOKE: *Scorpions*, 1970

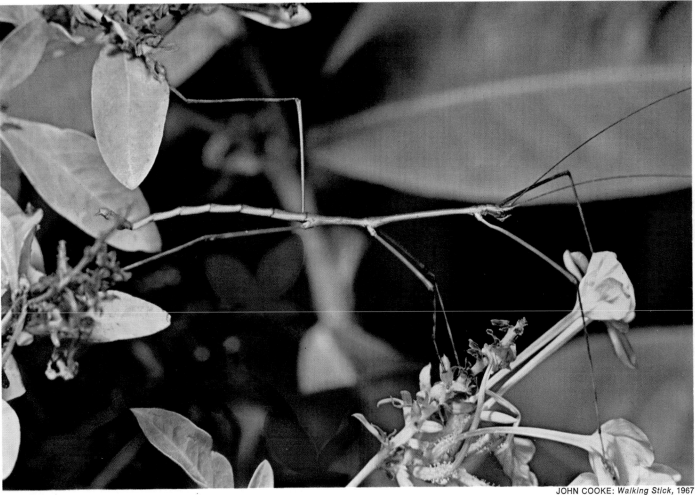

Looking like another twig, a walking stick stretches away from a branch. It was brought, branch and all, from a bush in Jamaica into a portable studio. There the photographer was able to adjust two electronic-flash units so that highlights along the length of the insect would make it more visible in the picture.

Baby scorpions line up on their mother's back under the protective stinging tip of her tail. To confine this mobile family in a small area, the entomologist taking their pictures coaxed them, very carefully, into a container. Once they were indoors, he released them in a tray filled with sand and rocks from their Arizona desert habitat and got this picture, which is enlarged to 7x life size.

Some of the close-up photographer's subjects are so skittish or need such careful lighting that they have to be captured and taken into the studio to be photographed. Even indoors the pictures can be made to look as real as they would outside so long as some of the bug's habitat is also collected and taken along to be photographed with it. This is normally no major problem because a clump of foliage or a shovelful of sand is generally all that is required

to fill the frame in a close-up view.

But sometimes the setting for the picture must be transported as carefully as the bug itself. This is particularly important when taking pictures like that of the walking stick above. The purpose was to show how the insect blends into its setting. Thus the subject and its environment were of equal pictorial interest. And it was an easier matter to bring the insect indoors by bringing its habitat along with it.

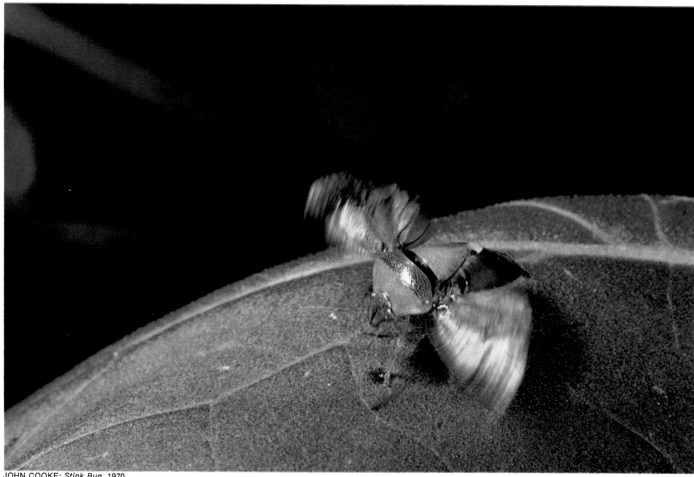

JOHN COOKE: *Stink Bug*, 1970

Careful observation can make all the difference between a picture like this one and a frustrating view of an empty leaf. Entomologist John Cooke already knew the habits of the stink bug: it whirs its wings while literally warming up to take off after a cool night's rest. Such a process often gives the alert photographer a chance to get a good action picture.

Cool nights and mornings are favorable times for photographing such subjects. Some insect photographers even try to subdue a hyperactive bug by capturing it in a plastic bag and putting it into a refrigerator for a few minutes. The insect can then be replaced in its natural environment and photographed while thawing out. This technique is not always successful, however. An over-chilled insect acts drugged, and the camera will unerringly reveal the fact. To the trained eye, a groggy bug makes as distressing a picture as a wilted flower. So refrigeration should be used only as a last resort. ☐

After pausing on a leaf in the cool night air of Arizona, a stink bug exercises to warm up before flying away. Photographer John Cooke glimpsed the bug with the aid of a flashlight and knew it would continue its calisthenics for the few seconds needed to adjust his camera rig and take a picture. Even the high speed of an electronic flash was not enough to stop the motion of the wings, but the realistic blurring contributes to the naturalism of an exceptional photograph.

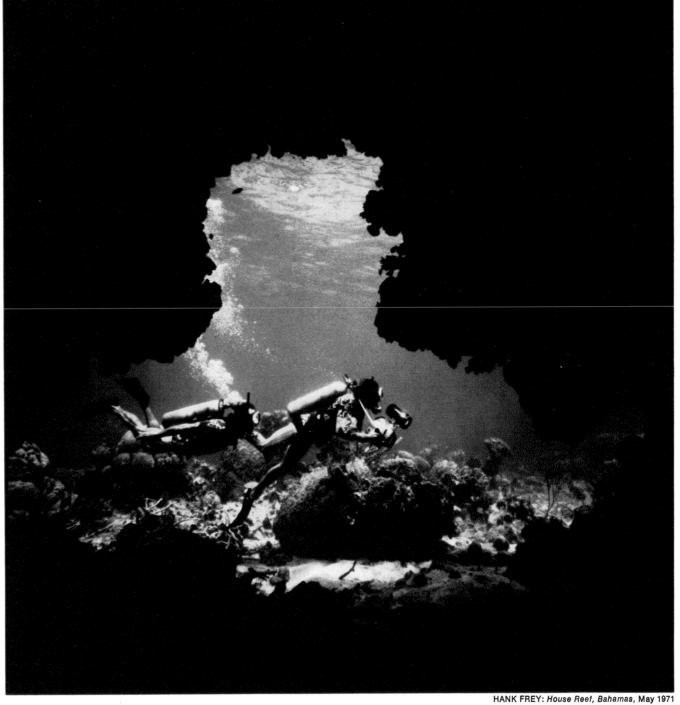

HANK FREY: *House Reef, Bahamas,* May 1971

The Deceptive Deeps

Man and the undersea world are not really meant for each other. Human eyesight is weak and blurry underwater; ears cannot pick out the direction of sound; human skin wrinkles like a prune after lengthy immersion. The pressure of water, increasing by 14.7 pounds per square inch for every 33 feet of depth, poses a threat to the air spaces in the lungs, ears and sinuses. Water's drag makes swimming slow and fatiguing. And its thermal property, draining off precious calories many times faster than they are lost in air, is inimical to a warm-blooded intruder.

Despite all these obstacles, the romance between man and the underwater realm flourishes as never before. With a face mask to restore sight, scuba gear to provide air and to counter water pressure, swim fins to improve locomotion, and a foam-rubber wet suit to preserve body heat, a new amphibious creature has come into being. Properly trained, this man-fish can dive safely to 130 feet—and breathing a special mixture of gases and taking precautions to avoid the bends, he can go deeper than 1,000 feet.

Nowadays a diver's equipment will often include one item not related to survival—the camera. Carried into the sea, it has recorded visual wonders that can equal anything found on the surface of the planet. It has revealed labyrinthine landscapes of coral, fish as sleek as swords or bright as chips of sunshine, creatures that sail the currents like diaphanous yachts, stodgy animals that spend a lifetime in a single spot, worms as beautiful as flowers, odd denizens of the deep that move on armored legs or by jet propulsion, and countless other fascinating sights. No one who has seen the results of underwater photography ever asks, "Why bother?"

Yet underwater photography was in fact too much of a bother for three decades after the camera was invented. The reason was simple: ordinary cameras were no better suited for taking pictures underwater than human beings are for living there. Water will corrode the metal parts of a camera and damage photographic emulsions. And even if the camera is waterproof, it must also be structurally strong enough to resist great pressures (at a depth of only 60 feet, an eight-inch cube is subjected to a crushing force of more than five tons). In addition to these liabilities, light—the basic necessity for photography—weakens rapidly as it passes through water. In the clearest seas, seven eighths of daylight is lost after traveling 35 feet down.

William Thompson, the first man to dunk a camera intentionally, was not aware of the finer points of these difficulties when the inspiration for underwater photography seized him in 1856. But he probably would not have been deterred, because the applications that he envisioned were far from artistic. An engineer by training and a photographer by avocation, he was watching the swollen Wey River in England rush through the arches of a bridge one rainy day when it occurred to him that a camera might be useful for inspect-

Louis Boutan, posing here for an underwater self-portrait, recognized the limitations of trying to study marine life from above the surface. His pioneering experimentation with underwater photographic and lighting techniques led in 1900 to one of the earliest books on the subject.

ing the threatened, submerged part of the structure. Translating idea into actuality, he constructed a watertight box large enough to hold a camera, with a sheet of plate glass at one end. Outside the glass he placed a heavy wooden drop-shutter, attaching a string to it so that it could be lowered and raised. Then he and a friend rowed out into Weymouth Bay and eased the unwieldy apparatus 18 feet down to the riverbed. The shutter was opened for 10 minutes. When the two men pulled the camera aboard again, it was full of water. However, Thompson succeeded in developing a dim image that showed sand and boulders covered with weeds. He sent a print to the Society of Arts, along with a note saying: "This application of photography may prove of incalculable benefit to science. Should a pier or bridge require to be examined, you have but to suit your camera, and you will obtain a sketch of the pier, with any dilapidations, and the engineer will thus obtain far better information than he could from any report made by a diver."

Thompson's interest waned, and several decades passed before the idea was picked up again. But Louis Boutan, the next man to build an underwater camera, made tremendous advances and deserves to be credited as the true founder of underwater photography. A robust and adventurous zoologist, Boutan had roamed the world before accepting a position on the Paris Faculty of Science. During the summers, he lectured and did research at the Arago Marine Laboratory in the South of France and there, in 1892, he conceived the idea of taking underwater photographs to aid his studies.

Originality marked his efforts from the very beginning. One of his early underwater cameras was housed in a large copper box connected by a tube to a rubber balloon full of air; when the apparatus was submerged the water squeezed the balloon, forcing air into the housing, where it helped to offset the exterior pressure. Another even bolder design was a "drowned camera" whose innards were permitted to fill up with water. This eliminated any concern about pressure and waterproofing, as well as certain optical problems. Boutan procured some specially varnished photographic plates that were almost impervious to salt water, then proceeded to test the system. The results were not auspicious. Apparently the shutter stirred the water in such a way that the image was blurred. Boutan's most successful design utilized a strong housing that required no balloon for pressure equalization. The inventor himself put on a diver's suit and went down to operate the camera.

Although the waters of the Mediterranean were clear, available light was too weak to register images of moving fish on the gelatin dry-plates that Boutan employed. Depending on the depth, he had to make exposures lasting anywhere from 10 to 30 minutes. (Since waterproof watches did not exist in those days, the exposure time was gauged by assistants in the boat above, who signaled to Boutan by tugging on his safety line.) Undiscouraged by this

problem, Boutan set out to solve it by creating the world's first submersible lights. With the help of an electrical engineer, he came up with a gadget whose description sounds strangely familiar. It consisted, Boutan wrote, "of a spiral wire of magnesium in a glass balloon containing oxygen, and a fine platinum wire, connected to the two poles of a battery. When the current was turned on, the platinum wire reddened and ignited the magnesium, which oxidized with a brilliant light." It was, in short, the progenitor of the modern flash bulb. Unfortunately the bulbs often overheated and burst.

The indefatigable Boutan went on to new schemes for underwater light. In 1899 he built two submersible arc lamps and attached them to a camera housing. Lowering the rig 165 feet into the sea, he operated the electromagnetic shutter by remote control and snapped a picture of a sign that had been attached in front of the lens. It wasn't a very exciting sign; it merely stated that this was an underwater picture, and gave the depth. When Boutan pulled the apparatus up again, one of the lamps was out of action, but the picture came out sharp and clear. After that, Boutan never took another underwater photograph; he devoted the rest of his career to other research. (He later discovered how to grow cultured pearls, among other accomplishments.) Some 40 years were to pass before anyone dared to descend deeper into the water for a picture than he had done.

The public got its first taste of undersea cinematography through the efforts of a shrewd moviemaker named Jack Williamson. Strictly speaking, his technique was not in-water photography. Both the camera and its operator were enclosed in an observation ball dangling from the bottom of a barge. Through the glass porthole of this "photosphere," as he called it, Williamson filmed such gripping subject-matter as a treasure hunt, divers fighting sharks with knives, and one lissome swimmer starring in a movie entitled *Girl of the Sea.* In 1915, he shot his greatest hit, the first film version of Jules Verne's epic *Twenty Thousand Leagues under the Sea.* Its cast included a giant octopus—U.S. Patent No. 1,378,641—made of rubber and coiled springs, with a diver manning the controls inside the monster. The public, ready to believe anything about the alien undersea world, generally regarded the octopus as real.

The first underwater pictures in color were taken in the 1920s by a more serious experimenter, the American ichthyologist W. H. Longley. He used slow Autochrome film whose color derived from millions of embedded grains of tinted starch. To create enough light for moving subjects, Longley placed tremendous one-pound charges of powdered magnesium on an open-bottomed raft. The blast, equal to 2,400 flashbulbs, produced the greatest illumination ever used for undersea pictures. It was really "more than human nerves could stand," Longley said, and one charge blew the raft to smith-

This was Boutan's ingenious way of making his heavy equipment easy to manage. The watertight and pressure-resistant housing was so massive that even though it was buoyed by submergence a block and tackle had to be used to raise and lower it in the water, and the husky zoologist wore himself out maneuvering it on the sea floor. Boutan's solution to this problem was to hang the equipment from a floating barrel that counterbalanced most of the weight. The pulley system between barrel and housing could be adjusted to set the apparatus at the desired depth.

ereens. This rather cataclysmic lighting system worked most of the time, however, and the pioneering pictures that it yielded were printed in the National Geographic Magazine in 1927. Nearly three more decades passed before another underwater color picture was published.

Undersea photography, moving by fits and starts for almost a century, finally came into its own in the 1950s. The main reason was the development of the Aqualung, a contrivance of cylinders with compressed air that permitted divers to breathe for longer periods underwater. This was a true quantum leap in undersea freedom, and photographic equipment manufacturers were not quite ready for it. Divers who wanted to document what they found down there had to improvise their own photographic gear at first. Waterproof housings of every description were used—homemade wood and plastic boxes, Mason jars, and even rubber hot-water bottles with glass portholes. Today divers can readily buy factory-made housings, light meters, lenses and various other accessories designed for undersea photography. This does not mean that taking pictures under water is now a simple matter. Although almost anyone can get a reasonable picture a few feet below the surface of the Caribbean with a box camera in a plastic case, the subjects of the deep cannot be recorded so easily. Underwater photography still has definite hazards and restrictions.

What should an entrant into this field know? First of all, he ought to be familiar with what happens to light in water—and he does not need a camera to see that a great deal happens. Looking through the glass of a face mask, a diver will note that the underwater world is dimmer than the surface world, that he cannot see very far and that there is a general lack of contrast and a loss of color as he goes deeper. He will find that everything appears a bit larger and closer than it really is. If he stays below for a few minutes, his brain will become partially adjusted to these conditions, and he will be less aware of them. But a camera does not possess this amazing power of adjustment—which explains why so many underwater pictures surprise the inexperienced photographer by turning out to be dull, monochromatic, badly exposed or improperly focused.

The purest water is very "hazy" compared to air. Even in such crystalline spots as the eastern Mediterranean or the Sargasso Sea off Bermuda, where clear surface water is continuously sinking downward, visibility is limited to a few hundred feet. Elsewhere, the visibility only a dozen feet below the surface may be so poor that a diver will hardly be able to see his hands directly in front of his face mask. There is always less light below water than above, one reason being that some of the sun's rays bounce off the surface of the sea—the amount depending on the angle of the sun and the roughness of the

surface. The main difficulties of vision, however, stem from two phenomena known as scattering and absorption.

Scattering occurs when photons—the energy packets of light—are briefly trapped and then re-emitted in a new direction by suspended particles in water or by the water molecules themselves. Absorption occurs when photons strike water molecules or suspended particles and are converted from light energy into heat. Both of these processes happen in air to a certain extent, but much more so in water. Not only is water about 800 times denser than air, but it has a great deal more particulate matter—which may consist of bits of sand, mud, coral, decayed organic matter, minerals, bubbles and plankton or other minute organisms.

Scattering lowers contrast by creating nondirectional, diffuse light, thus eliminating the shadows that help to define an object. Contrast is further reduced by the diffuse glow of scattered light from the surrounding water. Scattering and absorption together diminish the light reflected from an object, reducing its brightness and making details more difficult to distinguish.

Both scattering and absorption also affect color, by acting on different wavelengths to different degrees. Short blue wavelengths are scattered more than long red ones in water. Absorption, however, is the main determinant of colors in the undersea world. Water absorbs more of the longer wavelengths—the "warm" hues of red, orange and yellow—than of the shorter green and blue wavelengths. This selective absorption, together with scattering, is responsible for the so-called blue-green window of the sea—a metaphor that simply means that blue and green wavelengths pass efficiently through the water while warmer colors are blocked. Actually, peak transmission of light energy is not always located in the blue-green part of the spectrum. Decayed marine plants produce a yellowish pigment that absorbs strongly in the blue spectral region, shifting the "window" of maximum transmission to the green-yellow area. This fact explains why water looks greenish wherever vegetative life is abundant in the seas—near coasts and the closer one approaches the poles. Nevertheless, the absorption of warm colors occurs everywhere, from the plankton-rich waters of Labrador to the clear waters of the Bahamas.

The depletion of red, orange and yellow wavelengths begins to be noticeable only a short distance below the surface. If a brilliant red object is photographed 15 feet down in clear tropical waters, it will appear rather dull, even close up. At 30 feet the object will hardly look red at all, because the red wavelengths are almost entirely attenuated at that depth. Yet a blue or green object will retain much of its color as deep as sunlight can reach, since these wavelengths are only slightly absorbed. (To the eye, a full range of colors may appear to be present at 30 feet beneath the surface, but film will

This diagram illustrates what happens to sunlight when it goes underwater. The spaces shown between the light rays are smaller beneath the surface because the rays are bent, or refracted, when they pass from air to water. At any given depth the brightness of the underwater rays is proportionate to their length on the diagram. A ray entering the water at an angle of 90°—when the sun is directly overhead—will travel straight down, the shortest possible distance, to reach an underwater point. A ray entering at a lesser angle— in morning or afternoon—must travel obliquely through a greater distance of water to reach the same point, and its brightness will be lessened along the way by diffusion and absorption.

record the real proportions of various wavelengths with greater honesty.)

What can the underwater photographer do about these various effects of scattering and absorption? For one thing, he must forswear long shots. They simply will not work. In general, high-quality images cannot be made at a distance of more than one fifth of the range of visibility. That is, if a diver can see 50 feet, he should not try to take a picture of anything more than 10 feet away, because the camera, contradicting the testimony of the eye, will yield images degraded by loss of contrast. To obtain maximum contrast, it is almost always desirable to be as close to the subject as possible. For this reason, underwater photographers use wide-angle lenses much of the time. A wide-angle, that is, short focal-length, lens can be focused at closer range than a long lens while still encompassing a generous field of view. Also, a wide-angle lens has more depth of field than a long lens. This is a major asset underwater, where exact focusing is often difficult, due to the movement of the subject or of the weightless diver himself, who cannot steady himself by planting his feet on firm ground.

In black-and-white photography the loss of image contrast can be partially countered by choosing a medium-speed film. Slow films have the greatest contrast, but are not very practical in such dim conditions; fast films permit smaller apertures for more depth of field, but have the least contrast. Medium-speed film is a wise compromise, except in the gloomy deeps, where sensitivity is the foremost concern. A yellow filter will heighten contrast somewhat by holding back the scattered blue wavelengths, but then the background will come out almost black if the camera is aimed toward open water. Still another means of increasing contrast is to underexpose the film deliberately and to extend the developing time by 10 to 20 per cent. High-contrast printing paper also helps.

Color film, of course, raises the ante, holding out the promise of exciting images—and at the same time introducing a clutch of new problems.

Few picture-taking experiences are more frustrating than photographing a reef that appears to be exploding with yellows and oranges and violets —and getting back from the film processor what looks like a black-and-white picture that has been tinted blue-green. In ordinary photography, color balance can be adjusted by filters, but down below the filters do not work as well. Color-correcting filters that restrain the blues and greens while passing the longer wavelengths will help to keep natural-looking color as long as the light does not pass through more than about 30 feet of water. However, at greater distances the filter is not very useful; the long wavelengths are virtually gone, and nothing can restore them except artificial light. Filters also call for increased exposure, which can be a drawback in situations where the light intensity is low to begin with. There is a new color film that is less

sensitive to blue than any other yet developed. Originally used for cutting through the haze in aerial photography, it is now being marketed also for underwater photography. Not only does it help bring out reds and yellows without the use of filters, but it is a high-speed film (ASA 1,000). The pictures it provides, however, are grainy and not as sharp as those from slower film.

Artificial light provided by flash bulbs or electronic flash is the answer to many of these difficulties of underwater photography. With its fresh infusion of a full range of wavelengths, artificial light revives colors that have been dulled or extinguished by the passage of light through the water. It also allows pictures to be taken at any depth and at any time of day. Flash bulbs are perfectly suitable for underwater use: they can withstand the pressure of water to a depth of 250 feet, and their terminals can be exposed to electrically conductive salt water, since the flash bulbs use a low voltage that could not harm a diver. Another advantage of flash bulbs is that they can be synchronized at any shutter speed when a camera with a focal-plane shutter is being used; electronic flash can be synchronized only at 1/60 second with a focal-plane shutter, and in bright shallow water this relatively long exposure may register a ghost image around the sharply defined image recorded by the electronic flash's very fast wink of light. However, electronic flash can be synchronized at any shutter speed with the leaf shutters used in rangefinder and twin-lens cameras, and it is far cheaper if a photographer takes a lot of pictures—there are several reliable units designed especially for use underwater. Finally, electronic flash has no disposal problem; some divers have complained that areas have become littered with the worn-out flash bulbs left by careless photographers.

When using flash bulbs with daylight color film, blue bulbs are best for lighting any subject closer than about six feet. For more distant subjects, clear bulbs should be used. Their excess of red wavelengths is offset by the red-absorption of the water. To calculate exposure settings, a rough rule is to divide the above-water flash factor by four. This allows for the water's attenuation of light as well as the absence of reflecting surfaces. (Special allowances must be made for very murky water or, at the opposite extreme, an underwater cave where the walls reflect much of the light.) Generally the use of flash underwater is as much an art as a science—and some valuable artistic tricks are shown in the picture essay on pages 136 to 144.

Underwater light obviously places a brand-new set of demands on photographers. Not only do scattering and absorption have profound consequences, but even the optical behavior of lenses may change. When light passes from water to air, its speed increases from 135,000 miles per second to 186,000 miles per second. As a result, the path of the rays bends slightly. This bending, called refraction, produces a 33 per cent magnification, mak-

How Focal Length and Angle of View Change Underwater

	focal length of lens		angle of view	
	above water	underwater	above water	underwater
35mm cameras	21mm	28mm	92°	75°
	28mm	37mm	75°	60°
	35mm	47mm	63°	50°
	50mm	67mm	47°	36°
2¼ x 2¼ cameras	38mm	51mm	93°	77°
	50mm	67mm	78°	62°
	60mm	80mm	68°	53°
	80mm	106mm	53°	41°

Because light is refracted as it passes from water into the air in the camera housing, both the focal length and angle of view of lenses are affected, as shown in this chart. Thus the focal length of a 50mm lens, normal for a 35mm camera above water, is increased by one third to 67mm underwater, and the angle of view is narrowed from 47° to 36°. Note that the slightly wide-angle 35mm lens performs underwater much as the normal 50mm performs out of the water.

ing everything look larger or closer than it is. A lens, in effect, becomes longer: that is, because of refraction, its effective focal length increases by one third, causing it to have a narrower angle of view and less depth of field than it would in air *(chart)*. Since the photographer's eye and the camera's lens are similarly affected, the lens should be focused at the apparent distance of the subject, rather than the actual measured distance. Focusing errors can sometimes occur, especially with rangefinder cameras, because the mind second-guesses this optical change. If the photographer employs the viewfinder of a reflex camera he will avoid trouble, since he will be seeing exactly what the lens sees.

Another optical complication is produced by the glass or plastic window, or port, through which the camera lens looks. In most housings the port is flat. Rays of light striking the flat surface at a sharp angle are refracted more than those that strike nearer to the perpendicular—and this causes distortion and the prismatic effect on colors called chromatic aberration. In practice the trouble arises only with wide-angle lenses. An extreme wide-angle lens, shooting through a flat port, will yield pictures that are blurred and "stretched out" at the edges; also, the colors near the edges will display rainbowlike fringes. A moderate wide-angle lens will produce better images. With a normal or telephoto lens—useful for photographing shy fish—the distortion and chromatic aberration are nearly imperceptible, because such lenses have a narrower angle of view; hence the light rays they admit are close to being perpendicular to the port.

Clearly, the photographer faces a conflict of interest here. Does he have to accept distortion and blurring of colors in order to gain the benefits of a wide-angle lens that enables him to get close to the subject? He does not; several ways out of the dilemma have been devised. Dome-shaped ports can correct much of the distortion. Due to the curvature of a dome port, most of the light rays pass through it fairly close to the perpendicular, eliminating the sharp angles that cause trouble. When extreme wide-angle lenses are used, a dome port is absolutely necessary; otherwise the distortion would be intolerable. Another optical remedy for the problem makes use of a plano-concave port (flat on the outside and curved on the inside) and introduces a corrective lens between the port and the camera. Both these systems pay an extra dividend: they restore the above-water focal length of lenses, making them perform in their normal fashion. But there are drawbacks, too: these optical systems add considerably to the expense of the equipment and they give good results only if the additional lens is very carefully positioned inside the housing between the port and the camera.

The camera housing itself can mean the difference between success and exasperation. Dozens of different kinds of housings are on the market,

priced from less than 30 to more than 10,000 dollars. Most are made either of rigid plastic or of cast aluminum with a port made of glass or optically clear plastic. The primary criteria are that a housing be watertight and able to withstand the water pressure down to normal diving limits of about 130 feet. For a satisfying degree of photographic flexibility, the housing should have outside controls that will manipulate focus, shutter and aperture settings, film transport, and shutter release on the enclosed camera. A housing that lacks any of these controls (or is so constructed that they are hard to operate) will soon frustrate its owner.

The housing should be as small as possible, since extra interior air space will necessitate extra ballast to make the housing sink. Most plastic housings are lightweight, and generally call for two to five pounds of ballast; cast aluminum housings usually present no ballast problems. Metal housings have some additional advantages: they are more rugged than plastic ones; there is no danger of internal reflection spoiling pictures; and there usually is no lens-fogging problem. In plastic cases, the camera lens sometimes fogs over because the cool underwater temperature causes condensation of moisture in the air within the housing. This can be controlled by placing packets of moisture-absorbing silica gel inside the housing—but the trouble will not arise at all in metal housings, since the moisture condenses on the metal walls, which cool faster than the lens.

The most versatile housings give the photographer full access to the viewer of a reflex camera for easy composition and focusing. With many housings, only a small part of the viewer is visible because the photographer cannot get his eye close to it. This can be an inconvenience, forcing the photographer to focus by estimate and to compose the picture with some inherently inaccurate device like a wire-frame sport-finder.

The ultimate solution is to get rid of the housing altogether. Exactly that has been done with the versatile Nikonos camera, which looks much like an ordinary 35mm camera but is watertight and pressure resistant. The Nikonos can accommodate 15mm, 21mm and 28mm lenses that are specially corrected for underwater use, as well as watertight 35mm and 80mm lenses that can be employed either above water (in a driving rainstorm, for example) or below. The Nikonos also offers attachments for close-up work to magnify small animals and plants in the water.

Such waterproof cameras may not be the last word in equipment. The United States Navy has experimented with a camera that can take pictures while filled with water, eliminating numerous structural and optical problems of other systems. Perhaps an old prophecy is coming true; the water-filled camera was originally suggested at the turn of the century by Louis Boutan, the French zoologist who made so many breakthroughs in the field.

Yet even with the finest equipment, underwater photography is full of uncertainties. The number of suspended particles and the amount of yellow pigment in water change so much from place to place that there can be no such thing as perfectly accurate and universal exposure tables, flash-guide numbers, or rules for the use of color-correction filters. A light meter, either in the camera or in a separate housing, is a must. And water affects light in so unpredictable a fashion that the photographer should take out some insurance by bracketing his shots.

The underwater realm must be approached with proper caution and humility. Besides all the photographic liabilities, there are physical dangers to the photographer himself—the bristling spines of sea urchins; fire coral whose touch can produce a painful burning sensation; sharks and stinging jellyfish; and such exotic killers as the stonefish, whose 13 dorsal spines are hypodermic needles filled with deadly poison. But after learning what to avoid, a diver can easily spend a lifetime learning what to look for—the intricate life styles of the creatures of a coral reef, the fauna that have perfected the art of camouflage, the tiny color displays of coral polyps and nudibranches and other fragile forms of life. Once seen, this world offers the photographer irresistible temptations, repaying him a thousandfold for whatever obstacles he has to overcome. ☐

How One Aquatic Expert Works

Undersea photography with flash is like alchemy come true. While the medieval experimenters failed to find the magic key that would transmute lead into gold, an underwater photographer has but to fire a flash bulb, flashcube or electronic-flash unit and the touch of light will briefly turn a blue-green world into an extravaganza of color. There is nothing faked about the transformation. The pigments for such hues as those of the yellow feather star at right are there to begin with; they lack only a full spectrum of light to reveal their presence.

The famine of color that is ordinarily observed underwater results chiefly from selective absorption. As explained on pages 130-131, water absorbs the wavelengths of sunlight unevenly; it quickly filters out the long red, orange and yellow wavelengths, while passing most of the spectrum's short blue and green wavelengths. Fifteen feet down in clear tropical waters, so much of the long-wavelength energy of sunlight has been absorbed that red subjects start to look muddy. Thirty feet down, the long end of the spectrum has been so severely reduced that only blue and blue-green wavelengths remain in strength and any subject that does not reflect blue or green light comes out gray or black in a color photograph.

A burst of light from a flash unit provides a full complement of wavelengths and revives the lost hues. But flash illumination is not immune to absorption by water, and some of its longer wavelengths are attenuated as the light travels to and from the subject. To get a maximum of color with flash, the photographer should be as close to the subject as possible. This is the secret of the pictures on the following pages, taken by a master of underwater photography, Douglas Faulkner.

All but one of the pictures were made with a special close-up lens that will focus only on subjects from 12 to 20 inches away. And all of the pictures were lighted by flash bulbs. The combination of short working distance and flash illumination produces sharp images in the inherently hazy medium of water, and gives Faulkner the one thing that he prizes most—color. It was the lure of glittering colors that started him off on his career. As a youth, he collected tropical fish and photographed them in aquariums. Today he travels thousands of miles a year to aim winks of flash at blue-green scenes from Maine to Pacific atolls—and to record the photographic rainbows shown here.

The yellow color of a feather star is restored by ▶ flash illumination at a depth of 20 feet, where sunlight is impoverished in the long red, orange and yellow wavelengths. Like a weird undersea bird, this creature—a relative of the starfish —swims by flapping its feathery arms.

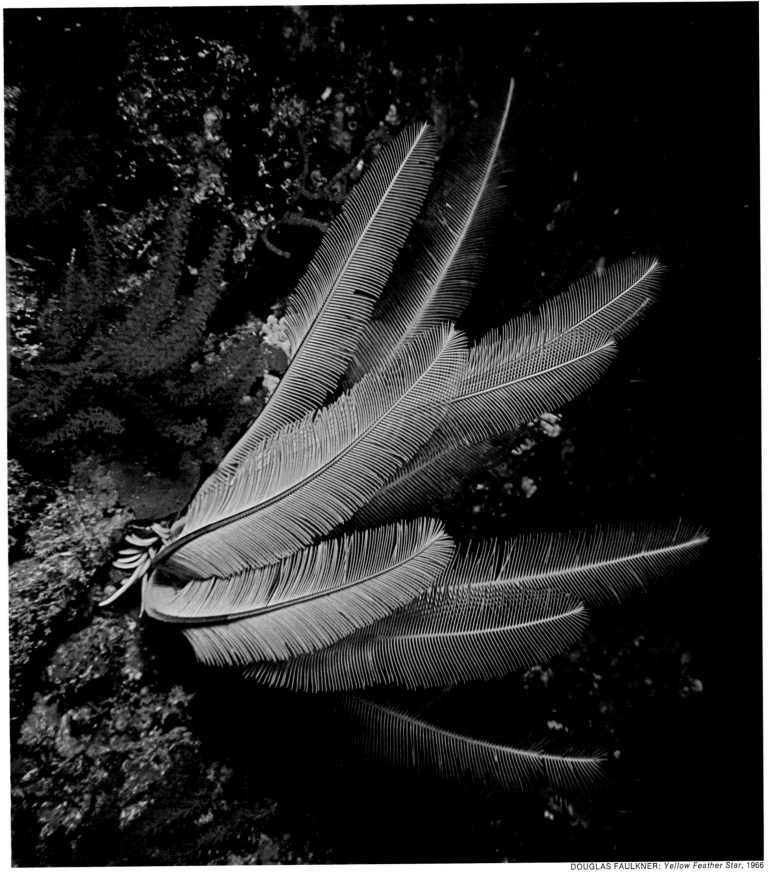

DOUGLAS FAULKNER: *Yellow Feather Star*, 1966

Flash possesses an amazing ability to liberate the secret beauties of the blue-green underwater world, but one caveat should be borne in mind. If a flash unit is mounted on or held close to the camera, part of its burst of light will be reflected back to the lens from the nearest suspended particles that always seem to be present in sea water. As a result of this backscatter of light, the picture will look as though it had been taken during a snowstorm. Faulkner's remedy is to photograph as close as possible, thus keeping the number of particles to a minimum. There also is another remedy for the blizzard effect. The light rays can be prevented from passing immediately in frônt of the lens by positioning the flash unit off to one side of the camera.

However, the position of the flash unit ought not to be dictated by purely defensive considerations. Just as a studio photographer deploys his floods and spots to create highlights, soften shadows or generate other shadows for dramatic effect, the undersea photographer can wield his flash unit to make the most of his subject. Even though Douglas Faulkner usually shoots from within a foot or two of the subject, he directs his light from different angles to achieve different effects. His pictures at right demonstrate this careful tailoring of illumination to accentuate the special features of two types of coral.

Red Gorgonian, 1968

◄ *Frontal lighting and a straight-on camera angle minimize the sense of third dimension and emphasize the patterned structure of this red gorgonian. The fragile lacework is made of calcium carbonate secreted by hundreds of tiny coral animals, whose tentacles can be seen sifting a meal of plankton from the water.*

Toplighting and a 45° camera angle were used for the study of maze coral at right. The shadows cast across the coral clearly display the cleft surface structure of this Pacific species and impart a strong three-dimensional quality to the photograph.

Maze Coral, 1967

Golden Longnose Butterfly Fish, 1965

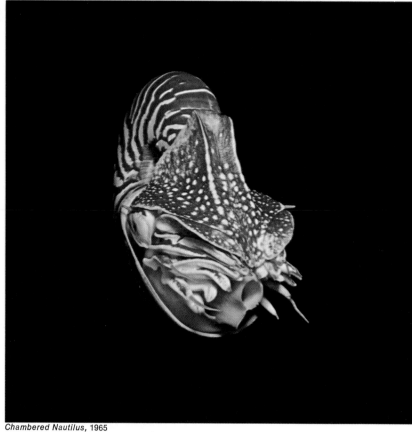

Chambered Nautilus, 1965

Taking pictures of underwater creatures with flash would seem to be a fairly straightforward procedure, requiring only that the photographer seek the most advantageous angles for his light and camera—and, of course, that he account for particles in the water *(page 138).* But there are a number of other pictorial factors he would do well to remember. Three of the most important considerations are the background, the color of the water and the potential translucence of the subject.

The background can spell the differ-ence between a merely satisfactory photograph and a stunning one. For example, a gleaming tropical fish may make an even better picture if it swims past some spectacular underwater scenery that provides a bonus of colors.

Even open water can provide different sorts of backgrounds. Near the surface, where the ambient light is strong, the water can be made to look either blue or black, depending on the exposure. Faulkner prefers and usually gets black backgrounds. He achieves this effect by using a light source of ex-

By itself, a golden longnose butterfly fish (above) is an alluring subject with very vivid colors and a false eye near its fantail that serves as an inviting target for predators, giving the fish time to escape. But even this bright endowment can be improved upon: Faulkner simply resisted shooting until the fish swam in front of multicolored coral and algae—and his subject became a bewitching character in a fairyland world. For a picture of a chambered nautilus (above, right), no reflecting surface was available for a scenic setting. So Faulkner frontlit the animal and exposed only for it. The water thus became a black backdrop entirely appropriate to this eerie shelled creature as it glided through the deeps by jet propulsion.

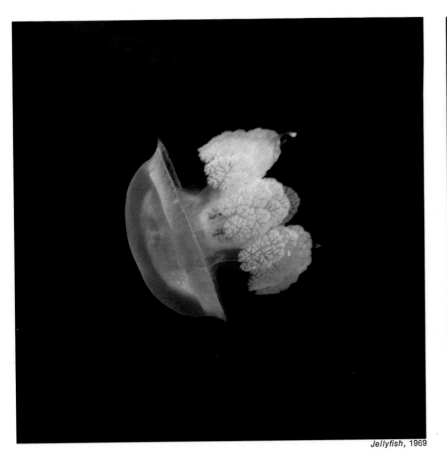

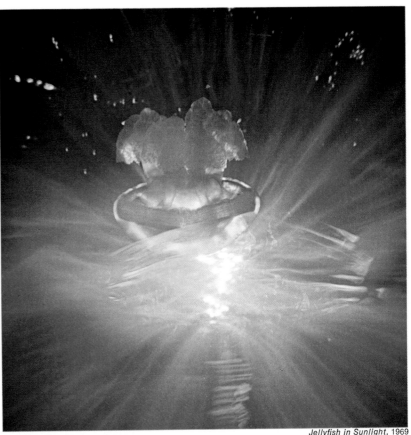

Jellyfish, 1969

Jellyfish in Sunlight, 1969

Jellyfish have been described by biologists as little more than "organized water"—and the pictures above, both of the same Pacific species, seem to bear this out. Two different methods for showing the translucence of the subject were employed. Toplighting with flash produced the yellower version. The light, entering the jellyfish from above, bounced around inside of the watery tissues, setting the creature aglow and revealing its internal structure. A completely different effect was created when the photographer swam below the jellyfish and shot through it toward the sun. The strong, direct rays of sunlight streaming through the subject have made it look almost as transparent as glass. Although flash was used as a fill light, the preponderance of available light brought out the blueness of the water.

treme intensity at a close working distance and exposing for his subject, so that the flash is the only illumination. However, by using a flash unit with less light output, a photographer can calculate his exposure to include the light of the water as well, without worrying about burning out his subject.

Translucence is another photographic challenge. In the above-water world, most living things are composed of tissue that absorbs or reflects most of the light, producing an opaque appearance. In the underwater world many creatures are translucent or almost transparent. To frontlight a jellyfish with flash would be a waste, for its tissues are dense and pigmented enough to bounce back much of the light and to make the creature look opaque. But flash directed at the jellyfish from the top will produce a lovely luminosity. And a photographer can even call on the services of sunlight: if he shoots through the subject toward the bright surface of the water, he will get a vision of see-through life that is one of the glories of the underwater world.

141

Getting correct exposures underwater can be tricky, even with flash, which generates a predictable amount of light regardless of the depth. Exposure calculations are affected by the distance of the subject, the intensity of ambient light in the water, the clarity of the water and the presence of reflecting surfaces. No rule book can make the job easy. The best way to gauge underwater exposures is to test your equipment under a variety of circumstances and keep careful track of the results.

Douglas Faulkner has arrived at an exposure system that is simplicity itself: he shoots the same way almost every time. His light source (#5 flash bulbs) is very strong and the distance to the subject is less than two feet, so he can forget about flashguide numbers and variations in water clarity. Nor does it matter whether he is shooting in bright, shallow water or the dim deeps, for flash supplies almost all of the light. He normally exposes at 1/250 second and f/22—settings that yield maximum depth of field and arrest a subject in motion. However, standardization has its limits. In an underwater cave or cranny, where light is bounced around by reflecting surfaces, Faulkner must use different settings—but nothing is lost in photographic capability, for he has more light to work with, not less.

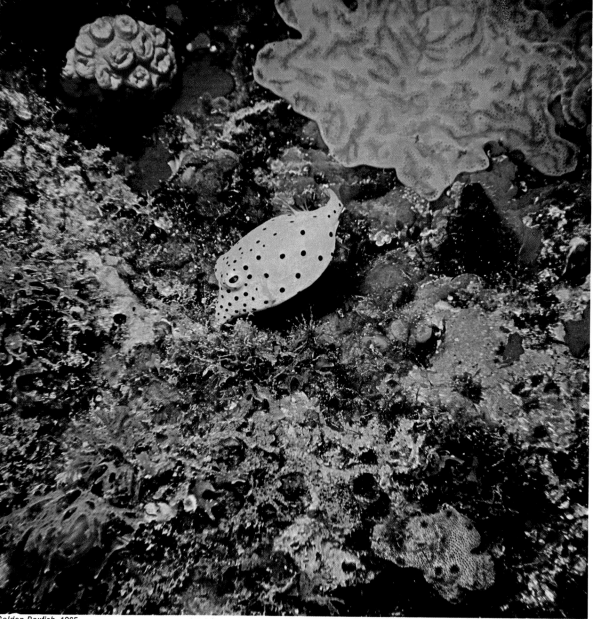

Golden Boxfish, 1965

Faulkner's standard exposure settings of 1/250 second and f/22 produced the picture of a golden boxfish, left, swimming along a colorful sea bottom of coral, algae and tunicates. Since the use of flash at close distances provides intense illumination, the ambient light could be discounted as a factor in the exposure—although it was more than sufficient for good vision at a depth of 40 feet in these clear waters off Australia.

Exploring a reef in the western Caroline Islands, Faulkner swam under a ledge 60 feet below the surface to photograph a spectacular encrustation of life. Although the subject looked quite dim, his flash illuminated it sufficiently. And because he knew that the flash would be repeatedly reflected off the overhanging ledge, thereby raising the light level, he increased his shutter speed from 1/250 second to 1/500 second.

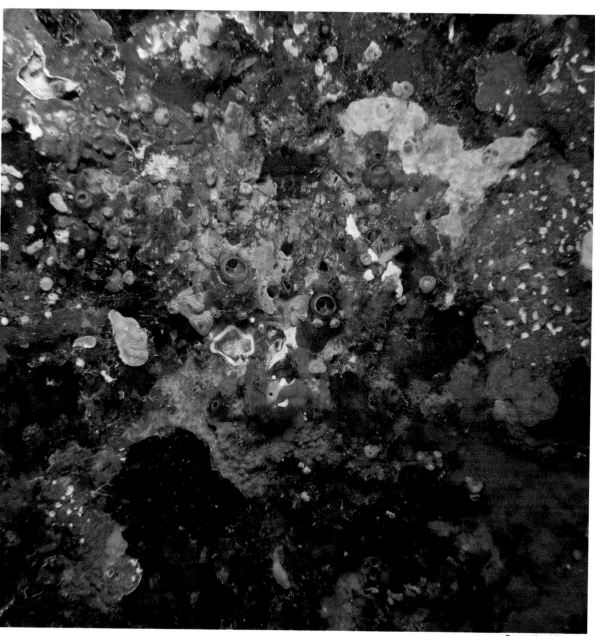

Encrusting Life, 1969

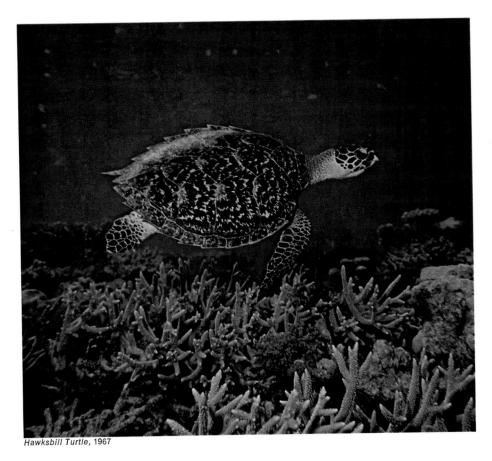

Hawksbill Turtle, 1967

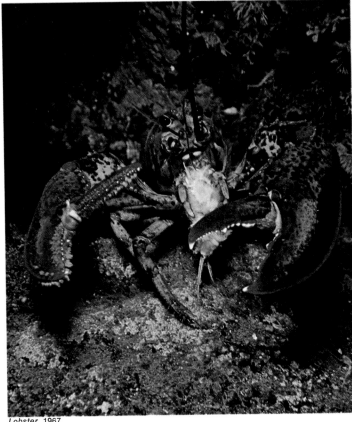

Lobster, 1967

The range of underwater visibility can change radically from place to place. In clear tropical waters, a diver may be able to see distances of as much as 150 or 250 feet; in northern waters, where plankton grow in great abundance, thriving on minerals swept off the floor of the ocean by upwelling currents, the visibility may be reduced to as little as 10 or 20 feet; and in New York City's harbor the visibility is even more limited than that.

These figures apply to eyesight—not to camera and film. Human vision en- lists brainpower to make sense out of dim, low-contrast, dull-colored images; but a camera cannot adapt to such adversities. Even with flash the distance is severely limited: in clear water, flash is unable to bring out reds or oranges more than about seven feet away, because the light is actually traveling a double distance—from the flash unit to the subject and back to the camera. In sum, the sea is a grudging medium. Above water, a camera can often see more than the eye; below water, it generally sees less. ☐

Using a normal lens, Faulkner was able to get a sharp picture (above, left) of a turtle seven feet away—but only because the tropical water off the western Caroline Islands, where he took the picture, was extremely clear, with a visibility of at least 150 feet. Nevertheless, at that distance the long wavelengths in his flash illumination are noticeably weakened, and everything beyond the turtle is blue green. For crisp detail in a picture of a Massachusetts lobster (above), Faulkner had to shoot from about 16 inches away, since the New England waters were full of particles in suspension, which held visibility to about 15 feet.

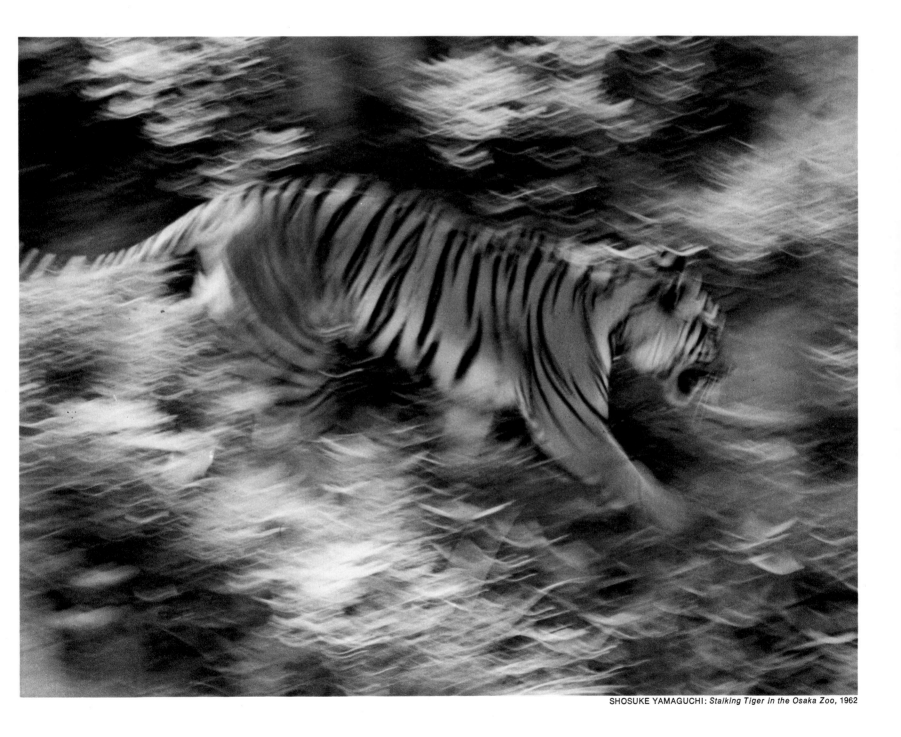

SHOSUKE YAMAGUCHI: *Stalking Tiger in the Osaka Zoo*, 1962

Wild Animals, Free and Captive

Trophies from a Photographic Safari

Although I am writing here specifically about animal photography in Africa, much of what I say is applicable to other places. If you are not about to go to Africa, you may still get ideas that will be useful next summer in Yellowstone Park or the Everglades, or even on a lakefront near your home.

The Company You Keep

If you plan to take pictures of animals on a trip into the wild, try to travel only with photographers. If it is an arranged trip such as a safari, it is worth some effort to find out in advance as much as you can about any group you may join. Sign up with an outfit that not only bills itself as a photographic one, but also makes an honest effort to accommodate photographers by keeping its numbers small and limited to people who really want to take pictures. Otherwise you will be under constant pressure from nonphotographers in the party to move on, which means you will be rushed in your picture taking, and the results will show it.

Cameras

For me the 35mm single-lens reflex is the only camera that makes any sense on a field trip. Its lightness, ease of handling and lens-interchangeability make it the choice over any other type. If you already own a larger camera, if you do not mind its bulk, and can work well with it in fast-moving situations, then by all means take it—but only if long lenses can be fitted to it. If they cannot, leave it at home, because the majority of your pictures will be taken with such lenses.

On any long journey away from civilization take two camera bodies. If one breaks down, you will have a spare. And with two, you can keep one loaded with black-and-white film, the other with color. Or, even more convenient, you can keep a short lens on one and a long lens on the other. Be sure your second body is the same make as your first. Then both bodies will have the same controls in the same places, and you will never have to fumble for them when shifting from one camera to the other. Most major companies offer bodies at different prices. For your second, buy the cheapest that the manufacturer supplies. There is no sense in spending money to duplicate features already on your other body, such as light meter, super-fast shutter, self-timer, etc. A cheap body ordinarily will cost about half as much as the manufacturer's most expensive one.

Focusing devices are often a problem when using long lenses. They admit less light than lenses of normal focal length, so the image on the viewing screen may be dim. And, because of their shallow depth of field and their high magnification, a slight error in focusing may be disastrous. Finding the sharp point with such a lens, particularly late in the day when the light is low —and most particularly after a long day's shooting when the eyes are tired

This article, with the following portfolio and the notes accompanying it, is the work of an amateur photographer, Maitland A. Edey. It is presented here to show what a nature-minded photographer who is willing to think about his pictures and work at them can accomplish in this field—in this case, in that Mecca for nature photographers, East Africa.

To be sure, Edey is not exactly a casual tourist. He is a naturalist's naturalist, editor of the LIFE Nature Library and author of The Cats of Africa. But at the time he took these pictures, his photographic career had been relatively brief. The first photograph he ever took was on an African safari in 1962; he had never handled a camera before. Predictably, many of his early efforts were failures, but the opportunities were so good that he came home with some fine shots in spite of himself. Now he carries a camera on all vacations and trips, where his safari experience is invaluable, but he is still convinced that for sheer eye-popping excitement and opportunity, there is nothing in the world of nature photography to match a few weeks in East Africa's game parks.

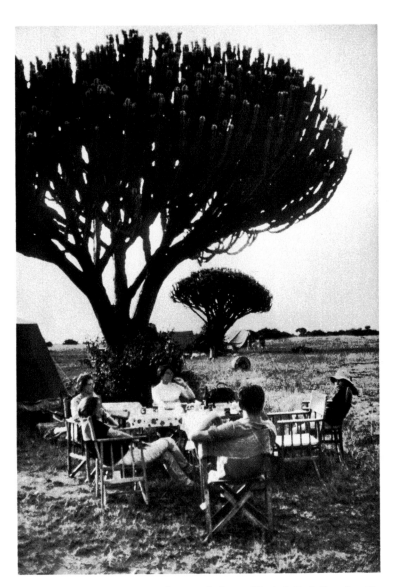

Campers in Queen Elizabeth Park, Uganda, relax under a Euphorbia tree. These trees are a feature of the landscape; the photographic problem with this one was to get close enough to the campers to make an interesting picture and still include the treetop. The solution: use a wide-angle 28mm lens. The picture was composed to silhouette a second, smaller tree in the background.

—is sometimes very hard. I have often wished for a split-image rangefinder focusing mechanism, which makes the point of sharpest focus very obvious, or at least a brighter sensitivity spot in the center of my regular through-the-lens focusing device. If you have had this trouble, discuss it with your dealer to see if a special low-light viewing screen or split-image finder can be fitted to one of your camera bodies. If you are shopping for a new camera, I would advise your putting viewer-brightness high on your priority list. It is important in nature photography.

Lenses

This may sound like madness, but if I could take only one lens on a wilderness field trip, it would be a 300mm. It is the one I find myself using most of the time. To prove its exceptional usefulness in many different kinds of wildlife situations, the picture essay that follows has been made up almost entirely of photographs taken with that single lens.

Wild animal photography, whether of lions or raccoons, absolutely requires a long lens. The problem is cost, which goes up rapidly with focal length. Many photographers already have 135mm lenses. If you have one, take it along, together with any others you have, for lenses take up little room. But for close-ups something bigger is needed. The 300mm is the ideal; 200mm often cannot bring you quite close enough, and 400mm begins to get unacceptably heavy and will horrify you by its price. Even a good 300mm lens comes high, but grit your teeth and pay what you must. I emphasize "good." A poor lens, no matter how cheap, is worthless. Buy the very best you can afford, and if you must compromise, always give up something in speed in exchange for high-class optics.

If I were limited to two lenses, I would add to the 300mm the 50mm normal lens that usually comes with the camera. My third lens would be a wide-angle one, either 28mm or 35mm. My fourth would be a 105mm or a 135mm —all of them, if possible, from the same manufacturer. You will get an argument that a wide-angle lens is almost never used in the field. On the basis of my safari experience, I disagree. Shots in and around camp, particularly those into which dramatically large foreground objects can be worked, scenic shots made in gorges and other awkwardly narrow or close positions—these and many others are possible only with a wide-angle lens, and they lend variety to your take. The camping shot *(left),* with its towering Euphorbia tree, was made with a 28mm lens.

It is tempting to economize on lenses by using inexpensive attachments that vary the image size produced by a lens you already own. You may ask: Why a big lens at all? Why not double or triple the magnifying power of a 135mm lens with a 2x or 3x converter at a cost of only about $20? The main reason is image quality. Converters, since they introduce optical problems

into the lens itself, are apt to produce unacceptably fuzzy images. They also require so much more light that maximum apertures and long exposures are necessary, inhibiting their usefulness. I would avoid them.

Other Equipment

Light meters. You probably have a meter built into one of your camera bodies, but take along a spare in case of breakdown. Use it periodically as a check against the other meter. If they begin to give different readings, you will be warned that one is malfunctioning. To find out which, check against a friend's meter.

Lens hoods. You will be shooting into the sun a lot and will need them. If you have bought all your lenses from one manufacturer, then most of them will accommodate the same lens hoods and filters—a great convenience.

Skylight filters. Take one for each lens if you plan to use color film. I keep a skylight filter on every lens all the time. It protects the lens from dust, and it can be wiped clean without the worry of scratching. If its surface gets marred, it can be replaced for a couple of dollars—not so with a lens.

Extension rings. These inexpensive metal rings, designed to permit focusing for extreme close-ups, are worthwhile additions that cost little and take up almost no space. I have just begun using a single adjustable ring that replaces the customary three-ring kit; it makes a marvelously flexible close-up lens out of my 300mm. I can think of many times I could have used it in the field—for insects, for flowers and for small birds in nests on which I could focus in advance while I waited for the parent to return with food. Without the ring, the focusing limitations of the 300mm would have kept me too far away to get a big close-up.

A watchmaker's small screwdriver. The constant vibration of an automobile engine, to say nothing of travel over rough ground, may loosen camera screws. This has happened in the film advance of one of my cameras. Without a screwdriver, the camera would have been inoperative.

Two cable releases. You may lose one.

A roll of black masking tape. It provides an easy fix for light leaks in broken or bent bodies.

Lens-cleaning paper.

Film

For black and white, choose a fast film, 300 to 400 ASA. It will have an acceptable grain structure and will be fast enough to be used in near darkness and then forced in printing. For desert, seashore or tropics take along a neutral-density filter in case the midday sun is too bright for the aperture and shutter speed you want.

For color slides, take the film you know and like best, and stick with it. I use fine-grain film, ASA 25, because I am familiar with it and am willing to put

up with its slow speed in order to get the richness of detail and good color balance that it provides. Also, it is not all that slow. The pictures on pages 166 and 167 were made at f/4 just after sunset, and yet the film was able to stop the movement of a frisky young hippopotamus pretty well. If you are not so fussy about grain structure, and value the flexibility that faster speed gives, then use faster film—many professionals do. But don't switch around; stick with the film whose characteristics you understand.

For color prints, do not use transparency film but a color-negative film made for print production; the prints you get will be much better than conversions made from color slides.

Never leave any kind of film in the sun, and never take it out of the cardboard box until you are ready to use it. Try to find a shady corner for a film change; never do it in direct sunlight. Always put the exposed roll in the aluminum can that the new roll just came out of. Do it immediately. That way, you are never in any doubt as to what a particular can contains—if it is in a box it is new film; if not, it is used. Canning the rolls also helps keep your exposed film moisture- and dust-free. Back in camp, put your exposed film in the bottom of your suitcase and leave it there. That is the coolest and safest place for it. If you are traveling overseas, do not try to have film processed there, even though you may be away from home for some time.

Spend film! Considering the cost of your equipment and the time, money and distance often involved in getting you to wherever you are, it is downright stupid to be chintzy with film, particularly color film. Color tolerances are narrower than black and white, and it pays to bracket exposures. Do not waste film by popping at random as you go, but when you find a subject with potential, milk it. When I have a couple of lions in a good setting, I often shoot half a roll or even a full roll on them, using different poses, different angles, different combinations of aperture and shutter speed, even different lenses. What you want is one good picture and if you are as uncertain as I am about exact exposure factors, you will be thankful when you get back home for the bracketing you have done. Furthermore, that one subject may end up producing three or four superior pictures that stand on their own.

Keep an eye on your film counter. If it shows only three or four frames left on a roll, and you suspect that something interesting is coming up, forget about those last few frames; change the roll. Otherwise you may catch yourself with the back of your camera open just as the action breaks—a priceless opportunity missed in an attempt to save less than 50 cents.

Upkeep

Check out all your equipment before you leave home. If it has not had a professional going-over in some time, it is worthwhile taking it to a camera service shop for tests of shutter-speed accuracy and lens condition. Check

your light meters and put new batteries in them. It is a good idea to carry a set of extra batteries for each meter.

If something goes wrong in the field you will not be as far from help as you might think—as I have learned in Africa. Nairobi has several first-rate camera stores that carry a full line of equipment and film and can do most repairs. So do Arusha in Tanzania and Kampala in Uganda. On my swings around the African parks it was not unusual to find myself passing through one of those places.

In the field, dust and heat will be your principal problems. I deal with the former by conscientiously following a rule that so far has saved me any malfunction due to dust. I keep a lens cap and rear cover on every lens all the time, except when the lens is on a camera. For a lens change, it takes only a moment to remove these and put them on the lens being replaced (again, note the convenience of having a line of lenses made by one manufacturer). Anything I am not actually using I put back in the camera bag, and throw a sweater or jacket over the bag rather than bothering to zip it up. Zippers may jam, and if you cannot get into the bag as the herd approaches . . . ! Dust also gets through zippers more easily than through thick cloth.

In a car I try to keep the camera bag on the floor and in the shade. I never put it up on the shelf behind the back seat, where it will almost certainly be exposed to sun. If you are traveling in some sort of field vehicle like a Jeep, Scout or Land Rover, the rough cross-country trips may jounce the bag to the floor, so put it there in the first place. Then, if there is a roof hatch (or no roof), it will not be trampled by excited people standing up on the seat to shoot pictures.

Make a habit of devoting some of your down time, during siesta or after supper, to sorting out your equipment—which may have become rather jumbled during the excitement of the day—and to cleaning the dust from lenses and viewfinders. I find that blowing briskly, followed by rubbing gently with lens paper, will do the trick. A bit of lens paper wound around the end of a toothpick will get dust out of the corners of a viewfinder.

Lighting Conditions

In the morning, the first hour after sunrise is the best time for making pictures. The animals are at their most active. The light is warm and low, with interesting long shadows. There is a freshness and dewiness that disappears as the sun goes higher. Meter readings will change very fast early in the morning (particularly in the tropics, where the sun comes almost straight up). Keep checking your meter as you shoot. Right after sunrise, especially with a long lens, you might try exposing half a stop under for your first shots.

Midday photography in mixed sun and shade is very difficult. The contrasts are extreme and the shadows hard. But beautiful pictures can be made

in shade, just because of the great amount of light that is bouncing around.

If the weather is right, late afternoon is the best time of all for pictures. Although I have been able to find no scientific reason for it, the afternoon light seems to be warmer than it is in the morning, producing magnificent tones of deep gold on plains and escarpments. I noticed this golden effect particularly in the Mara Reserve, a game park in southwestern Kenya, where the topography produces local thundershowers that clear the air and often provide dramatic dark backgrounds for all that rich sun. In such light animals stand out realer than real. But remember, the light is skidding away fast, and you must keep checking your meter.

Holding Steady

Most of your work will be done with your longest lens, which produces such a magnified image that the slightest camera shake blurs the picture. I have found that, even at 1/500 second, I can get perceptibly sharper pictures by resting my 300mm on something, rather than hand-holding it. At 1/250 I refuse even to try to hand-hold, although I know photographers who claim they can get acceptable hand-held pictures at such speeds. My advice is: always use a rest unless you are panning on a moving animal or bird. Since you will probably be shooting from the window or roof hatch of a vehicle, there is no reason not to support your camera. The best support of all, quicker than a tripod and just as resistant to camera motion, is a simple beanbag or sandbag. Put the bag on the car's roof or window sill, and settle the camera firmly on the bag, holding it down and guiding it with one hand while you operate the shutter and film advance with the other. A little practice will enable you to frame and focus, and also hold the camera rock-steady—all with the left hand. If the nearest store does not supply beanbags, or if you cannot get your wife to make you one over cocktails at the lodge, then use a folded coat or sweater; either will do nearly as well.

Whether you take along a tripod depends on the kind of trip you are making. If you remain in the car, you may not need one, for you can always rely on the vehicle itself for support. (Conventional tours in Africa stick to game parks whose rules forbid visitors to get out of vehicles.) But if you are going camping, you will probably be doing a lot of walking in interesting wild country—sometimes in flat places without a handy tree or rock pile anywhere nearby. So for campers and hikers I do recommend a tripod, and with it a small universal-joint attachment to go between tripod and camera.

Technical Notes

The pictures that follow were all made on Kodachrome II film, with Honeywell Pentax cameras and (except for two shots) a 300mm f/4 Takumar lens. I use a Gossen Lunasix light meter, and check it regularly against the readings I get from the meter built into a Spotmatic body. □

First Principles, Including Patience

The shot that you will find yourself making over and over again on any nature trip is a portrait of an animal just standing there. At first, the thrill of being able to get right on top of your subject is reason enough to begin clicking away. But if worthwhile pictures are to result, you will have to begin thinking about how to elevate that moose or antelope shot into something more than just a statement that the animal was there and was photographed.

There are two basic ways of attacking this problem. The first is to settle for a portrait, but try to make it interesting. For example, the body surface of a lion, notably the heavily maned head of a male, is utterly unlike the leathery covering of an elephant or a rhino. A picture of any animal should be lit to bring such features out—and low-angle light is most useful. It is not merely a matter of color, but of texture, which can be properly revealed only by tonal contrasts induced by the numerous and extremely valuable small highlights and shadows that soft, low light produces. Take a look at the elephant shown on pages 168-169 and note how low-light shadowing has brought up the mud caked on its head and the veins in its ears. (Elephants are very hard to photograph; their hides are dull gray and soak up light monotonously unless it is coming from a usefully low angle.)

The potential in low light jumped out at me the first time I began photographing a lion under these conditions. Its mane responded magnificently to side-lighting or to backlighting—particularly against a dark background, as in the picture at right.

Obviously a good pose will help any portrait. With herbivores, this is a matter of luck, persistence and quick reflexes, waiting for that pair of giraffes to line themselves up artistically and for both to look your way at the same time. Lions are more cooperative. They are phlegmatic beasts that almost automatically fall into noble and benign attitudes, oblivious to the photographer. I have found it worth considerable effort to maneuver around a lion to get the pose and light I want. But it takes alertness: just when everything is set, the subject may flop over on its side with a thud and go to sleep. When this happens, I get set anyway, then give the side of the Land Rover a swat; the lion may just sit up again to see what the noise was all about.

The second way of building interest is to try and catch the animal doing something—eating, yawning, scratching, fighting, mating, running. Position yourself, and hope. With lions I have learned to invest some time around a pride, but only if its members seem to be waking up. I train my lens on one animal or a pair of cubs, and keep shooting as they move. I have slowly learned to synchronize my own movements with theirs, and am getting better at capturing moments of action. I am also learning to build interesting sequences, not only of lions but of seemingly unpromising animals like hippos *(pages 166-167)*. The key to success is patience, and more patience.

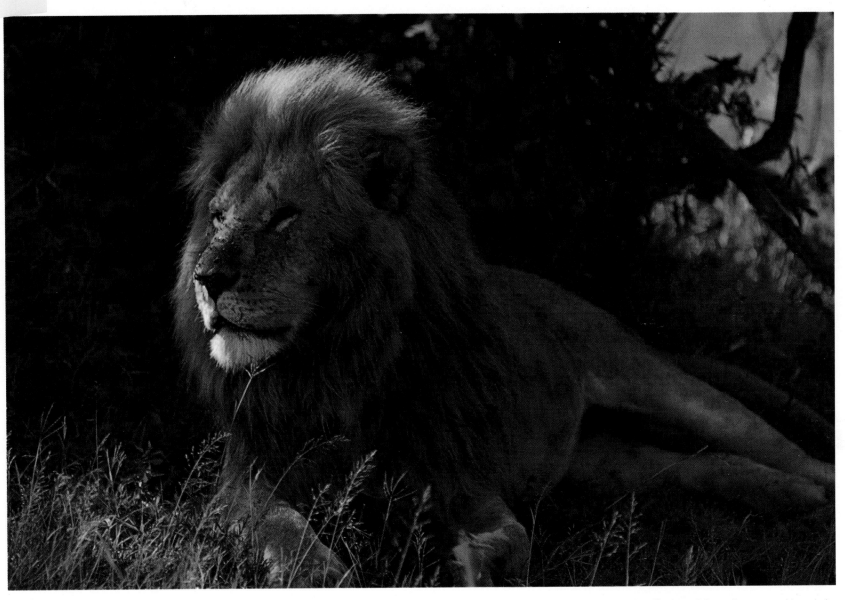

Low direct sunlight on the mane and beard of a lion—against a dark background—gives this picture its snap. Luckily the lion was a magnificent specimen that obligingly held a regal pose while I got the angle I wanted—enough to suggest the far side of the face but not enough to lose the contour of the nose. Low light also brings out the flies on the nose. I hoped to find a highlight in the eye, but the lion was too sleepy; his brow sagged too low.

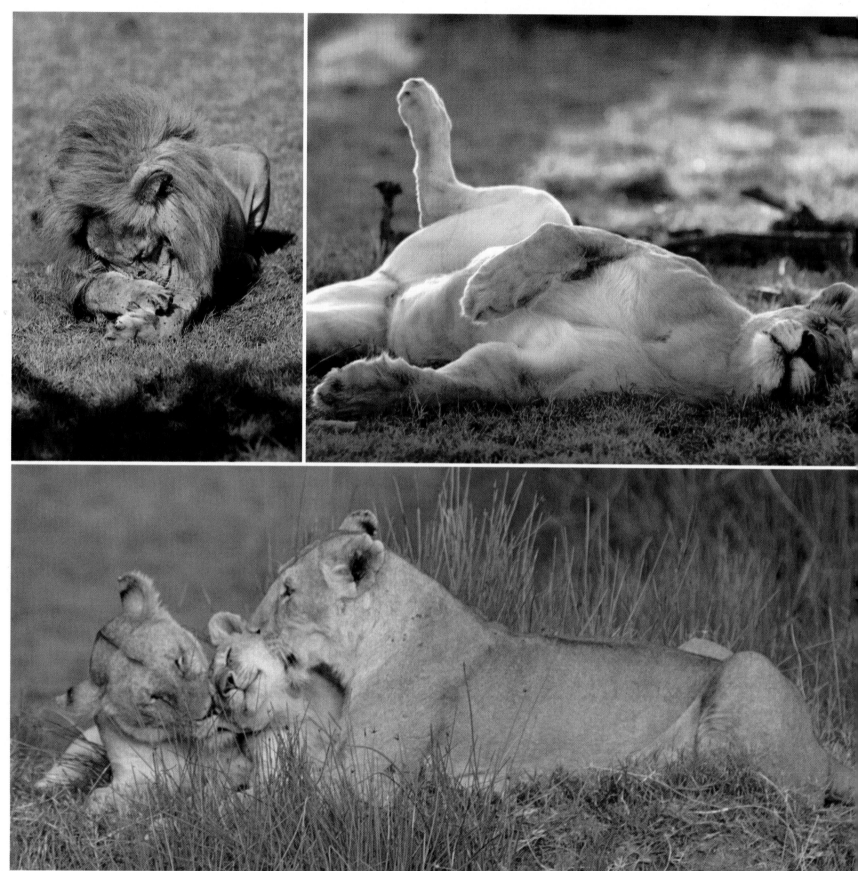

Some of the activities that can be recorded by hanging around lions: rubbing a sore nose, rolling, licking an ecstatic cub, an elderly clubman taking a snooze in the club lounge.

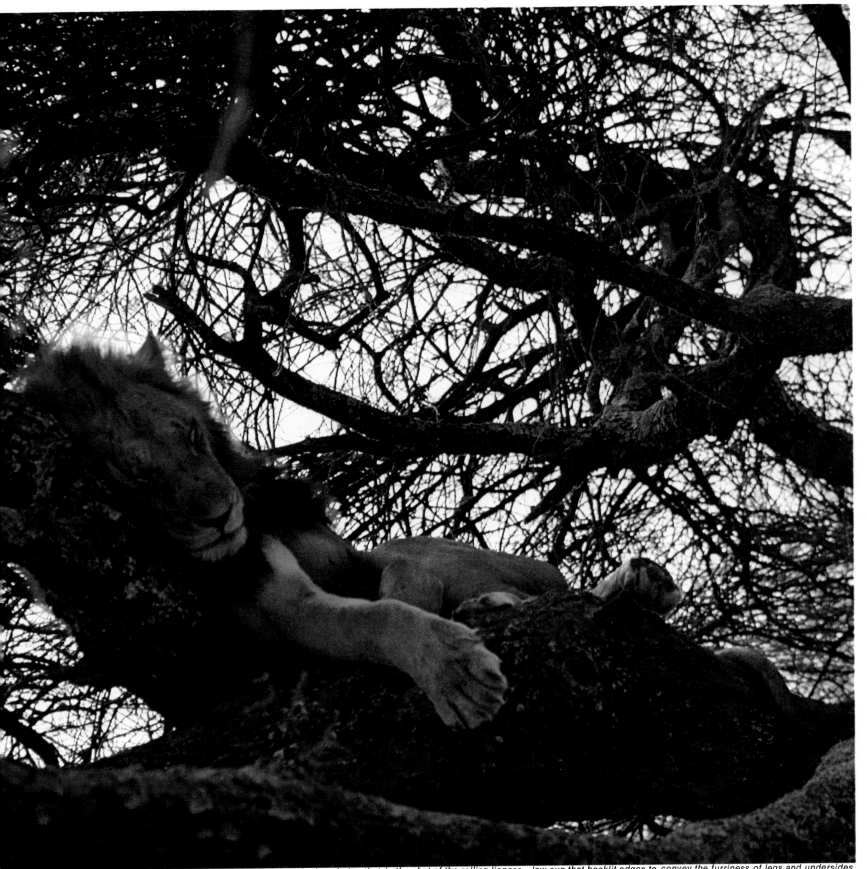

All these pictures were taken with different lighting, the best being that in the shot of the rolling lioness—low sun that backlit edges to convey the furriness of legs and undersides.

Overcoming Difficulties Posed by Birds

Birds are exceptionally hard to photograph; they are usually too fast-moving, too small, too far away. But sometimes their appearance in certain places can be predicted and then prepared for. The picture at right of a crowd of vultures descending on a wildebeest carcass in East Africa is a case in point. The kill was there. It was certain that vultures would come to it, and they did. They were so intent on their food, scuffling about within a very confined area, that I was able to get quite close and had time to focus carefully—a must for an action picture like this, which depends for its effect on sharp details of carcass, bloody heads and the spread wings of a bird caught in the air.

Certain other large and dramatic-looking birds—particularly such water birds as egrets, storks, flamingos and pelicans—come in flocks. It is sometimes possible to approach them where they congregate at the water's edge, and get a picture just as they take off. At other times they may be circling. You can follow such a circle with your camera as you would with a shotgun, focusing as well as you can and waiting for the moment when they are closest or the light is best. Sharpness under these conditions is rare, but it is not always an asset. I did the best I could with the picture opposite, but when I saw the result, I was glad that it had gone soft —dream birds drifting off behind out-of-focus greenery.

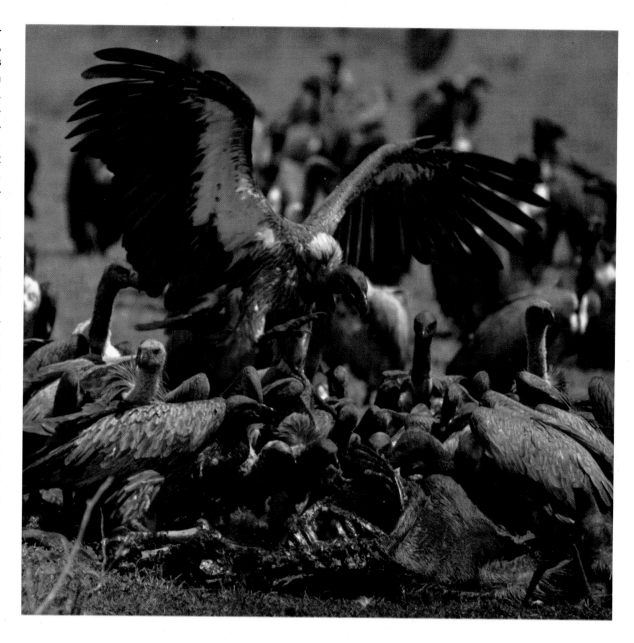

This picture was made with a camera fixed to a mount in a Land Rover. Thus it was possible to frame and focus with great care, then take my eye from the viewfinder so that I could see the entire scene, and trip the shutter at a moment of peak action. I was lucky to catch a bird about to land, freezing it with a 1/500-second shutter speed.

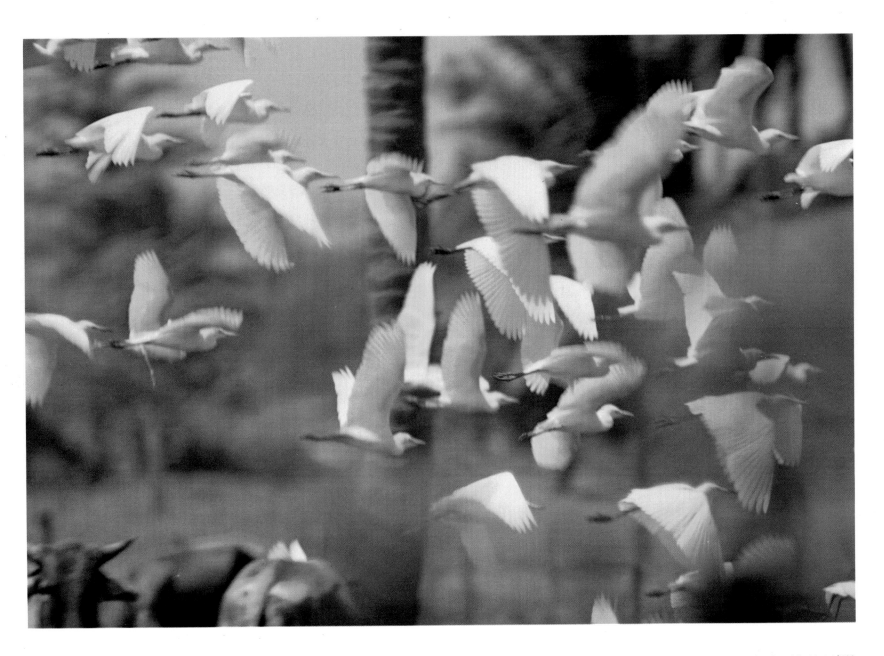

Circling egrets were shot hand-held at 1/500 second. With the sun overhead, there was no advantage to one side of the circle over another. However, one side had a better background, and the birds were flying against a strong wind. I noticed that they were going somewhat slower on that side, making the panning problem easier.

In photographing the nest of a spectacled weaver,
I used a 300mm lens to take advantage of the
long lens's limited depth of field and to be able to
isolate the nest. The palm fronds nearby turn into
graceful blurs, as does the background, which is
actually the muddy surface of the Mara River.

This marabou stork was a moocher at Serengeti's
Seronera Lodge and did not mind a close
approach. In photographing long-billed birds
close up, try to get them with their heads turned.
Otherwise, when you focus on the eye—as
you should—the end of the bill may blur slightly.

Just as vultures can be depended on to descend on kills, other birds' activities are also predictable. Garbage dumps behind safari lodges often lure marabou storks, such as the one caught scavenging in the picture at far left. Kingfishers and bee eaters return over and over again to certain perches over water, fish eagles to favored trees, sunbirds to their nesting young. All these habits can be exploited with success.

But in bird photography you need not shoot strictly for the birds. It is possible to work around them, to photograph odd-shaped nests and even do scenic shots in which birds, instead of being the dominant figures, merely provide enriching elements. What is an equatorial marsh without a lotus in bloom and a few water birds swimming in it? The coot in the picture at right are not even at the point of sharp focus, which belongs on the sunbursts of papyrus. Yet those birds do add something: they contribute to a sense of busy life in the marsh. Esthetically they fill up what would have been an awkwardly empty stretch of foreground water.

Kenya's Lake Naivasha has spectacularly lovely papyrus beds which explode along the shore like fireworks. I focused on them at the expense of three coot in the foreground. I could have stopped down to sharpen the birds a bit, but I think that would have impaired the picture.

How to Photograph Herds

◄ *A slow shutter speed—demanded by the very poor light—managed to stop this herd of moving animals. The high viewing angle has spread them through the picture, which would have been less successful if shot from ground level.*

Antelope, as soon as they sense danger, run. They zip past constantly, and your efforts to capture their motion can be directed either toward panning—with its attendant problems of sharpness—or else toward focusing in advance on a spot you think the animals will run through, and trip your shutter when they enter the viewfinder. This picture was made the latter way.

One of the features of open country is the immense herds of grazing animals that may inhabit it. If you are lucky enough to catch a sizable herd in migration, you may get some fantastic pictures, but only if you can photograph from an elevation. Down low, even a group numbering hundreds becomes simply a line of animals. Fortunately much of the world's open land is rolling. And if no hill is at hand, you can always stand on the roof of your car.

The Serengeti Plain in Tanzania, where large herds of wildebeest flow back and forth, is studded with kopjes, or hillocks. A scramble up a kopje —first making sure there were no lions or leopards denned up in the rocks —usually spread out the herd nicely before me. The picture at left was made from a low ridge in Ishasha, Uganda, over which a huge herd of topi was pouring. Luckily, the flow was to the left away from the sun, which was right on the horizon. It lit up their rumps as they trotted by, and—although a shutter speed of 1/15 second is usually too slow to stop such action—it just held them here because they were far enough away not to blur.

Finding Something Fresh to Say about the Animal

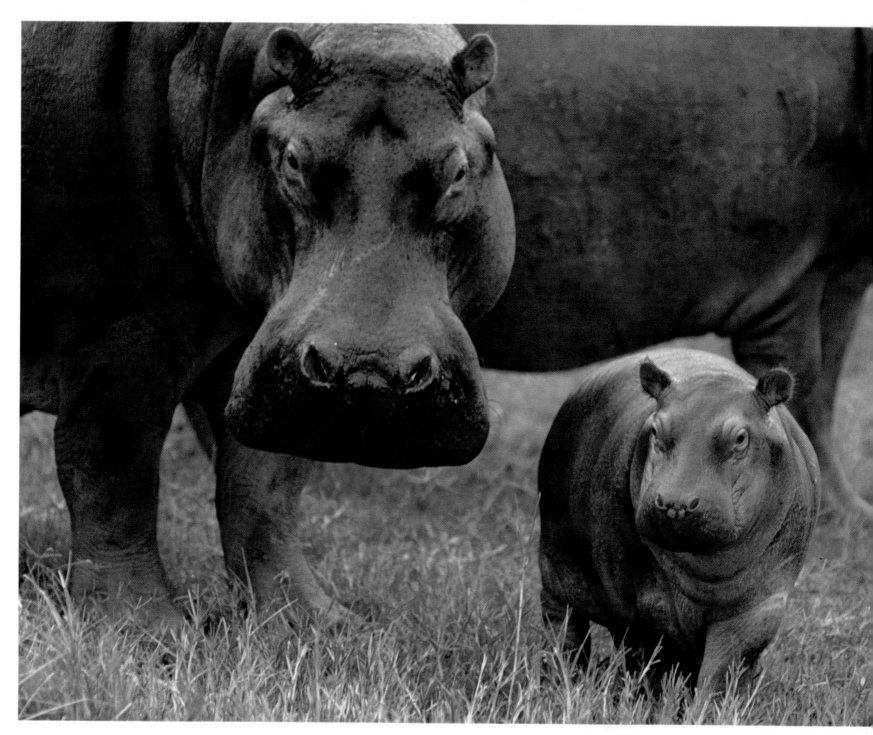

The picture at left could be dismissed as a nicely composed portrait of a mother hippo with her baby. But it is really more than that; it says something about the animals that will be new to most viewers. Because the hippos have their heads close together, and both face the camera, it is possible to compare the two and to note the enormous widening of a hippo's jaw that takes place as it matures. If you are showing your slides to an audience, a picture like this can lead into an absorbing discussion of an animal's way of life, and of the reasons it needs its special physical equipment—in this case, a big mouth and teeth to handle the load of green stuff it eats.

African animals provide many such opportunities. Antelope have horns of every conceivable size and shape. The patterns on zebras are worth investigating close up, as are the rasplike tongues of yawning lions and the sweeping eyelashes of ostriches. Ostrich eyelashes? Yes, I managed to photograph them in a center for ailing animals in the Nairobi Game Park. Do not turn up your nose at photographing captive or tame animals *(pages 170-186)*; they often provide better opportunities than wild ones.

◄ *This picture was made in Uganda's Kazinga Channel; a motorboat gently nudged the hippos ashore for an unusually close shot. And the female hippo obligingly turned its head so that I caught a view emphasizing the difference in physiognomy between adult and young.*

The picture above is the only one in this essay (apart from the photograph made in camp) that was not made with a 300mm lens. It was taken from only a few feet away, with a wide-angle 35mm Takumar stopped down to f/11 to get good depth of field at a short distance. The picture is a little underexposed, but it brings out details of the hairlike feathers that grow on the heads of ostriches, giving them what seem to be sweeping eyelashes—something other birds lack.

Building Sequences to Tell a Story

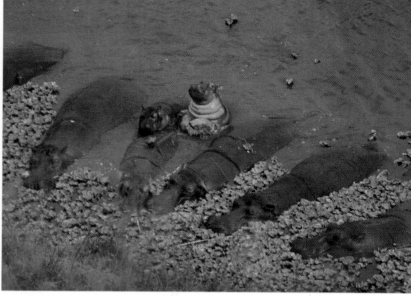

Ready for play, a young hippo nibbles gently at the lips of a friend, while the adults continue their snooze. Hippos can usually be found snoozing in water or mudholes during the day, and come ashore to do their feeding only at night.

Deciding to do a little dog-paddling, the youngster rears up and waves its front legs energetically. The rolls of loose flesh and fat built up around its neck are clearly visible in this photograph.

I have made sequences of lion cubs scuffling over their mother's nipples, prides waking up and going off to hunt, but never anything quite as unusual as this short story of a young hippo skylarking in the water. Any one of these pictures, by capturing something that is not often observed, would have made a shot worth keeping. By staying with the action to get a variety of nip-ups by one of the little hippos, I was able to build to the climax of its act: a backward somersault in the water *(far right).*

Equally important in underlining the friskiness of the youngster is the comical immobility of the grownups, which lie there like sunken barges, paying no attention whatsoever to all the antics around them. One picture could not possibly have revealed this monumental inaction; a sequence does it well. Obviously those adults have been here quite a while, nosed into the bank, a stray festoon of Nile cabbage on the back of one, a spatter of bird dropping on another. In the third picture a sandpiper lights briefly; still the animals pay no attention.

This strip also proves the value of being prepared at all times to take pictures. You never know, when photographing animals, exactly what will happen next—or when or where. I *always* carry a camera, right up to nightfall—a tripod too if I am walking. And I make a habit of checking shutter speed and f-stop periodically against the meter reading as I move about, so that in case something suddenly starts up in front of me, I can bang away without having to worry about exposure. Thus, when camped on the bank of the Kazinga Channel and taking a stroll one evening, I was ready—when I looked down and saw the opportunity below. It was nearly dark, but thanks to the tripod and that wonderful 300mm lens, I was able, at a shutter speed of ⅛ second, to get pictures. The long exposure did wash out the color somewhat, but that was a small price to pay.

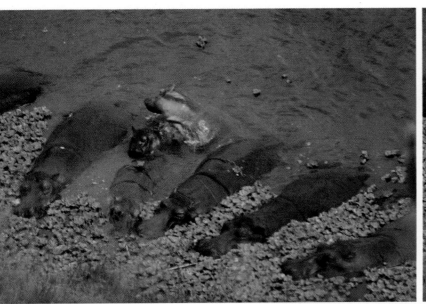

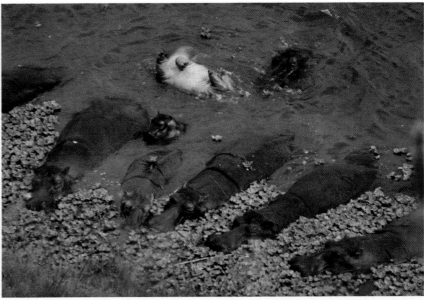

A sandpiper pauses on one adult, undisturbed by the decision of the youngster to leapfrog over its friend. This action, a bit too fast for the ⅛-second shutter speed, blurs somewhat.

With all four feet waving, the baby hippo flips over on its back. These shots were the best of nearly an entire roll. I bracketed at 1/15 and 1/30 second, but those pictures turned out too dark.

Shooting through Foliage

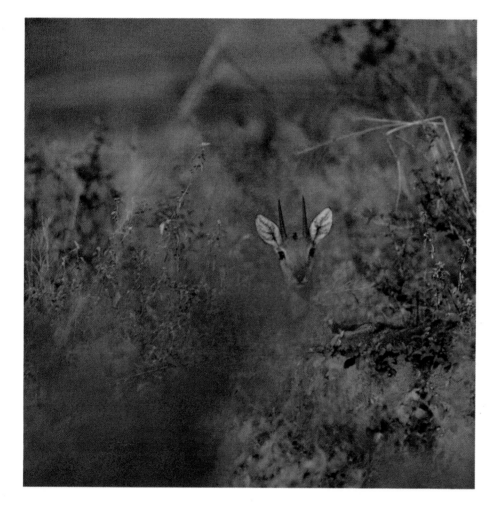

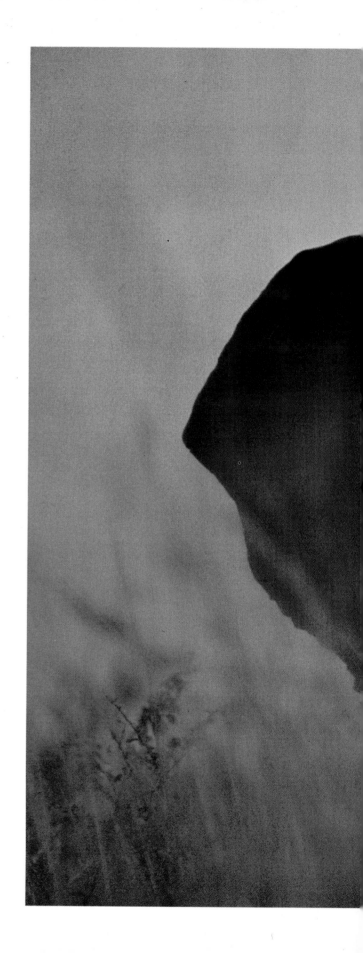

One of the great virtues of a long lens is its extremely limited depth of field. This not only blurs backgrounds but throws intervening twigs and leaves so far out of focus that they tend to disappear. If an animal seems hidden in foliage, don't give up. Focus on it anyway, and you may be surprised by the clarity of the portrait that emerges in your view-finder. Blurred foliage also heightens the sense of reality, suggesting that the animal has been caught unaware in its own environment. ☐

This oribi was so well screened that I despaired of photographing it until I focused on it. The blurred surroundings actually help the picture by concentrating attention on the animal and by suggesting what a shy little creature it is.

A low angle was deliberately chosen here to ▶ enhance the huge bulk of an elephant. This put grass in the way, but again, it improved the picture. The grass let one ear, one eye and one tusk come through, but made a menacing blur of the rest of the elephant's head.

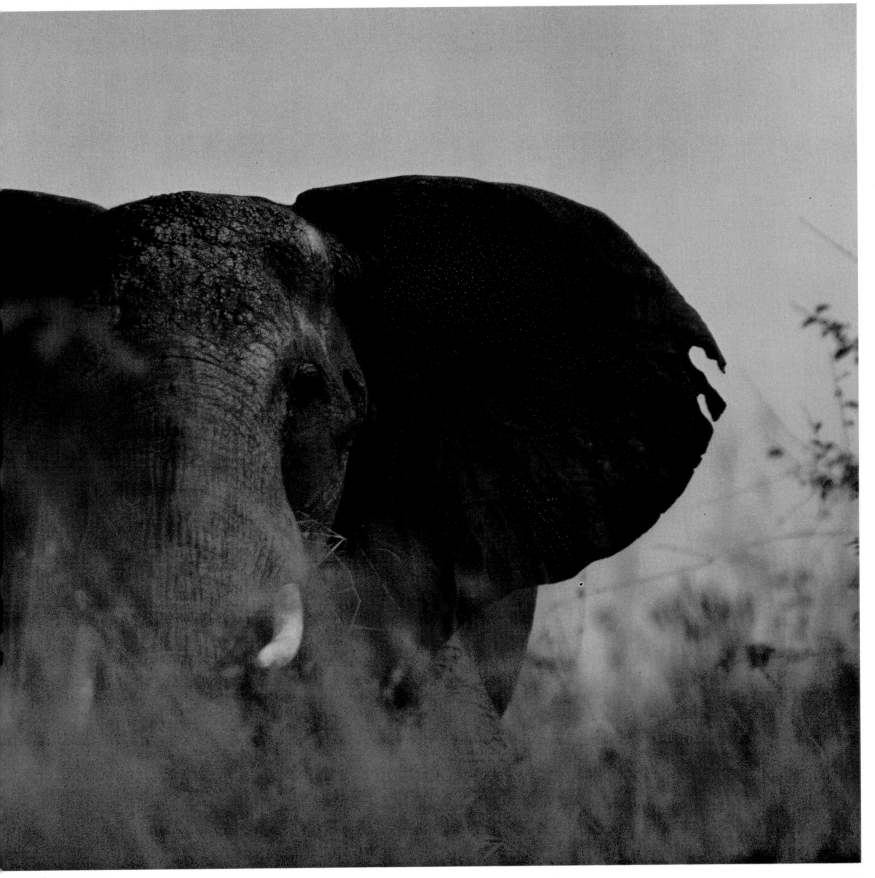

Photography at the Zoo

Nowhere but at the zoo can you get a portrait like this; such an exotic snake can be found only in remote areas, and even there it would be elusive and hard to see. Nina Leen got this one, an Indian tree snake, shown here life size, at the Bronx Zoo. She lit the scene with a small strobe unit and shot with a 35mm camera fitted with a macro lens, a device favored by many photographers for its versatility. It can take everything from a close-up to a long shot with just a twist of the focusing ring, and is therefore useful in photographing creatures that move rapidly about.

NINA LEEN: *Indian Long-nosed Tree Snake*, 1962

If you are among the vast majority of photographers who cannot go on safaris to Africa, you need not give up in despair. There is still the zoo. Years ago, someone estimated that for the investment of an hour in time and a nickel in fare you could see at the Bronx Zoo animals that would require 10 years and a quarter of a million dollars to see in the wild. Today subways cost more and safaris cost less, but a zoo is still a bargain—especially for the photographer.

That is so not only for the obvious reason that within a small area you can see everything from arctic bears to tropical snakes, but also for many other reasons. The animals are easier to locate; they cannot stalk you; they are good specimens of their kinds and well cared for; and they are more or less accustomed to the oddities of human behavior. If you plan later to photograph nature in the wild, in Africa or closer to home, the zoo is an ideal laboratory for training. Even if you do not, photographing at the zoo can be exciting and worthwhile in its own right.

It will be a more satisfying experience if you consider ahead of time some of the peculiar problems of zoo photography. In traditional zoos, for example, animals are kept behind bars. But by careful planning of angles and lighting and the proper use of your equipment, you can minimize or obliterate the telltale signs of imprisonment.

More and more, as the world becomes ecology-conscious, zoos are putting animals in settings that simulate their natural habitats. Some zoos have substituted open areas with moats for cages and bars. In aviaries and primates' preserves (pages 180-183) there are settings in which you can walk around, practically among the birds and the animals. But with this new accessibility come new problems—keeping the moat out of the picture, or detecting the animal despite its camouflage. While it can be interesting to take pictures showing the animals much as they would look in the wild, for the most part you will do well to regard zoo photography as portraiture, and use the surroundings sparingly. Even to the human eye the settings can be distracting; to the camera eye they are often a serious drawback.

In the zoo as in the wild, your first order of business is getting to know your quarry. The more you know about an animal and his behavior, the better your pictures will be. There are innumerable books on animal behavior. But do not stop with reading; go to the zoo and observe the animals. For all the verisimilitude to nature, zoo animals live under artificial conditions, and their behavior often differs from behavior in the wild. This can provide a picture quite different from what you would get in the forest. A raccoon, for example, washes its food when in captivity. In the wild it fishes for food, and the rinsing is an adaptation of the fishing instinct. Thus in a zoo you can get a picture of a raccoon washing its food; you could not get that picture in the wild.

Watch the animals' daily routine, and learn what to expect at different hours. Some animals grow restless as feeding time approaches; their movement—and the feeding itself—can provide good action photographs. Most animals are placid after meals and obligingly, or unwittingly, sit for their portraits, as did the tiger on page 175. Enlist the aid of the zoo officials, especially the keep-

171

ers. They are usually proud of their charges and pleased to show them off. They know an animal's idiosyncrasies and can often give you tips on what and when to shoot. A monkey in a large enclosure, for instance, will develop certain routes as it swings through the trees, and its keeper can tell you where and when to station yourself to get a picture like the one on page 183.

Nearly any camera will work under such controlled conditions, but most photographers prefer the 35mm single-lens reflex because of its versatility. You will need some lens changes—a normal lens, at least one wide-angle lens (28 or 35mm will do) and one long one (perhaps 300mm)—because the animals vary in size from two-inch mice to nine-foot bears, in behavior from daylong snoozing to quicksilver movement, and in surroundings from the spare and revealing to the dense and protective. Lighting can be a trickier problem in the zoo than in the field. Animals exhibited outdoors generally can be taken in natural light, but indoors you are likely to need either flash or strobe lighting. Some zoos prohibit the use of flash bulbs because of the danger of popping; others put no restrictions on either flash or strobe, so long as you take care not to frighten the animals or litter the floors.

Last but not least, you will need patience and a sympathetic concern for the animals. Nina Leen, who took several of the pictures shown here, talks to her subjects constantly while she is photographing them—even to snakes, which are deaf—on the theory that "every animal is trying to communicate with humans, if the humans are willing to get to know him."

DOUGLAS FAULKNER: *Orangutan,* 1969

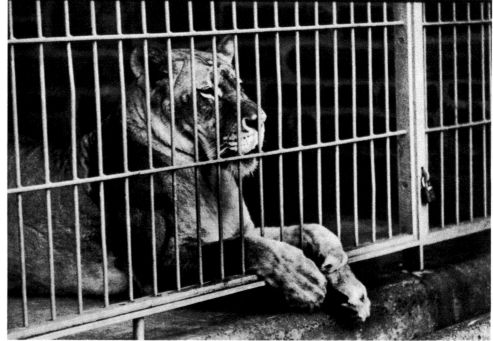

DOUGLAS FAULKNER: *Lioness,* 1969

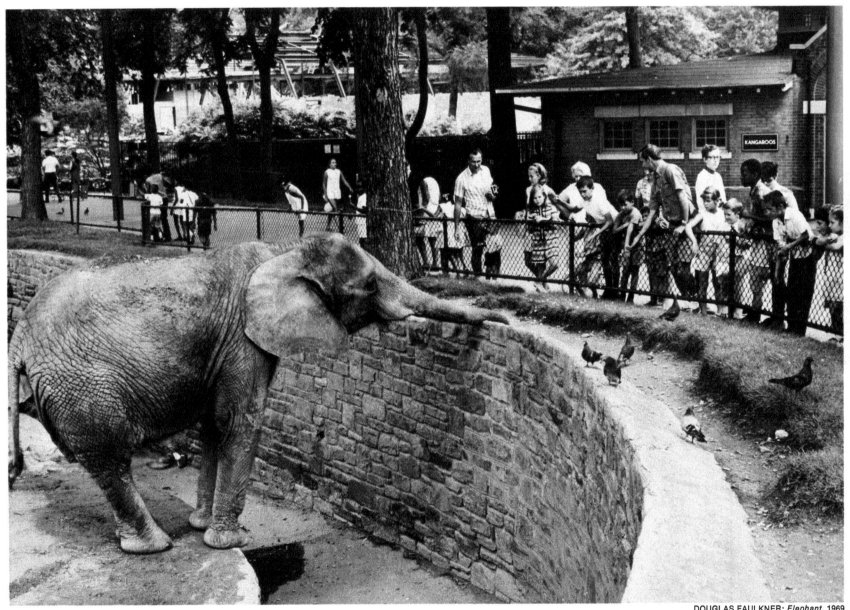

DOUGLAS FAULKNER: *Elephant*, 1969

The Philadelphia Zoo presents some good examples of the photographer's choices—and challenges—for taking pictures of animals in captivity. The orangutan cage includes a thick chain (top picture at left), which evidently pleases the orangutan when it wants to swing; the orangutan and chain can make an interesting picture, but one that clearly says that the picture was taken at the zoo. So do the bars in the lioness' cage at lower left; still, an amusing picture can be made as she pokes her paws through the bars. And a poignant picture can be taken (above) as a hungry elephant tries to reach across a wall; a walled enclosure might make an elephant feel more at home than a cage would, but it does cut down on the peanut supply. In such cases the photographer may have to decide that the zoo is part of the picture. In others, as can be seen on some of the following pages, it is possible to make the animal in captivity look almost like an animal in the wild.

The Beast as a Manageable Subject

The biggest single advantage to photographing an animal at the zoo, particularly one kept in a cage, is that the most elusive, ferocious and predatory of beasts is in effect a sitting duck. However, the very cage that confines him can obstruct the camera's view. But with the right equipment, properly used, you can eliminate the obstruction; and with a knowledge of the animal's habits you can be on hand at the right time for an interesting picture.

A friendlier or more incautious animal than a tiger will sometimes oblige you by coming close to see what you are up to. But when dealing with many beasts of the jungle you will have to learn their habits and their characteristics and use them to your advantage. To get the peaceable portrait of the ordinarily irascible tiger at right, photographer Teuscher waited for the languor that usually overcomes a cat after its midday meal, and caught this one in a moment of postprandial contentment.

For many zoo pictures a normal lens will suit your purposes. But for a portrait that will fill the frame a long lens is frequently necessary. For this portrait the long lens had a special use—the obliteration of the wire mesh on the tiger's cage. The shallow depth of field of the lens made the wire in the foreground disappear and threw all the distracting background out of focus. Teuscher used a 35mm camera, which he supported on a tripod because the lens weighed about three and a half pounds. He opened the aperture to f/5.6 and then shot the picture at a fast speed of 1/250 second.

You may have a lighting problem when shooting through wire in this way, for even though the wire seems to disappear from the film, it may cast a fuzzy pattern, and it cuts down the light entering the camera, sometimes as much as one f-stop. The problem is doubled if you use flash lighting; the light travels first through the wire toward the subject and then back again in reflection, so it is cut down a second time. Sometimes this will make a difference of two f-stops. The best solution is to experiment. Bracket your exposures, and for future reference write down what you have done: the light you used, the meter reading, the distance from the light to the subject, the f-stop and the shutter speed. Then, after selecting the best print, note which combination provided it—for your next safari to the zoo.

A Bronx Zoo tiger sits for its portrait while ▶ washing its paws as docilely as a house cat. The photographer made the wire in front of the tiger vanish by using a 400mm lens held right at the wire and focused on the tiger's head and paws.

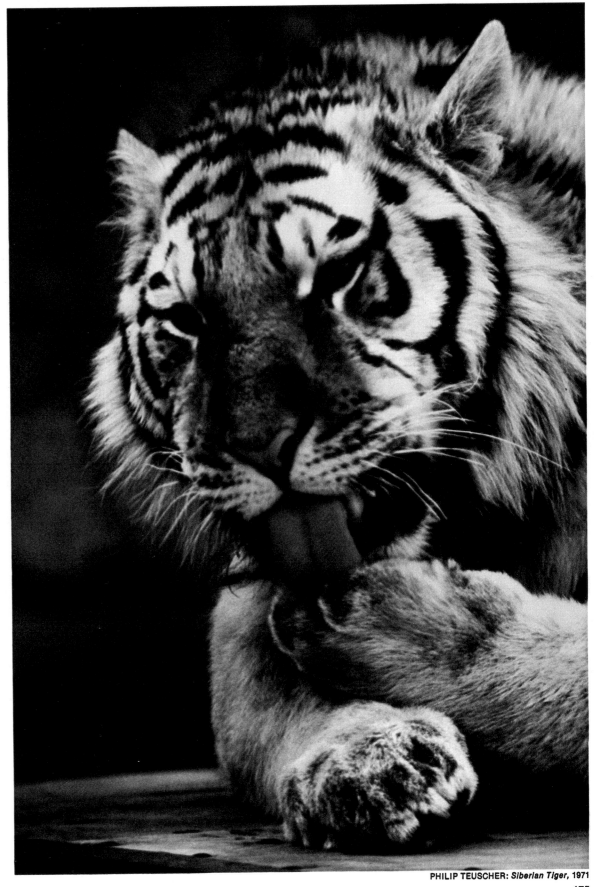

PHILIP TEUSCHER: *Siberian Tiger*, 1971

Watching a Baby Gorilla Grow

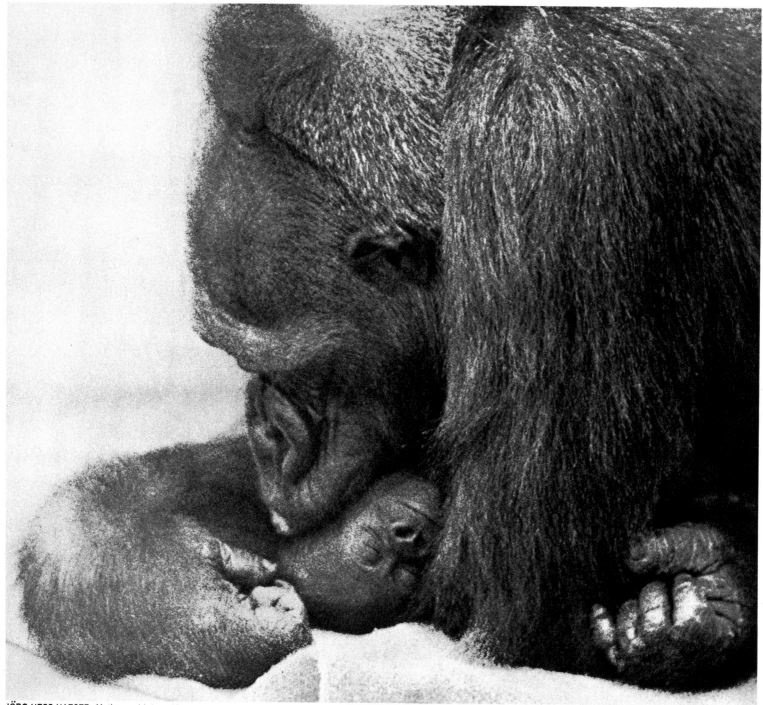

JÖRG HESS-HAESER: *Mother and Infant,* 1968

If a baby animal is your quarry, watch the newspapers for birth announcements at your local zoo. Lions, tigers, kangaroos and swans are among the most prolific of the creatures in captivity, but more and more animals are breeding as zoos learn how to make them feel at home.

Beyond offering obvious advantages over trying to photograph a skittish animal mother and her young in the wild, the zoo provides the added convenience of permitting a series of pictures documenting a baby's growth and development. One such study took place at the zoo in Basel, Switzerland, the residence of a gorilla named Achilla.

Achilla had already borne three young in captivity when, in the spring of 1968, her keepers found she was pregnant again. She was known to be a model mother—which is not always the case with gorillas that have been taken from the wild at too young an age to have learned from their elders. So when she showed signs of a fourth pregnancy, animal behaviorist Jörg Hess-Haeser began to watch her daily. One May morning he arrived shortly before 6 a.m. to find Achilla cradling a new baby, an almost hairless mite of less than six pounds. The zoo keepers christened the baby Quarta, and Hess-Haeser documented her development, as well as the tender care and instruction that Achilla gave her. The picture record took Hess-Haeser a year, and the photographs shown here are just two of the 10,000 that he made.

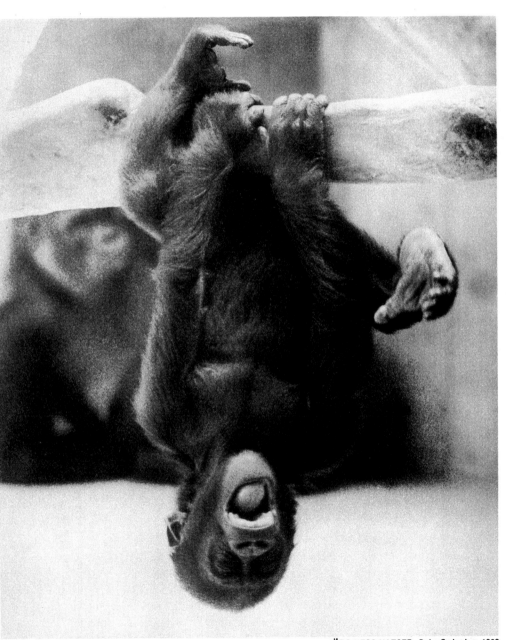

JÖRG HESS-HAESER: *Baby Swinging,* 1969

◀ *For this close-up of a 43-day-old gorilla asleep in its mother's arms, Dr. Hess-Haeser poked his 35mm camera between the bars of their cage. The cloth sacking was provided by the zoo keeper to cushion the baby from the cold floor.*

Just before the baby's first birthday, photographer Hess-Haeser got this picture of the young gorilla swinging from a bar. He had to photograph through the glass of the gorilla's new house and he held his 85mm lens close to the glass.

A Lens for Every Place and Personality

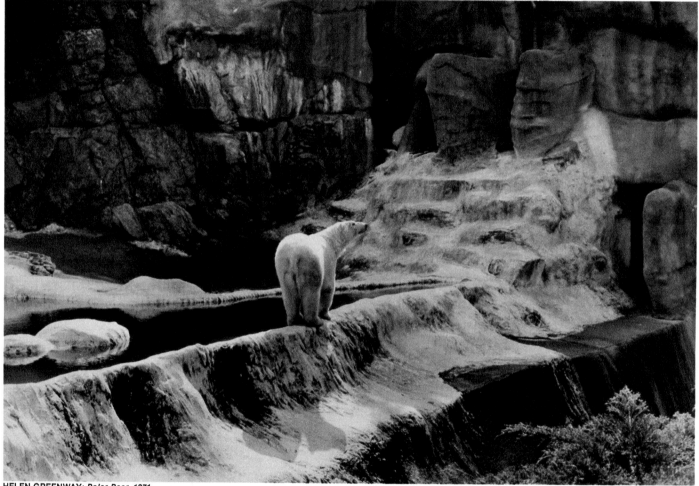

HELEN GREENWAY: *Polar Bear*, 1971

What kind of picture do you want to get? In many modern zoos you can photograph an animal in its native habitat as well as in a characteristic display of personality. Once you have decided what you want, the lens you use is all important. It can widen the field around the animal to present him in his background *(above),* or it can crop out the scenery in order to emphasize his characteristics and his temperament *(right).*

The picture above was taken at the Bronx Zoo in New York, where the animals live in environments carefully designed to give them the comforts of home and to create verisimilitude in the setting. Though the snow and some of the rocks are synthetic and the pool is colored blue on the bottom to make it look deeper than it is, the setting provides the bear with an icelike turf to patrol as he was born to do. The scene

was captured on film with a 35mm wide-angle lens.

Quite a different character is the Alaskan Kodiak bear, which may look ferocious but is actually a playful fellow. To convey that disposition the two Kodiaks were snapped, also at the Bronx Zoo, as they engaged in a mock water battle *(right).* The photographer used a long lens that filled the frame with their faces and their cuffing paws.

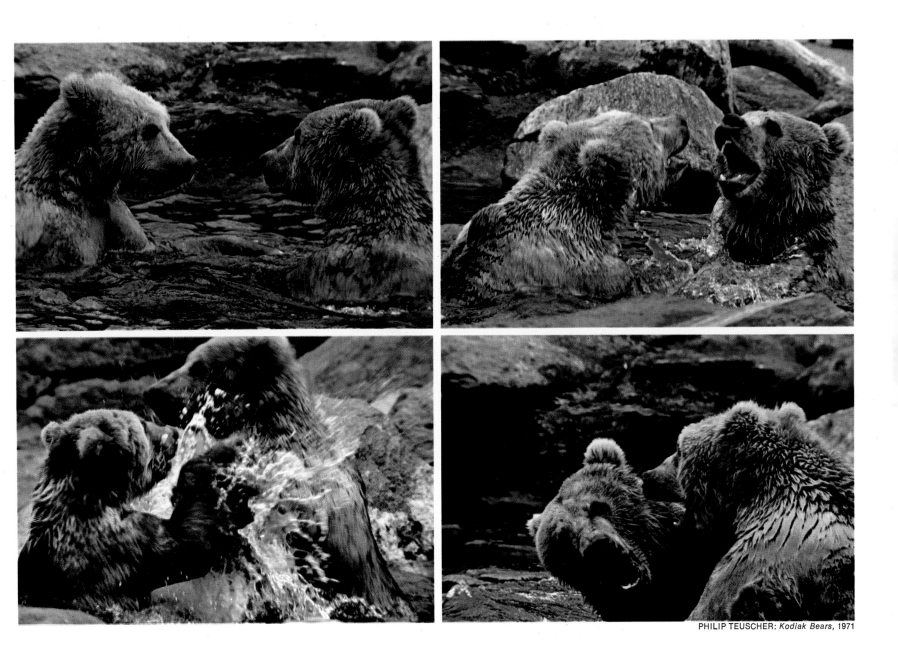

PHILIP TEUSCHER: *Kodiak Bears*, 1971

◄ A polar bear (left) strikes a regal pose in the Bronx Zoo, just as he would in the Arctic, where he is king of his icy domain. A 35mm wide-angle lens enabled the photographer to take in the landscape on either side of the bear; and by careful framing she eliminated the concrete walls that separate him from the other animals.

Patience and a 400mm long lens made this sequence of Alaskan Kodiak bears at play in the Bronx Zoo. The photographer mounted his 35mm camera on a tripod and waited until the bears tangled with each other. Then he shot fast and got this lively progression, from the face-off (upper left) to the culminating bear hug (lower right).

179

Handling a Bird in the Bush

AL FRENI: *White-crested Touraco,* 1971

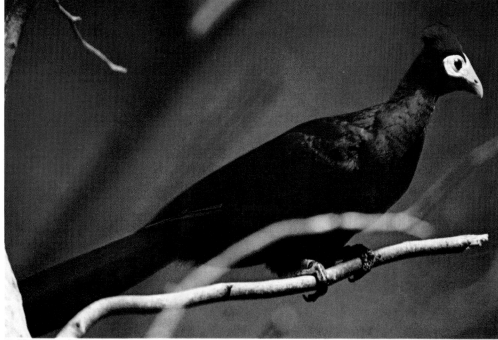

AL FRENI: *Ross's Touraco.* 1971

For the photographer, the modern zoo aviary provides an attractive combination of birds in an accessible location, which often is an authentic replica of their natural environment—in effect, a bird in the hand as well as in the bush. The Bronx and San Diego, Copenhagen and Frankfurt zoos have aviaries with trees and shrubbery appropriate to the birds on display. No fences, bars or wires separate them from the viewer; yet the birds stay in the trees of their own accord. Visitors move along darkened passageways, some of which rise to treetop level. And the photographer can get a splendid vantage point.

But by their very authenticity, such aviaries can present many of the problems the photographer would face in the wild. Shrubbery acts as camouflage, trees get in the way, leaves flick in front of the camera. Worst of all, the birds are darting all over the place. Even under the controlled conditions of the zoo or aviary, the bird photographer needs a quick eye, a quick hand and a fast-operating camera.

The camera used here was a motorized SLR with a battery-powered film advance mechanism. All three pictures were taken at the Bronx Zoo aviary.

For these two East African species of touracos —chattering birds that live in the forest—the photographer used a 300mm long lens, which in combination with a setting of f/4.5 enabled him to get the bird in each instance in sharp focus and the foliage in a blur of greens, a device that conveys the idea of their environment while calling attention to the birds themselves.

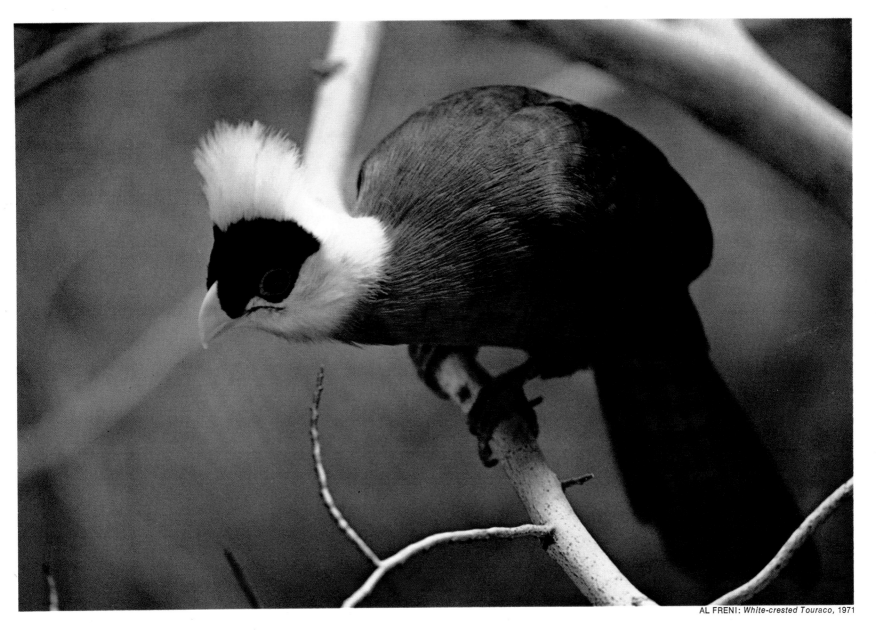

AL FRENI: *White-crested Touraco*, 1971

*For a front view of the same species as the one
shown opposite at upper left, the photographer
imitated the touraco's call until at last the bird
flew close and eyed him inquisitively. With a
300mm long lens and an aperture of f/4.5, Freni
put the bird's crested head and about three
quarters of its glossy feathers in focus, blurring
everything else except for a twig in the foreground.*

181

The Hazards of Natural Habitat

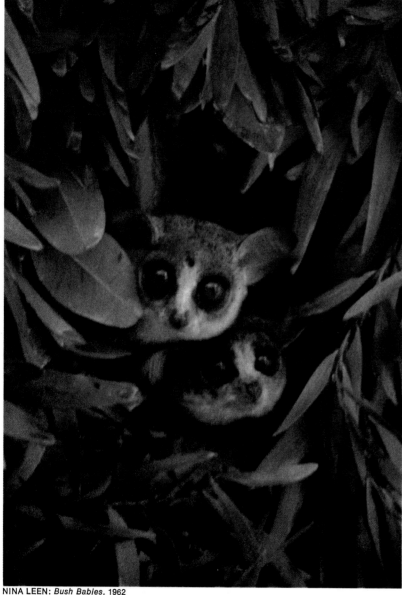

NINA LEEN: *Bush Babies,* 1962

Many of the same advantages and disadvantages that confront the photographer in the aviary *(previous pages)* also apply to any other section of a modern zoo. While the natural environment provides the animal with surroundings that contribute to its well-being, it presents plenty of problems for the photographer. The animals cannot be expected to be as available to the camera as they are when confined in a bare cage. When they are given a leafy branch, they may scurry about; when given a cozy tree house, they may elect to spend all day inside it. If they do decide to peek out, the photographer must be quick to discern them in the midst of their camouflaging foliage. And even then the camera may not catch them, since it lacks the depth perception of the human eye. So the photographer must be patient and quick, and must carefully calculate film, lighting and exposure, frequently ahead of time.

Nina Leen, who took the pictures shown here, waited half a day for the shy bush babies (a type of lemur) at left to peek out of their leaf-covered tree house at the San Diego Zoo; then she had to compensate for the natural shading provided them by the foliage, and for the further problem that it was a rainy day. To catch the squirrel monkey in the picture at right, she took advantage of the partial sunlight and succeeded in silhouetting the swift little animal in its reconstructed jungle.

On a rainy day the photographer waited several hours for these tiny primates, which are hardly bigger than a chipmunk, to emerge from their tree house at the San Diego Zoo. To compensate for the foliage and the weather, she shot at f/4 and 1/125 second with medium-speed daylight film.

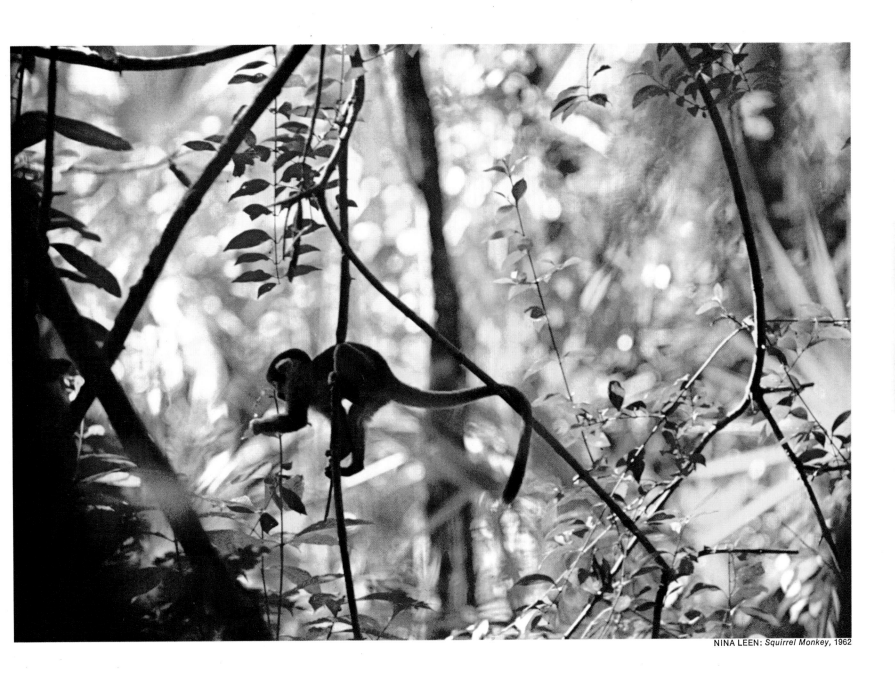

NINA LEEN: *Squirrel Monkey*, 1962

The sun filtered through the leaves to backlight this tree-high, swift-moving monkey. Miss Leen used a 300mm long lens and an exposure of f/5.6 at 1/250 second to catch the agile creature as he swung through the dense, imported Amazonian vegetation of Monkey Jungle, a park near Miami.

Looking through a Glass Darkly

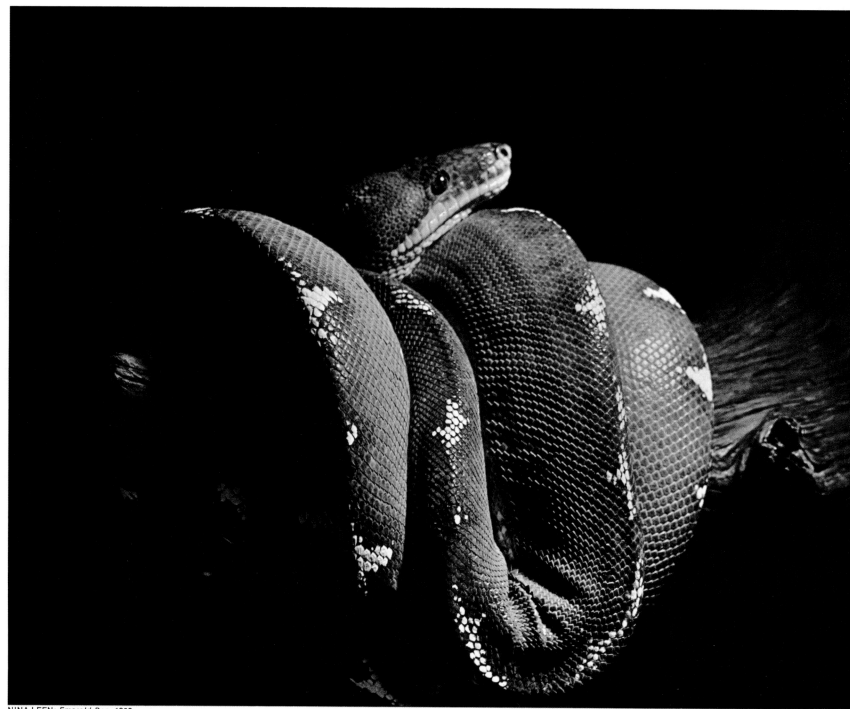

NINA LEEN: *Emerald Boa*, 1962

The shallow glass-fronted niches in which zoos display some creatures provide good views for the casual visitor but special problems for the photographer. The light in such spaces is at best flat, usually dim, and sometimes red—a device that fools nocturnal animals into thinking it is nighttime. (When real darkness comes, the animals are put to sleep under bright lights that simulate daytime.)

The photographer can add light to show the animal's shape or texture, but he must be careful not to place it so that there is a glare on the film, a shadow on the wall behind the animal, or—worst of all—a reflection of the cameraman and his camera on the glass. For this reason Nina Leen, who shot the pictures on these pages, takes the precaution of wearing black clothes, even black gloves, and she frequently shrouds herself and her camera in a portable black tent to block out everything behind her.

The scaly texture of this South American tree snake (actually a gentle creature) stands out under floodlight illumination pouring down from one side of a glass cage at the Philadelphia Zoo. The intensity of the sidelight also plunges the glass-enclosed niche into darkness.

Despite the fact that this slow loris in the San Diego Zoo is nocturnal and exhibited in a weak light, the photographer was able to get a good portrait without extra lighting because it is a placid creature. She set her camera shutter at 1/60 second and opened the aperture to f/4.

NINA LEEN: *Slow Loris,* 1962

A Tender Studio Portrait Outdoors

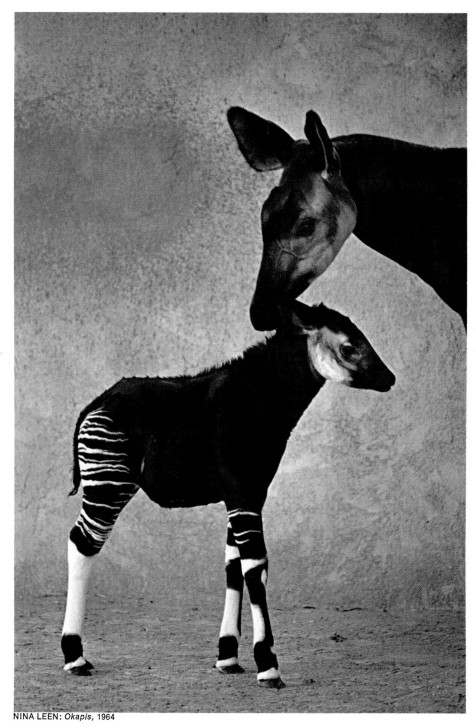

NINA LEEN: *Okapis,* 1964

For all that modern zoos have done to simulate natural environments, some animals are still kept in old-fashioned enclosures. That is not entirely bad from the photographer's point of view, for it allows him to get portraits under conditions almost as well controlled as those in his studio. This is a particular boon in the case of animals that are so skittish that men are seldom able to catch more than fleeting glimpses of them in the wild. Among the most easily frightened animals are the okapis, which are native to the Congo rain forest. A pair of them are shown at left in a stucco enclosure at the San Diego Zoo.

Nina Leen made no attempt to disguise the location. Instead, she used the neutral color of the stucco to set off the rich browns, velvety blacks and creamy white stripes of the okapis' coats. To avoid the harsh shadows that would have been thrown on the ground behind the animals by bright light, she waited until a cloud passed across the sun. Then she started shooting, being careful to frame her pictures to exclude the food pans, a water trough and any other cage equipment that might mar the simplicity of the setting. When the mother bent over her calf, Miss Leen captured the attitudes of the two animals—the one protective, the other docile—that give this picture its emotional appeal. □

Okapi mothers are so nervous that they have been known to kick their offspring to death when startled by photographers' flashes. To get the picture at left photographer Leen used a long 185mm lens that let her stay approximately 45 feet away from her subjects—far enough so they never knew she was there. The mother's easy nuzzling of her calf indicates that they were undisturbed.

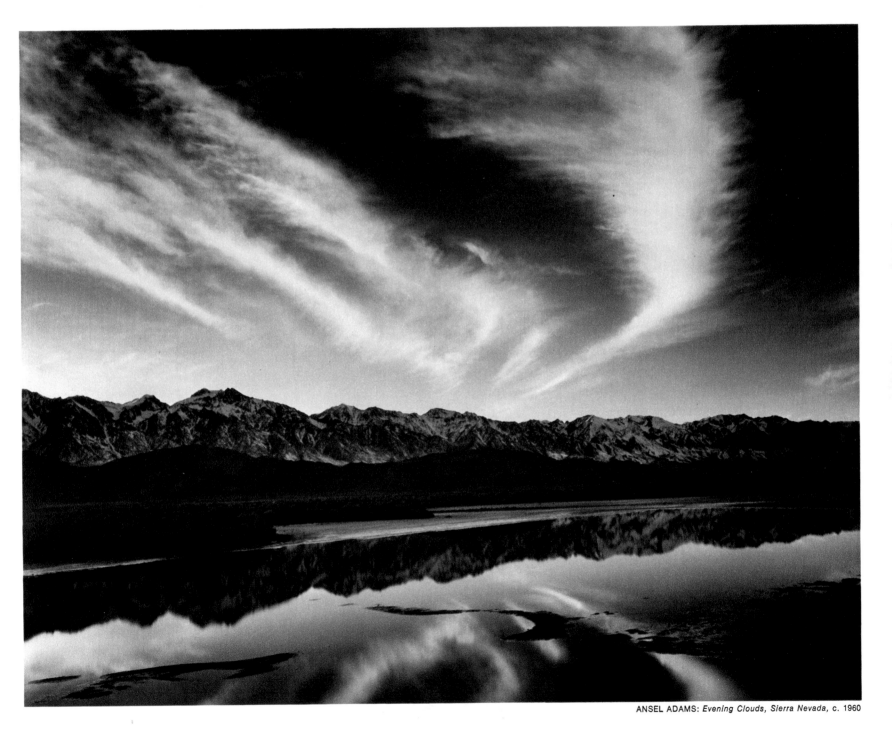

ANSEL ADAMS: *Evening Clouds, Sierra Nevada,* c. 1960

Getting the Grandeur onto the Film

Nothing seems easier, to a person who has never tried it, than photographing a landscape. The beauty is all there to start with—the bright flowers, the rich forest greens, the clear or cloud-studded sky, the gently rolling fields and hills. Surely all the photographer needs to do is point his camera and click away. And surely nothing is more exasperating than the pallid snapshots that usually result. Where is the panoramic sweep, so clearly remembered, of those rolling hills? The wild flowers seem barely visible in the finished print, and the groves of trees have turned flat and colorless. How did those telegraph wires get into the picture? And the little blue bump on the horizon—could that be the distant mountain that looked so majestic to the eye? What went wrong?

Almost everyone, after shooting his first casual landscape, faces such a moment of truth. For landscape photography is no casual matter, but a skill that requires time and patient effort. Ansel Adams, who has spent a lifetime at it, calls it "the supreme test of the photographer—and often the supreme disappointment." Scores of variables must be considered. Each hour of the day, each change of weather, the slightest shift in viewpoint, can radically affect the way a picture will look. A range of mountains that looms dramatically in the dawn light, with the oblique rays of the early sun casting each spur and pinnacle into bold relief, may shrink into insignificance under the hard vertical light of noon. A field that seems visually exciting when dappled with the shadow patterns of clouds may turn drab and monotonous under a clear sky. Yet all these pitfalls may be avoided by applying a few basic principles.

One reason many landscape pictures fail is that the camera and the human eye do not see the same thing. Stand on the top of a tall building, or on one of those mountain lookout points that offer a broad, uninterrupted vista. The eye sweeps across the land, from side to side and toward the horizon and back, sending hundreds of different visual messages to the brain. Together they add up to a composite impression. But the camera takes just a single segment of the total view. Unless the segment is well chosen, it will fail to convey the sense of spaciousness that is perceived by the eye and the brain. A picture that includes only distant countryside, for example, defeats the very concept of distance that the photographer wants to illustrate. This is because it offers no point of reference, no contrasting object in the foreground or middle ground. The eye without the camera picks out such reference points by shifting alternately from near objects to far ones. To give the same sense of depth with its single view, the camera must show both in the same photograph, so that the distant hills may be compared with, and contrasted to, some foreground object: a rock formation, the branch of a tree or even a bit of turf.

Film also registers images differently from the way they normally appear

to the eye. No emulsion yet devised has the capacity to respond simultaneously to the range of dark and light tones that the human retina accepts as a matter of course. The photographer must frequently make a choice: to shoot for the highlights, in which case the shadows may turn completely black, or to show detail in the shadows, which may turn the highlights into areas of flat, undifferentiated white.

Another built-in weakness of many scenic snapshots is that the photographer made no real effort to study his subject, or to determine exactly how he wanted to portray it. Return again to the mountaintop observation post. Take a hard analytical look at each of the visual elements that contribute to making the scene so impressive, and decide which is most important. Is it the color of autumn foliage on nearby hills seen against the hazy blue backdrop of distant mountains? Clearly the photographer must include both, perhaps using a telephoto lens to bring individual trees closer to the camera. Mist rising from a river may be the most interesting element, in which case the best plan might be to return the following morning when the mist is even thicker and presumably more expressive. A beam of sunlight breaking through storm clouds may add a note of drama to the scene. Ansel Adams relishes such dramatic lighting effects, and habitually ventures out in stormy weather to find them.

Professional landscape photographers, in fact, will take endless trouble and go to almost any lengths to achieve unusual effects. The Swiss photographer Toni Hagen, who specializes in taking pictures of the Himalayas, repeatedly went back to the area over an eight-year period in order to take a particular photograph of a 26,000-foot peak with blossoming rhododendrons in the foreground. (Rhododendrons bloom in the spring when mist usually obscures the mountaintops.)

Not all landscapes demand such perseverance. Nor must they all be exotic or dramatic panoramas. A well-executed photograph of a single maple tree may say more about the beauty of autumn than an entire forest. A cluster of rocks in the foreground may evoke the feeling of out-of-doors more powerfully than an overall view of the field itself. But in each case the photographer has been successful if he has decided what effect he wants to create, and has emphasized the visual elements that help him create it.

Landscape photography, then, involves two fundamental steps. The first is a seeing process, in which the photographer perceives what he wants to convey. The second step is implementation—in which he decides how to convey through his camera what he has perceived.

The time-honored tool of the professional landscape photographer is the versatile view camera. All the great 19th Century landscapists used view

cameras, carting them into the wilderness in wagons or on pack mules; in 1898, photographer Wallace Nutting declared that the ideal equipment for picture-taking excursions into the countryside was a large camera, a small carriage and a smaller wife. Today many landscape photographers still prefer large format cameras. Though heavy and cumbersome, they allow the photographer to control his pictures in ways that small hand-held cameras do not. With a view camera securely mounted on a tripod, the photographer has the leisure to study each square centimeter of the ground glass to determine exactly what will appear in the final picture. There is little danger that stray beer cans and candy wrappers will intrude into the corners. Because the various parts of a view camera can be moved independently of each other—shifted up or down or pivoted—the photographer can manipulate the shape and location of images in his negative. And because the images the view camera produces are large, some photographers feel that the details of each leaf and grass blade can be rendered with unmatched clarity and precision.

One advocate of the carefully controlled, crystal-clear view-camera school of landscape art is George Tice, three of whose pictures appear on the following pages. On a typical excursion into the field, Tice loads his car with close to 50 pounds of photographic equipment: an 8 x 10 view camera weighing 12 pounds, half a dozen black-and-white film holders, a lens of medium focal length, a wide-angle lens, a lens shade, a tripod, a dark cloth, a small magnifier for reading fine focus on the ground-glass viewing screen, two light meters, two cable releases, a notebook for jotting down exposure details—plus waterproof boots for wading through streams and a bag of fruit to give him the energy to carry all this equipment around. This is a bare minimum. Many other photographers also pack a special camera-back for Polaroid Land film to make test exposures, and a set of filters—yellow to darken shadows, orange to bring out the shapes of clouds, red for even stronger cloud and shadow effects, green to lighten foliage, ultraviolet to cut through haze, and polarizing to eliminate glare and reflections.

Tice usually sets out before dawn and is on location by sunrise. The slanting early morning light is almost always the best for casting the soft, long shadows that bring out the shapes of rocks and hills. Normally Tice knows beforehand where he is going and precisely what scenes he will photograph. To avoid toting his gear unnecessary distances, he scouts the terrain a day ahead of time, planning in his mind's eye where he will set up his camera. When he photographs remote areas he often uses a compact 2¼ x 3¼ view camera—less unwieldy than the 8 x 10 and almost as effective in rendering detail. Still, Tice does not hesitate to carry his largest camera into the wilds, occasionally at great risk to life and limb. Once while photographing

in Colorado he found his way blocked by a mountain river. Though it was only six feet wide, it ran 30 feet below him at the bottom of a steep, narrow gorge. Undaunted, he tucked camera and tripod under his arm, took a running start—and leaped. On the other side, he proceeded with unruffled poise to take his picture.

The precisely detailed view-camera approach has not entirely appropriated the field. Some photographers, striving for more quickly glimpsed views that reveal a general sense of place and atmosphere, rely on the 35mm single-lens reflex camera. It is the most practical camera for particularly arduous shooting situations—scrambling up a mountain face, for example. Wolf von dem Bussche took the picture of a forest glade on page 225 with a 35mm camera because he prefers the colors produced by Kodachrome film, which is not available for larger format cameras. One of the most notable landscape sequences to appear in LIFE magazine was a picture essay that captured the varying moods of the world's oceans, photographed by Leonard McCombe, a photojournalist who usually takes pictures of people. McCombe spent half a year voyaging through the seven seas, carrying only two 35mm cameras, an assortment of wide-angle and telephoto lenses and a tripod, which he used only once. "I wanted to evoke a feeling, a general sense of place," he said. "It's very hard for me to get the same kind of spontaneity with a 4 x 5 camera."

Thus armed, with large camera or small, the good landscape photographer concentrates on his goal: to record the look of the land in a memorable and evocative way. He studies the character of the landscape—the grandeur of cliffs and mountain ranges, the intimacy of forest glades, the crispness of grasses and wild flowers. He searches for the unusual effects of light or atmosphere—sunshine pouring through foliage or sparkling on the ripples of a lake, the pattern of shadows cast by furrows in a plowed field, mist enveloping a valley at dawn. In each case, the good photographer relies on a keen, sensitive eye to refresh his vision of the countryside, and a thorough knowledge of equipment and technique to capture that vision on film. □

Composing the Scene

In this comparatively open view of a woodland pond, the eye is led by the foreground ripples across the water to the opposite bank, which it follows to a vanishing point near the picture's left side. Two subtle compositional devices help frame the picture: the strong vertical line on the left, formed by a tree trunk and its reflection, and two crossed tree stumps in the water at the right.

The first problem for every landscape photographer seems deceptively simple: deciding what to show. But nearly any landscape presents more than a single photograph can include, and so the photographer must select from the general scene. He must, in effect, compose his own landscape within his camera's viewfinder.

Unlike a studio photographer, who controls composition by rearranging subject matter, a scenic photographer must take his subject as he finds it, with only minor exceptions *(pages 202-203)*. His basic method of composing is to move his camera until he finds an angle that pleases him. But even the slightest shift in a camera position can radically change a photograph. The two pictures shown here, though worlds apart in composition, differ only because the photographer stepped back a few feet when he took the second one.

The problem of composition has al-

ways preoccupied landscape photographers. One method at the turn of the century divided all landscapes into four sections: foreground, middle ground, background and sky. While these divisions may seem arbitrary, they can be useful in analyzing the relationships between the different elements in a picture. A sense of distance, for example, can be created by catching the viewer's eye with a foreground detail, and then directing it into the background by

means of a winding road or riverbank. Another device is to use a foreground object such as an outcropping of rock to put a frame around a faraway view. Filling an expanse of empty sky can be another tough compositional problem. One trick is to elevate the camera and then aim it downward to include more ground. A preference for such lofty viewpoints often impels many professionals, such as Ansel Adams, to set up their tripods on the roofs of their cars.

Both subject and composition change abruptly when the photographer moves back to include a fallen tree, probably felled by beavers. The huge foreground image completely dominates the picture, preventing the eye from traversing the water, and producing a more intimate, closed-in effect. The picture now shows that this is not only a woodland pond; it is a beaver pond.

How Different Lenses Change the View

One way the photographer can change his composition without moving his camera is simply to change his lens. A telephoto lens, for example, not only makes distant objects seem closer; it also acts as a cropping device: by enlarging part of a scene so that it fills the picture frame, the lens allows the photographer to exclude whatever periph-

eral images he may not want. Conversely, a wide-angle lens, by shrinking the size of the images, allows the photographer to squeeze an immense expanse of trees and hills into the limited confines of his negative. Shifting the camera itself closer or farther away will not produce exactly the same effect, since the sizes of the objects would

then change in relation to each other.

Wide-angle lenses supply another valuable effect. Because they can encompass both distant horizons and the grass under foot, they provide a subtle kind of framing. In the picture at left, above, the large white stone in the foreground acts as a framing device that contrasts with the distant trees.

The same scene photographed through four different lenses has produced four quite different landscapes, each with its own composition and each conveying its own distinctive impression to the viewer. A sweeping sense of spaciousness characterizes the picture at far left, shot with an extremely wide-angle 18mm lens. In the picture next to it, a 35mm lens produced a similar but less pronounced sweep from nearby grass to distant trees and hills; it also allowed the photographer to crop out the rock in the foreground. At top right, a 50mm lens preserved the relationship of size and distance that the photographer saw with his naked eye. And at right below, a 100mm lens offered a close, intimate view that eliminated all but the six central trees. Each picture was taken from the same spot, with the same 35mm camera. A different format camera (with a larger film size) would have required a different set of lenses to produce similar results. To achieve an effect like that in the picture at far left with a 2¼ x 2¼ camera, the photographer would have used a 30mm lens; for the picture next to it, he would have needed a 65mm lens. For the "normal" view at right he would have used a 100mm lens, while a 150mm lens would have been required in order to produce the telephoto effect at right below.

Sharpening the Focus

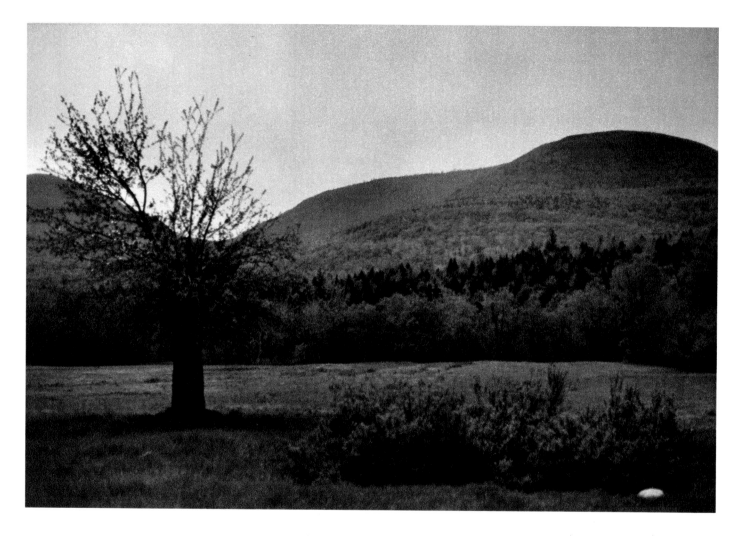

Foreground blur in the picture above resulted from at least two mistakes. An aperture of f/4 allowed only a limited area of focus, as indicated by the brackets on the lens's depth-of-field scale (above). And with focus set at infinity the photographer lost most of the area of sharpness.

One of the most frustrating technical problems in landscape photography is that of keeping the whole scene in focus. Impressionistic images can sometimes create fascinating effects, but most landscapes are more appealing when you can see everything. Complete clarity can be hard to achieve, because the distance between foreground and background in landscapes is usually so great. The photographer must use a depth of field broad enough to in-clude the nearby rocks as well as the distant mountains.

The most obvious way to increase depth of field is to use a small aperture. Closing down the diaphragm means that a longer exposure time will be needed, of course. But unless a high wind is blowing, 1/125 second is usually fast enough, and on a still day exposures can be far longer.

The next rule of thumb for sharp focus is to use *all* the available depth of

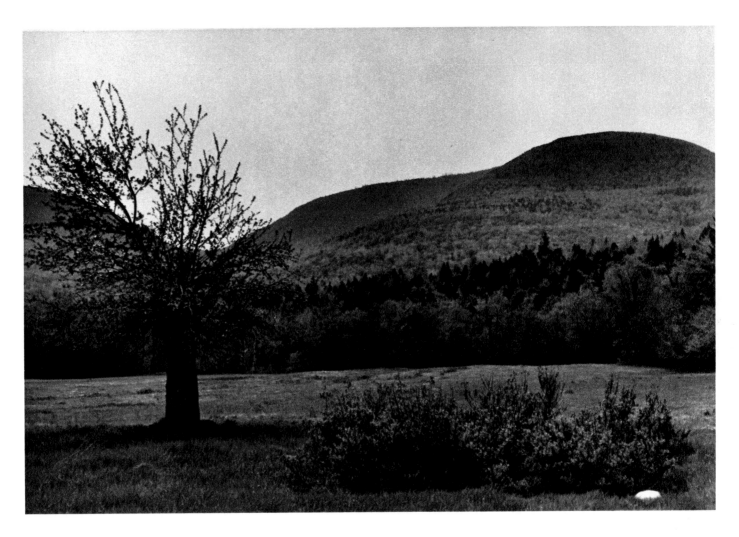

field. This does not mean setting the focus at infinity, even for the most distant landscapes. When a lens is focused at a particular point, the depth of field extends twice as far behind that point as it does in front of it. A setting at infinity, therefore, wastes two thirds of the available depth of field—which is exactly why so much of the picture at left is out of focus. To make the most of the available depth of field, set your camera at a point called the hyperfocal dis-

tance. This is done by consulting the depth-of-field scale engraved on most lenses. First determine the aperture setting; then adjust the focus so the infinity mark on the focusing scale coincides with the appropriate aperture mark on the depth-of-field scale *(lens at far right)*. The area of sharp focus will then extend from infinity back toward the camera with nothing wasted, allowing the wide range of clarity that distinguishes the picture above.

Now the photographer has increased the depth of field by using an aperture of f/8 (brackets on lens at left). And by aligning the infinity mark on the focusing scale with the f/8 mark on the depth-of-field scale (lens at right), he has brought the sharp focus even closer—down to almost 15 feet.

Exposing for Effect

How does a photographer choose the best exposure for a landscape? The problem is more complicated than just pointing a light meter into space and taking a reading. For exposure is an esthetic as well as a technical matter. A photograph with dark, somber tones delivers one kind of emotional message to the viewer; a bright, luminous picture delivers quite another. Selecting the exposure is only the first step in controlling the tones in the final picture, of course. Developing time and printing both influence the way a photograph will look. But a properly exposed negative is always the starting point.

In scenes that are evenly lit, with no great contrast between light and dark, getting a clear, detailed negative is no real problem; the photographer takes his meter reading from one of the middle tones, such as an area of grass that has no strong highlights. But in scenes like the ones shown here, including deep shade and bright sunlight, the photographer must make a decision. In the picture at the right, he exposed for the bright light, thereby causing deep shadows and contrasting highlights that provide a dramatic quality. In the picture at far right, taken with an exposure four times as long, he brought out the gray middle tones to give a gentler, but more precisely detailed effect. Neither picture is better than the other; each one conveys its own effect. But the effect should be intentional, not accidental, since accidents rarely produce such pleasing results.

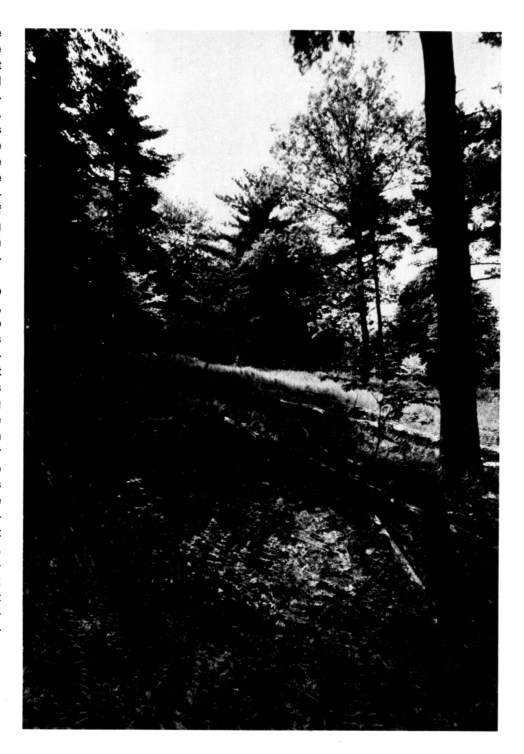

◄ *Confronted with a scene including deep shadows and intense sunlight, the photographer chose to keep the shadows murky in order to emphasize the detail in the highlights. His setting of f/8 at 1/500 second gave the scene a moody, romantic aspect where splashes of brightness barely penetrate the predominant dark gray tones.*

A longer exposure of the scene brought out detailed shapes of ferns, tree bark and fallen logs. But the photographer had to sacrifice the detail in the highlights, which are slightly overexposed. The meter reading—f/8 at 1/125 second—was taken from the shaded area of the foreground.

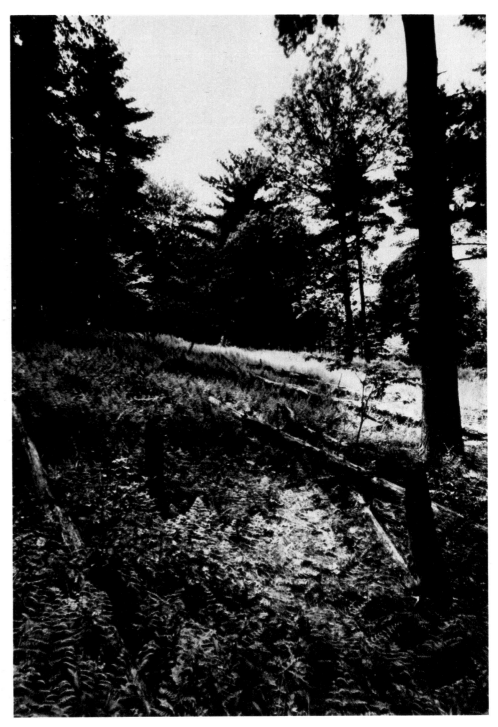

Reshaping Nature with the View Camera

A photographer enjoys little of the painter's freedom to reshape reality. The painter can move trees, change the outlines of rocks, even shift the course of a river. The photographer can accomplish only a few of these miracles —and then only if he has a view camera and uses the various adjustments available with it. Because the view camera's lens and film plane can each be moved independently, the photographer can slide and pivot them to control the shape and placement of its images, and thus achieve an apparent viewpoint that otherwise is physically impossible.

One way a view camera can reshape images is illustrated by the two photographs of a New Hampshire forest at right. When the photographer stood on the forest floor and simply aimed his camera upward, the trees all seemed to tilt backward. This was because the film in the back of the camera was no longer parallel with the tree trunks. With an ordinary camera, the only way to keep the film parallel and still include the treetops would be to take the picture from a greater distance. But in the cramped space of the locale this was impossible. With a view camera, however, the photographer could adjust both the back of the camera, to keep the film parallel with the trees, and the front of the camera, to include all of the tree *(diagrams at right, below).*

Other view camera adjustments can correct other types of distortion, alter the position of boulders or sharpen focus. The two-step manipulation on the right-hand page changed the camera's depth of field so that the close-up of the rock, the tree trunk and the leaves of the sapling in the background were all recorded with the same sharpness.

When a camera is tilted upward to include the treetops, the film is no longer parallel with the tree trunks. The result is a distorted perspective, which makes the tips of the trees seem to merge together toward a vanishing point in the sky.

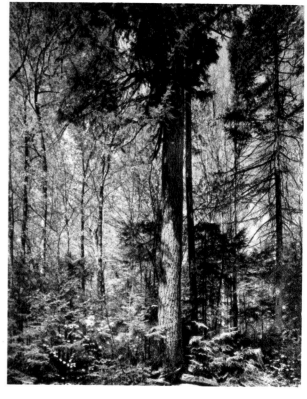

With a view camera, the photographer is able to prevent distortion by keeping the film parallel with the trees. In order to include the image of the entire tree, he simply raises the camera's front (the lens) in relation to its back (the film).

This closely glimpsed woodland scene has been carefully framed in the view camera's ground-glass screen to give it a pleasing composition. But the camera's lens and film plane are not parallel to the plane of the subjects (the tree, rock and sapling), so most of the picture is out of focus.

To restore the original composition, the film plane (the back of the camera) is shifted so that the unwanted white space no longer registers on the film, and the area at right does. The photograph now combines the desired composition plus sharp focus on the tree, the rock and the sapling.

Swiveling the back and the front of the camera brings both lens and film parallel with the subjects so the area of sharp focus encompasses most of the scene to be recorded. But now the composition is slightly askew—chopped off at the right with unwanted space at the left.

Filtering the Light

filter	physical effect	practical use
Filters for photographing with black-and-white film		
yellow	Absorbs ultraviolet and blue-violet rays.	Darkens blue sky to bring out clouds. Lightens foliage and grass. Keeps natural tones in sand or snow scenes when photographed in sunlight and blue sky.
dark yellow	Absorbs ultraviolet, violet and most of the blue rays.	Lightens yellow and red subjects such as flowers. Darkens water in marine scenes and blue sky to emphasize foreground objects or clouds. Increases contrast and texture in sand or snow scenes with sunlight and blue sky.
red	Absorbs ultraviolet, blue-violet, blue and green rays.	Lightens red and yellow subjects: darkens blue water and sky. Cuts haze and increases contrast in landscapes.
dark red	Absorbs ultraviolet, blue-violet, blue, green and yellow-green rays.	Produces almost black sky and bleached white clouds.
green	Absorbs ultraviolet, violet, blue and red rays.	Lightens foliage, darkens sky.
blue	Absorbs red, yellow, green and ultraviolet rays.	Lightens blue subjects, enhances aerial haze and fog.
Color correcting filters modify the color of transparencies and color negatives.		
yellow	Absorbs blue.	If the color in the transparency does not match the visual effect desired, a filter can correct the results. This alteration can be achieved by placing one or more color-correction filters over the transparency on a light box until one or more are found that give a more natural effect. If the picture is then to be reshot, the filter used on the lens should be the same color but one half the density of the filter that gives best correction over the transparency. This is because a filter used over the lens when exposure is made has about twice the effect of one used over the finished transparency.
magenta	Absorbs green.	
cyan	Absorbs red.	
red	Absorbs blue and green.	
green	Absorbs blue and red.	
blue	Absorbs red and green.	
Light balancing filters balance the light instead of controlling the color response of the transparency or color negative.		
yellowish	Lowers color temperature of the light.	Produces warmer colors.
bluish	Raises the color temperature of the light.	Produces cooler colors.
Other filters		
neutral density	Stops a portion of all visible colors. Since the color of the light is not affected, this filter can be used with color film as well as black and white.	Useful in reducing exposure when photographing a bright scene in sunlight with high-speed film.
polarizing	Eliminates reflections and unwanted glare.	Useful in taking pictures of water. Also darkens sky and lightens clouds when sun is not directly overhead.
ultraviolet	Stops ultraviolet light.	Eliminates haze. Generally used to obtain sharper results.
skylight	Reduces excess of blue. Use only with daylight type color-slide film.	Useful when photographing in open shade or on heavily overcast days.

Even when he takes a landscape with black-and-white film, a photographer has to control color. This is because subjects that stand out vividly in color sometimes lose all contrast when rendered in tones of gray. Red and green, for example, photograph in virtually identical shades of gray, so that apples in a tree become almost indistinguishable from the surrounding leaves. The photographer can make one of them seem darker than the other by using a colored filter—green to darken the apples or red to darken the leaves.

Filters can also bring out the clouds in the sky. Since most black-and-white film reacts more quickly to blue light than to light of any other color, the blue sky becomes as bright as the clouds, and the clouds disappear, as in the picture at top, near right. To put back the clouds, the photographer needs a yellow or red filter that will remove some of the blue light but let most of the white light from the clouds pass through.

Other filters can be used with color film to give a scene warmer tones or cooler ones, and a polarizing filter can eliminate glare. The table at left lists the most common filters both for black-and-white and for color film and gives their uses. Instructions for exposure compensation, included with each filter, should be followed carefully.

A succession of increasingly powerful filters has ▶ progressively darkened the sky and brought out the clouds in these four pictures. Without a filter, the sky registers as a uniform white (near right, top). A yellow filter blocks out enough blue sky light so that the shapes of clouds begin to appear (top, far right), restoring the balance of tones that would normally have been seen by the eye. But with a red filter (bottom right) the sky is darkened, giving a rich, dramatic effect that is intensified (bottom, far right) when a polarizing filter is added to eliminate glare.

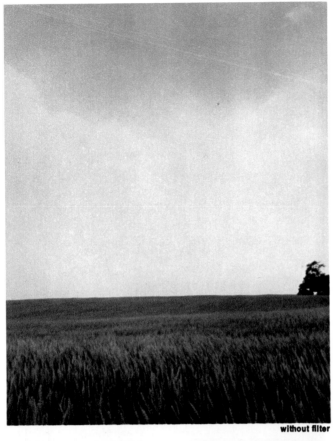

without filter

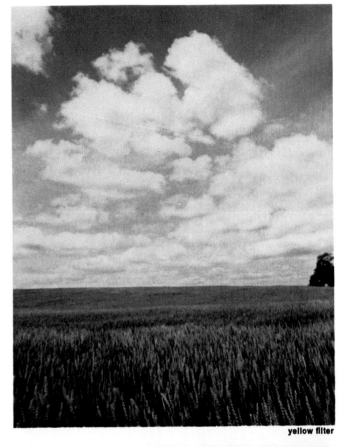

yellow filter

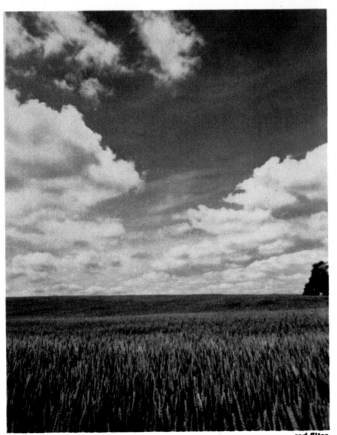

red filter

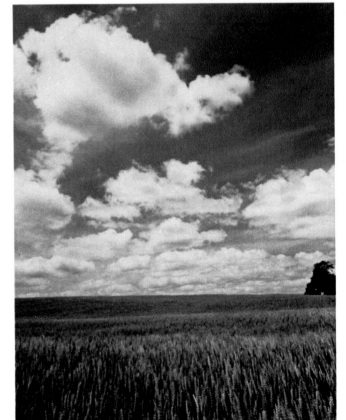

red filter and polarizer

Removing the Haze

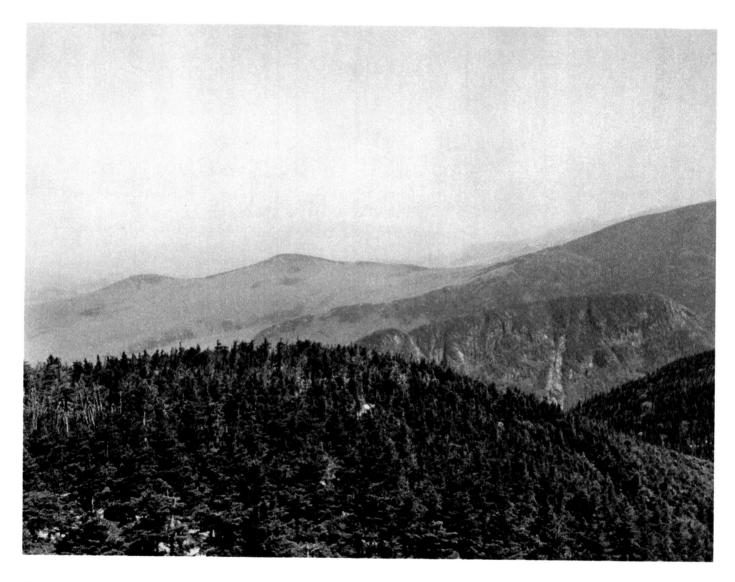

A panorama of mountain ranges, photographed here without filters on a particularly hazy day, seems flat and uninteresting: the haze has softened contrasts, washed out details, and rendered the more distant ranges all but invisible.

For centuries landscape painters have conveyed a feeling of distance by softening the colors and outlines of faraway objects. This device, known as aerial perspective, produces its effect because particles of dust and moisture suspended in the atmosphere shroud distant views in a bluish haze. Aerial haze gives photographers as well as painters a useful way of indicating distance, but too much of it can be ruinous, causing a photograph to lose sharpness and detail, and sometimes obliterating faraway mountain ridges. Since most film is particularly sensitive to blue light, it shows even more haze than is normally seen by the eye itself.

Filters, of course, are the way to get

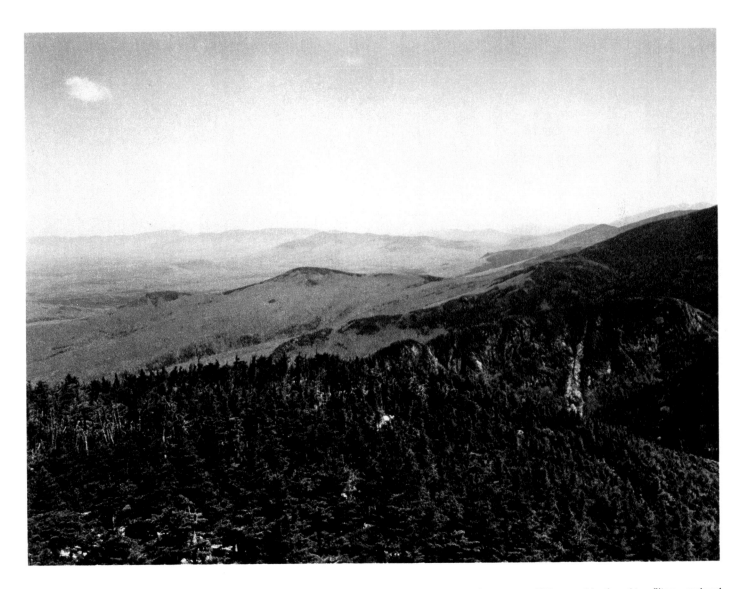

rid of haze. Just as yellow headlights on an automobile penetrate fog, a yellow, orange or red filter will cut through aerial haze. This is because the moisture particles that cause haze tend to reflect blue light while letting light from the opposite end of the spectrum pass through. (The sky itself seems blue because that is the color most strongly reflected by atmospheric moisture.)

With color film, haze is slightly more difficult to eliminate because colored filters change the hues in the landscape. Since some haze is ultraviolet light, which appears colorless, a clear ultraviolet filter will get rid of some of it. And glare from the haze can be cut down with a polarizing filter.

With a combination of two filters—red and polarizing—the same scene can be made to look entirely different. Dark tones are blacker, white tones brighter, the details of foreground evergreens sharper and more interesting, and the shapes of more distant mountains are revealed. The filters did not darken the sky, however, since the haze made the sky more white than blue.

The Necessity for a Theme

The landscape photographer might well take a hint from the late Winston Churchill, who was never known to take a photograph but who had a flair for the direct, vivid statement. When finishing off a meal at a London restaurant one evening, he was served a dessert so bland that it was virtually tasteless. "Pray take away this pudding," he growled. "It has no theme." Many landscape pictures fail for exactly the same reason. They have no theme, no definite point of view that distinguishes them from thousands of other landscape pictures. Unlike Churchill's succinct observation, they deliver no clear, concise idea of what the photographer is trying to express.

The themes of the pictures on the following pages are as various as the shifting weather and changing moods of the land itself, and as different as the sensibilities of the photographers who took them. Some are detailed views, carefully singled out from the natural scene and lovingly rendered to reveal each nuance of shape and shading. Others open out into broad vistas, especially when a wide-angle lens has been used to accentuate the feeling of spaciousness and depth. In others, the photographer has employed a telephoto lens to flatten perspective, so that the point of the picture becomes the rhythmic patterns formed by overlapping hills or tree trunks. Occasionally the subject is simply light itself—the way a shaft of sunshine picks out a cluster of flowers in the woods, or the setting sun silhouettes the branches of a tree. But in each case, the photographer had a definite idea to express, and in each case he found just the techniques to convey it best.

A fresh, delicate beauty distinguishes George Tice's picture of an oak tree on the opposite page. Its impact comes not from any dramatic effects of lighting or composition, but from its profusion of clearly rendered details—the finely etched reeds in the foreground, the textured bark of the oak, the young leaves reproduced so precisely that the viewer can almost count them. Tice used the camera that he believed was best suited for showing such clarity and detail—an 8 x 10 view camera mounted on a tripod. Because of the generous size of the negative, no enlargement is needed in making a print, and therefore no clarity is lost.

But a view camera presents difficult technical problems. Because a normal lens on an 8 x 10 camera has a focal length of 12 inches it allows very little depth of field, except at an extremely small aperture setting. To get sharpness throughout, Tice stopped down to f/45—which required an exposure time of one second. But at long exposures the motion caused by even the slightest breeze is enough to blur the leaves. Tice had to watch the wind and anticipate the very second between gusts when the leaves were almost completely at a standstill.

He needed a long exposure for another reason: he took the picture at dusk. To preserve the picture's delicate gray tones, Tice had to eliminate all strong shadows and highlights. A preliminary exposure that he had made under bright sunlight was so riddled with harsh, distracting contrasts that he waited until the sun had set before he took the final picture. The early evening light gave the picture exactly the soft quality that Tice was striving for.

A combination of soft tones, rich detail and gently contrasting textures gives an understated impact to this stately oak tree, photographed in late spring before the leaves had grown thick enough to obliterate the gnarled branches. Every effect is low key, including the compositional device that holds the picture together—two parallel diagonal lines, one formed by the tops of the reeds in the foreground, and the other by the tops of the trees in the wooded area behind the oak.

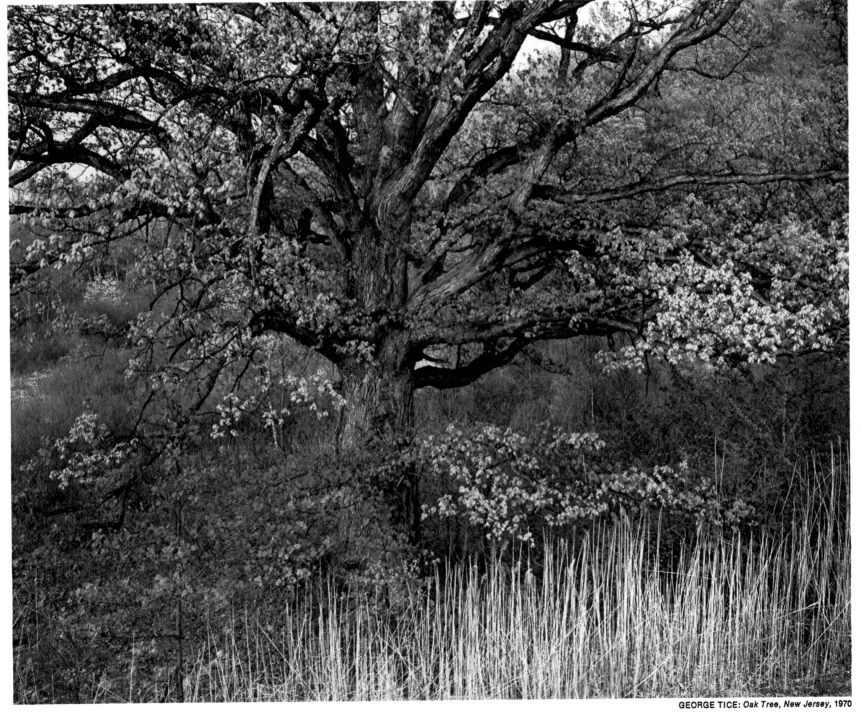

GEORGE TICE: *Oak Tree, New Jersey*, 1970

The View Camera's Expressive Eye for Detail

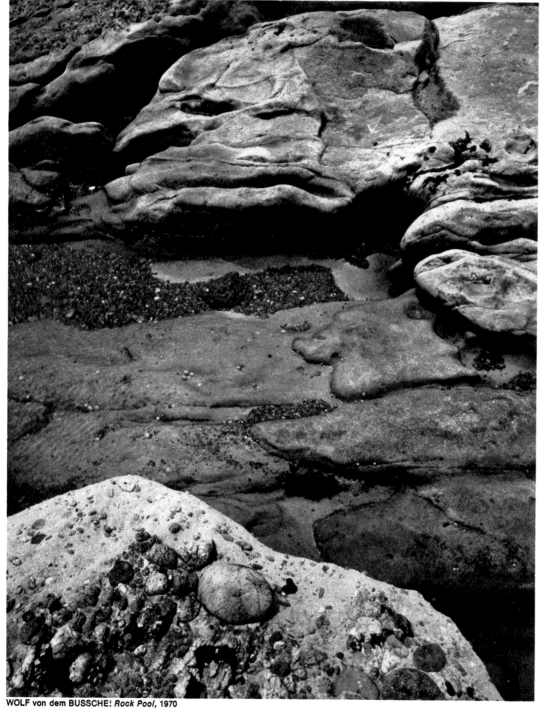

WOLF von dem BUSSCHE: *Rock Pool*, 1970

The peculiar problem for the landscape photographer is that, while his subject may stretch off over the horizon, his photograph cannot be any bigger than the four edges of the picture frame. So his ability to pick out isolated segments from the overall scene is often his best creative tool. And many landscapists, when closing in on the countryside's evocative details, rely on the instrument that they believe captures details most clearly—the view camera, with its large-sized film.

In addition to clarity, the view camera has another virtue: it swings and tilts, making possible a final degree of perfection in the landscape close-up. The picture at right was taken with an 8 x 10 view camera aimed down at an angle of approximately 45° to the surface of the field. By itself, a small diaphragm opening of f/45 would not produce a broad enough depth of field to bring both the closest flowers and the farthest grasses into sharp focus. But by tilting his lens a little closer to the horizontal, the photographer achieved clarity throughout.

Aiming his 4 x 5 view camera almost straight down between the rocks into a pool of clear water at Point Lobos, in California, the photographer has created an almost abstract composition of forms and textures. He used a 75mm wide-angle lens and stopped down to f/22, to give sharp focus throughout to the rough texture of the nearest rock ledge, to the ripples on the water, to the stones at the bottom of the pool.

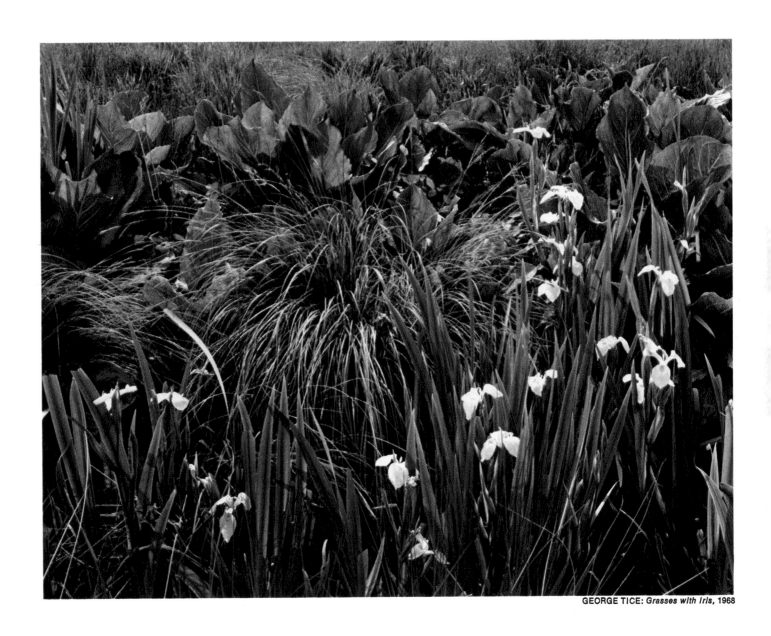

GEORGE TICE: *Grasses with Iris*, 1968

Wild iris that looked to the photographer like a flock of darting butterflies inspired this exquisitely detailed close-up of a field, taken on a late afternoon in spring with an 8 x 10 view camera. Gentle backlighting from the low-lying sun contributed to the picture's delicacy and softness.

Motion: Free-flowing and Frozen

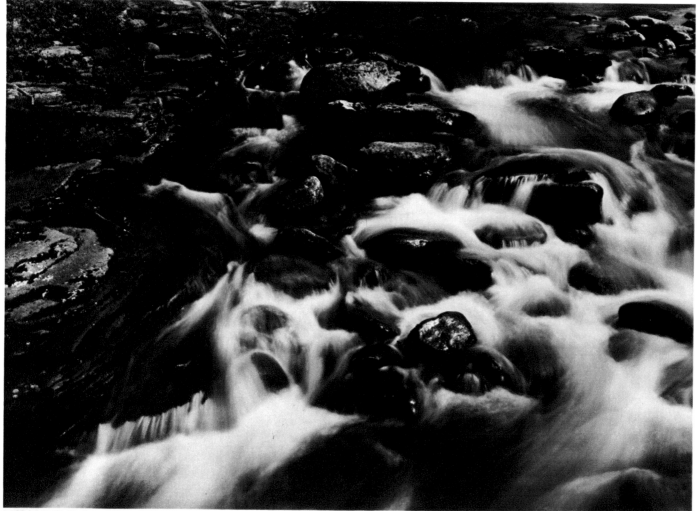

GEORGE TICE: *Rocks and Water*, 1971

The landscape photographer has an advantage over the person who photographs animals or birds; his subject does not run away. But neither does it always sit completely still. Flowers sway in the breeze, treetops flutter, water flows. On a breezy day, for a shot into the middle distance, a shutter speed of 1/125 second is needed to stop the motion of foliage. In a high wind, 1/500 second is required. And the closer the subject to the camera, the faster the shutter must be.

But total stillness can sometimes ruin a picture. The beauty of water comes, in part, from its motion. To convey this sense of fluidity, photographers sometimes use slow shutter speeds that create a slightly blurred effect. Otherwise a rushing brook may appear as solid as glass, and a waterfall may look like icicles hanging from a rock.

The opposite method—using ultra-fast shutter speeds that freeze action in mid-course—can also capture the dynamic force of moving water. The cresting wave at right, caught so precisely that each droplet can be clearly seen, was taken at 1/1000 second, providing an instant profile of a choppy sea.

To show the motion of the water in this brook flowing across the rocks, the photographer opened the shutter of his 2¼ x 3¼ view camera for a half second. The soft, foamy quality that resulted not only seems close to what our eyes tell us when we look at rapids, but it provides a contrast with the hard, glistening rocks.

To catch the bow wave of a Chesapeake Bay ferry at the moment when a gust of wind blew spume from its top, the photographer set his shutter at 1/1000 second. To gauge exposure to shoot the wave against the sun, he took a meter reading from the water to the left of the wave.

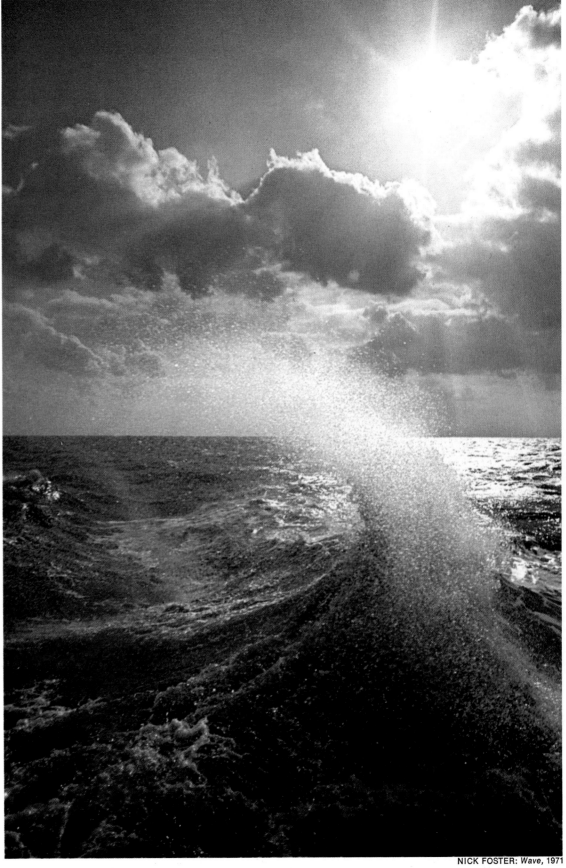

NICK FOSTER: *Wave*, 1971

213

The Wide-Angle Lens to Enhance Nature

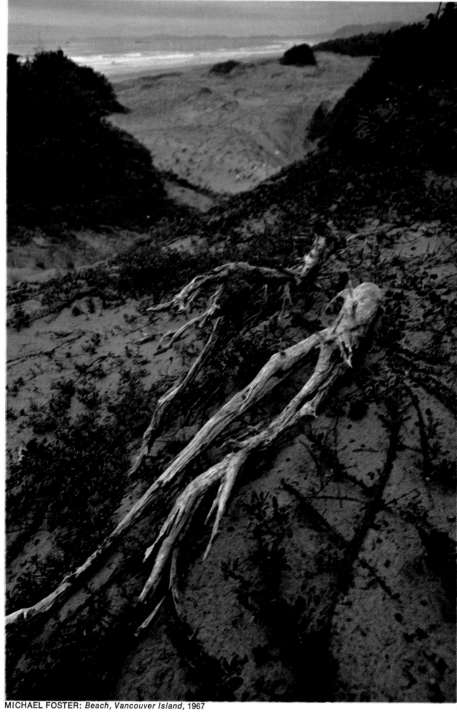

MICHAEL FOSTER: *Beach, Vancouver Island, 1967*

Nothing expands a landscape photographer's repertoire of effects like a wide-angle lens. By opening up the boundaries of a picture, it can give a feeling of spaciousness and panorama. The lens's extreme depth of field allows the photographer to focus with equal clarity on a rock in the foreground and a mountain in the distance. And by providing a different perspective from that seen by the eye, it makes near objects seem close and distant ones seem far, creating a dramatic sense of depth.

The result of all these visual changes is sometimes increased naturalness. Both of the pictures shown here include a sharply detailed foreground and a long sweep into the distance. Neither one would have been possible with the camera at exactly the same vantage point if the photographer had used a normal lens. But both convey the general impression that a viewer would get if he were standing on the same spot. His eye would dart from foreground to distance and back again, picking out bits of information that would give him an overall sense of place. The wide lens yields the same information, near and far, with a single click of the shutter.

By shooting this beach scene through a wide-angle lens, the photographer has, in effect, created two pictures in one. The first is a close-up of driftwood and wild flowers. With a normal lens this would have been the whole picture. But a 28mm lens used with a 35mm camera opened a vista to the ocean, conveying a sense of locale the picture would otherwise have lacked.

The panoramic distance between the rocks in ▶ the foreground and the mountains across the lake is partly an illusion caused by the ability of a wide-angle lens to stretch perspectives. An added dividend is the great depth of field allowed by a wide-angle lens, which enables the photographer to keep sharp focus throughout.

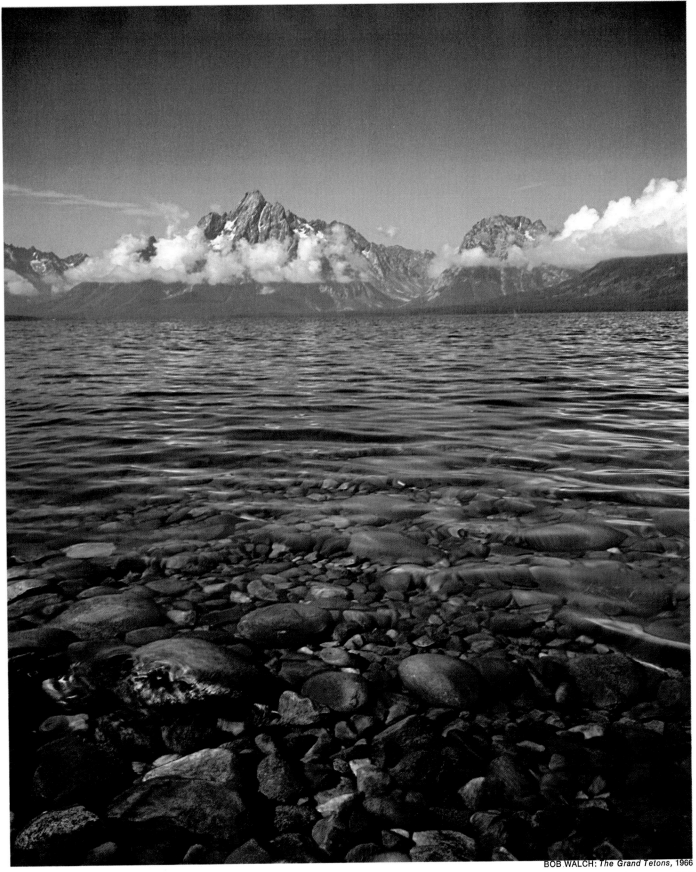

BOB WALCH: *The Grand Tetons,* 1966

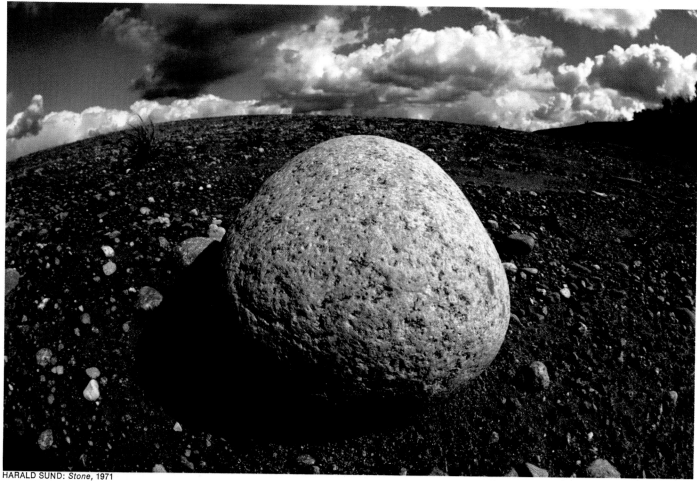

HARALD SUND: *Stone*, 1971

While the wide-angle lens permits the inclusion of more space than usual, it often makes the subject seem strangely distorted. Objects may change dramatically from their normal size, and so may distances. Straight lines may appear curved, as do the tracks in the field in the picture at right. The edges of a picture may seem to fall away, like the image in a convex mirror. When the lens is only a little wider than normal, these aberrations are usually so slight that they go unnoticed. But with extreme wide-angle lenses they may dominate the picture *(above)*.

Most of these distortions occur because a wide-angle lens allows the photographer to come extremely close to his subject, and still include a good deal of peripheral area. Try standing squarely in front of a billboard, near the center, and you will get the same effect with your own eyes. The center will be closer to you than the edges, and there-fore it will seem larger. A photograph taken from the same spot, with a lens that is wide enough to encompass the entire billboard, will also make the center disproportionately large, while the rest of the billboard will appear to shrink toward the edges.

It is this kind of distortion that photographers deliberately employ to add dramatic effect to their landscapes—as with the rock that looms mysteriously from the center of the picture above.

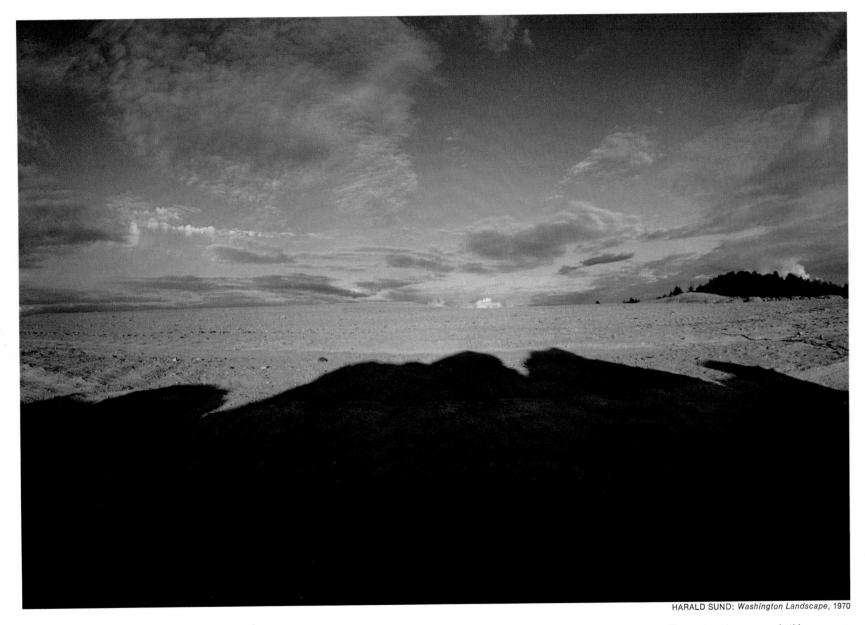

HARALD SUND: *Washington Landscape*, 1970

◄ To produce this exaggerated close-up of a stone the photographer used a system that was certain to throw perspectives askew: a 35mm camera fitted with a super-wide-angle 18mm lens. By aiming at the stone from only two feet away, he distorted it like a face in a fun-house mirror. The ground seems to recede to infinity, and the curved horizon suggests the curvature of the earth.

The vast, austere spaces in this scene are expanded still further by the wide-angle effects of an 18mm lens. The photographer set up his camera in the shadow of a rock formation, and aimed it level with the horizon. If the horizon had not crossed the exact midpoint of the picture, distortion from the lens would have caused it to curve, like the two tracks in the middle ground.

217

The Long Lens for Bringing the Subject In

Since time out of mind, an ability to move mountains has been considered the ultimate in miracle-working; even the Prophet Mohammed, in the well-known parable, could not make the mountain come to him. But the landscape photographer of today has just the tool to perform this marvel. By using the magnifying properties of a telephoto lens, he can reach out into the distance and make the mountain appear, at least, to come a good part of the way to him.

Besides giving the photographer the ability to bring distant things closer, long lenses can conjure up another intriguing creative effect. Because they flatten perspective, they can reduce the sense of three dimensions in a scene, and transform a three-dimensional landscape into a strong, graphic pattern of two-dimensional shapes. In the picture at far right, which was shot with a powerful 500mm telephoto lens, the distant trees at the upper left-hand corner are almost as large as the nearest ones in the lower right corner. To the eye, therefore, they appear to be equally close to the viewer. As a result, the picture becomes a visual tapestry of dark evergreens set in diagonal rows against a light green field.

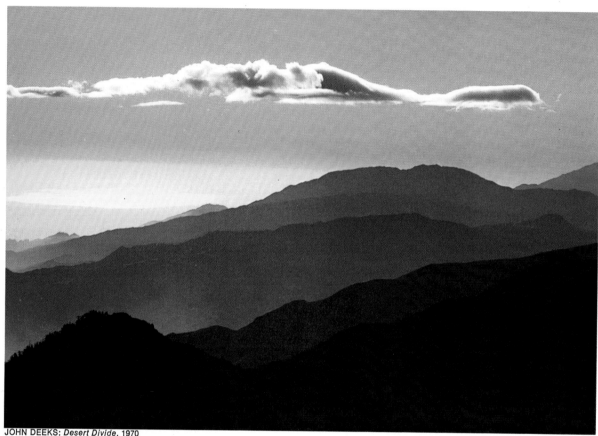

JOHN DEEKS: *Desert Divide*, 1970

Like flat paper cutouts, overlapping peaks of the San Bernardino Mountains become in this photograph a study of patterns. A 105mm long lens, combined with backlighting from the rising sun that turned the mountains into silhouettes, created the two-dimensional effect shown above.

A mountainside in Jasper National Park was ▶ transformed into a pattern of green on green when shot through a powerful 500mm telephoto lens. Because the day was overcast, shadows were too subdued to show much modeling of forms—thus further removing the sense of three dimensions.

MICHAEL FOSTER: *Trees on Mountainside*, 1967

The Changing Spectacle of Natural Light

CHARLES PRATT: *Glacial Snow,* 1967

SONJA BULLATY—ANGELO LOMEO: *Spring Leaves*, 1969

Judicious backlighting from the rays of the late afternoon sun gave the trees on this Vermont hillside their golden luminosity. The valley behind them, already in shadow, photographed a subtly contrasting blue. To enhance the golden tint of the leaves, the photographer took the scene through a yellowish light-balancing filter that is designed to give warmth to color pictures.

◄ *Cool, muted colors—plus a finely balanced composition—distinguish this glimpse of lingering winter snow, taken in June, on a ridge in Canada. Just enough light filtered through the overcast sky to bring out the jagged texture of the land and the shapes of the bushes in the middle ground.*

Light—the landscape photographer's most essential tool—is the one element that he is least able to control. Unlike the studio photographer with his flood lamps or the animal photographer with his flash or strobe, the landscapist must take his light as he finds it or wait until it changes by itself.

The changes can, however, produce spectacular effects. The slightest turn in the weather transforms the look of the land. The muted, opalescent illumi-nation of an overcast day brought out the subtle gradations of tones and colors in the scene at left; bright sunlight and strong shadows would have de-stroyed the subtle effect.

Besides picking his time, the landscape photographer can also shift his position in relation to the light source. The picture above was made facing into the afternoon sun. Its light, shining through the trees from behind, turned the leaves into brilliant flecks of gold.

221

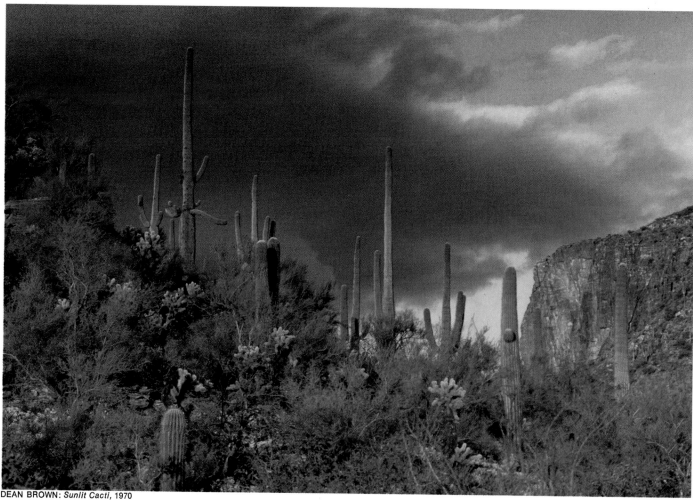

DEAN BROWN: *Sunlit Cacti,* 1970

The gradual change of light through the day can be as useful to the photographer as the dramatic contrasts brought on by the weather. Landscape painters have always been keenly sensitive to the subtle changes in daylight.

Light changes color because of the way the earth's atmosphere filters the rays of the sun: it tends to block out bluish tones and let reds and oranges pass through. Thus in early morning, when the sun is low in the sky and its rays travel obliquely through the atmosphere, most of the blue is sifted out. Objects have a warm cast, but shadows, which take their color from reflected skylight, are bluish. At high noon, when sunlight travels its shortest route through the atmosphere, less blue is filtered out and the light is closer to white. Colors are stronger than at any other time, contrasts greater, and shadows are black. Toward sunset, the light warms up again, and shadows become longer, softer and bluer. But the minute the sun goes down, the light changes dramatically. The world is suffused with blues and purples reflected from the sky and clouds.

All these changes in the quality of light give the landscape photographer an invaluable set of controls over the tones in his picture. To get the colors he wants—warm or cool, delicate or strong—he simply chooses the appropriate time of day.

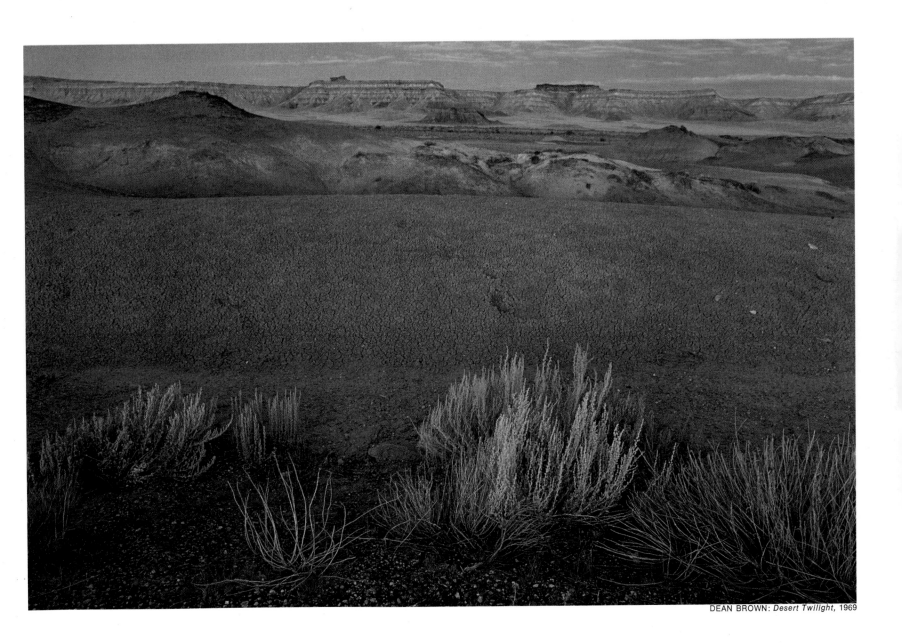

DEAN BROWN: *Desert Twilight,* 1969

◄ Nowhere is the change of daylight more obvious than in the desert, where skies are bright and luminous and clouds sometimes pick up reflected colors from the land. In this picture, taken an hour before sundown in the Sonoran Desert near Tucson, Arizona, the last afternoon light casts such a rich, warm glow over the landscape that even the cacti are tinted a vibrant gold.

After sunset the Arizona desert becomes a world without shadows, painted in varying tones of pink and purple by indirect light still lingering in the sky when the sun sinks below the horizon. Light fades so quickly after sundown that it is difficult to judge exposures. For this picture Dean Brown bracketed his exposures widely; the best one (above) was taken at f/8 and 1/15 second.

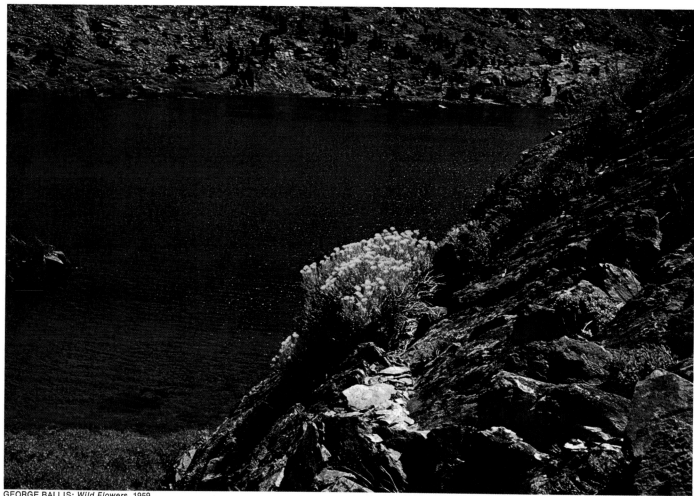

GEORGE BALLIS: *Wild Flowers*, 1959

Most color-photography manuals contain dire warnings against photographing scenes with strong contrasts of light and dark. The problem can be particularly frustrating when photographing landscapes. The brilliant rays of the midday sun invariably cast dense, impenetrable shadows. One reason why many photographers prefer to shoot on overcast days is that contrasts are softer, and film can register detail in both light and dark areas.

With some subjects, contrast is built in. Fresh snow under direct sunlight is so dazzlingly bright that trees and houses seem black by comparison; photographers often wait until evening, when the low-lying sun creates shadows that bring out the shapes of drifts. In woodland scenes, the dappled light that filters through overhead leaves will overexpose color film so that it appears as spots of pure white.

Yet some photographers search out strong contrast on purpose, to create special effects. In both of the pictures on these pages, the lighting seems almost theatrical, as though arranged by a stage electrician's spotlights. In both cases, the photographers selected scenes where contrasts were too intense for the capabilities of the film. By exposing for the highlights, they let large sections of the film go completely dark, in a way that gave dramatic power to otherwise ordinary scenes.

Two kinds of contrast make this clump of wild flowers seem vivid. Backlighting from the sun casts sparkling highlights across the flowers and the tops of the surrounding rocks. By deliberately underexposing, the photographer captured the sparkle, but left the shadows dim. The other contrast is color—the brilliant yellow of the flowers against the dull blues and greens of the water and the foliage. If the flowers had been violets, the picture would have lost much impact.

A perfect natural spotlight penetrates the forest darkness, giving drama to this woodland scene. By taking his meter reading from the bright area, the photographer kept the dark section underexposed, so that the predominant color in the picture is black. The pool of light on the forest floor and the colors of the background trees seem particularly brilliant by contrast.

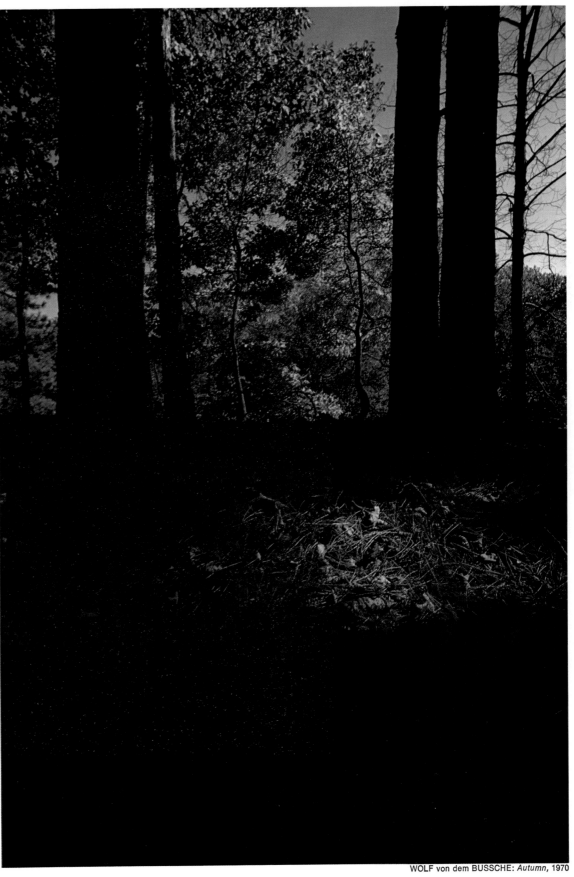

WOLF von dem BUSSCHE: *Autumn,* 1970

225

Shooting into the Sun

One of the most spectacular ways of using light in a landscape is to show its source—the sun itself. Strange things may happen, but if the photographer knows how to control them he can create images of surpassing beauty.

The first problem is exposure. If the photographer follows the usual rule of thumb when shooting into the light, exposing for shaded areas in the foreground to preserve their detail, he will almost invariably overexpose. When a bright sun is part of the picture, its light is so intense that it can bleach out all other images. But if he deliberately underexposes the foreground, he will get vigorous silhouettes against the overwhelmingly bright background.

Other problems arise from the way strong, direct light behaves when it enters a camera head on. Some of it bounces around erratically inside the lens, causing flare—a phenomenon in which stray light makes spots on the negative. Flare spots can never be eliminated altogether, but they can be reduced—in size by setting the diaphragm at its smallest aperture, and in number by shielding out errant rays with a lens hood. A similar phenomenon comes from the fact that intense light, passing through a small hole such as a diaphragm opening, appears starshaped. The result can be either disastrous or evocative *(near right)*, depending on the skill of the photographer.

With sunsets, flare is no problem, because the sun has lost most of its intensity. But exposure can be extremely tricky, for the light falls off from minute to minute. One solution is to take a meter reading from the sky, and then take pictures at both longer and shorter settings than the one indicated.

HARALD SUND: *Tree with Sun,* 1969

Both the darkness of night and the brilliance of daytime seem combined in this image of tree limbs against the sun. By using the fastest exposure possible (1/1000 second at f/22), the photographer turned the branches into a pattern of black. To give the sun its starlike flare, he framed it between two limbs; the small opening acted like a pinhole to diffract the sun's rays.

STEPHEN GREEN-ARMYTAGE: *Winter Sunset*, 1963

An orange sun dominates this moody vista of an English pasture on a late afternoon in winter. A 135mm telephoto lens brought the sun and background closer. By exposing for the sunset colors in the sky, the photographer reduced the trees in the middle ground to a bleak, wintry silhouette, and transformed the cattle in the foreground into dark, ghostlike presences.

A Fresh View of a Familiar Spectacle

MICHAEL FOSTER: *Niagara Falls, 1966*

One of the landscape photographer's most difficult challenges is to find an original approach to a well-known, frequently photographed scene. It was easier for the itinerant landscape photographers of the 19th Century. In those days each picture was a revelation. Few people had ever glimpsed such awesome mountains, such vertiginous gorges or such breathtaking waterfalls. But after the viewer has seen his first dozen pictures of the Grand Canyon, the scene begins to lose its impact.

Still, the best photographers do find ways to bring a fresh eye to familiar places. George Silk, on landscape assignments for LIFE, invariably shoots several throwaway rolls of film "to get the clichés out." Other photographers make practice runs, clicking the shutter without film in the camera, until they get the feel of their subject. Michael Foster spent a day wandering around Niagara Falls, looking for new moods and perspectives, before hitting upon the mist-drenched view at left. "The best way to photograph a landscape," says Foster, "is to let the atmosphere of the place guide the camera." ☐

This photograph probably could not have been made anywhere but Niagara Falls; no other cataract in the world has quite the same monumental breadth or disgorges such a thunderous volume of water. But how to take a new and different picture of Niagara Falls? This one, taken on a slightly overcast day, shows the falls in a fresh light—with mist from the cascading water softening the shapes of birds and rocks in the foreground and enveloping the entire scene in a delicate pearly gray.

Bibliography

General

Faulkner, Douglas, and C. Lavett Smith, *The Hidden Sea*. Viking, 1970.
Feininger, Andreas:
Feininger on Photography. Crown Publishers, 1953.
The Focal Encyclopedia of Photography. Focal Press, 1960.
Successful Color Photography. Prentice-Hall, 1968.
†Jonas, Paul, *Improved 35mm Techniques*. Amphoto, 1967.
Kinne, Russ, *The Complete Book of Nature Photography*. Amphoto, 1971.
†Linton David, *Photographing Nature*. The Natural History Press, 1964.
†Modern Photography editors, *Photo Information Almanac, '71*. The Billboard Publishing Co., 1971.
Rhode, Robert, and Floyd McCall, *Introduction to Photography*. Macmillan, 1966.
Stix, Hugh and Marguerite, and R. Tucker Abbott, *The Shell: Five Hundred Million Years of Inspired Design*. Abrams, 1968.

History

Gernsheim, Helmut and Alison, *The History of Photography*. McGraw-Hill, 1969.
Jackson, William H., and Howard R. Driggs, *The Pioneer Photographer: Rocky Mountain Adventures with a Camera*. World Book Company, 1929.
Johnson, Martin:
Lion. Putnam, 1929.
Over African Jungles. Harcourt Brace, 1935.
Safari. Grosset and Dunlap, 1928.
Kearton, Richard, *Wild Life at Home: How to Study and Photograph It*. Cassell and Company, 1901.
Maxwell, Marius, *Stalking Big Game with a Camera*. Medici Society, 1924.
Stenger, Erich, *The March of Photography*. Focal Press, 1958.
*Taft, Robert, *Photography and the American Scene*. Dover, 1964.

Wallihan, Allen:
Camera Shots at Big Game. Doubleday, 1901.
Hoofs, Claws and Antlers of the Rocky Mountains. Frank S. Thayer, 1894.

Techniques

Adams, Ansel, *Camera and Lens*. Morgan & Morgan, 1970.
Croy, Otto R., *Camera Close Up: Same Size and Larger than Life Photography*. Focal Press, 1961.
Dobbs, Horace, *Camera Underwater: A Practical Guide to Underwater Photography*. A. S. Barnes, 1962.
Eastman Kodak:
†*Close-Up Photography*. Eastman Kodak, 1969.
†*Filters for Black and White and Color Pictures*. Eastman Kodak, 1967.
†*Photomacrography*. Eastman Kodak, 1969.
Frey, Hank, and Paul Tzimoulis, *Camera Below: The Complete Guide to the Art and Science of Underwater Photography*. Association Press, 1968.
†Greenberg, Jerry, *Underwater Photography Simplified*. Seahawk Press, 1969.
Mertens, Lawrence, *In-Water Photography*. John Wiley, 1970.
Papert, Jean, *Photomacrography: Art and Techniques*. Amphoto, 1971.
Rebikoff, Dimitri, and Paul Cherny, *Underwater Photography*. Amphoto, 1965.
Simmons, Robert, *Close-up Photography and Copying*. Amphoto, 1961.
Tölke, Arnim and Ingeborg, *Macrophoto and Cine Methods*. Focal Press, 1971.

Field Guides

†Bean, L. L., *Hunting, Fishing and Camping*. L. L. Bean, 1969.
Bridges, William, *The Bronx Zoo Book of Wild Animals*. Golden Press, 1968.
Brockman, C. Frank, *Trees of North America*. Golden Press, 1968.
Burt, William H., and Richard P. Grossenheider, *A Field Guide to the Mammals*. Houghton Mifflin, 1964.

Conant, Roger, *A Field Guide to Reptiles and Amphibians*. Houghton Mifflin, 1958.
Greenewalt, Crawford, *Hummingbirds*. Doubleday, 1960.
†Harrington, H. D., and L. W. Durrell, *How to Identify Plants*. Swallow Press, 1957.
Klots, Alexander B., *A Field Guide to the Butterflies*. Houghton Mifflin, 1957.
LIFE Nature Library. TIME-LIFE Books
Lutz, Frank E., *Field Book of Insects*. Putnam, 1948.
Morris, Percy, *A Field Guide to the Shells*. Houghton Mifflin, 1951.
Peterson, Roger Tory:
A Field Guide to the Birds. Houghton Mifflin, 1968.
A Field Guide to Western Birds. Houghton Mifflin, 1961.
Peterson, Roger Tory, and Margaret McKenny, *A Field Guide to Wildflowers of Northeastern and North-Central North America*. Houghton Mifflin, 1968.
Petrides, George A., *A Field Guide to Trees and Shrubs*. Houghton Mifflin, 1958.
†Sargent, Charles S., *Manual of the Trees of North America*. Dover, 1961.
Stebbins, Robert C., *A Field Guide to Western Reptiles and Amphibians*. Houghton Mifflin, 1966.
Urry, David and Kate, *Flying Birds*. Harper & Row, 1970.

Recordings

American Bird Songs, Volumes I and II. Cornell University, 1954.
A Field Guide to Bird Songs. Houghton Mifflin, 1959.
A Field Guide to Western Bird Songs. Houghton Mifflin, 1962.
Mexican Bird Songs. Cornell University, 1958.
Songbirds of America. Cornell University, 1954.
Voices of African Birds. Cornell University, 1958.

*Also available in paperback.
†Available only in paperback.

Acknowledgments

For assistance given in the preparation of this volume, the editors would like to express their gratitude to the following persons and institutions: Ansel Adams, Carmel, California; William E. Congdon, South Glens Falls, New York; Dr. J. A. L. Cooke, the American Museum of Natural History, New York, New York; Ruth Dugan, Los Angeles, California; David Epp, The Sierra Club, New York, New York; Douglas Faulkner, Summit, New Jersey; Dr. Hank Frey, New York, New York; Ken Froehly, The Sierra Club, New York, New York; Frederick A. Hetzel, Director, University of Pittsburgh Press, Pittsburgh, Pennsylvania; Robert B. Inverarity, Director, Philadelphia Maritime Museum, Philadelphia, Pennsylvania; Nina Leen, New York, New York; Leica Technical Service, E. Leitz Inc., Rockleigh, New Jersey; Thomas W. Martin, New York, New York; Leonard McCombe, New York, New York; Dr. and Mrs. Roger Tory Peterson, Old Lyme, Connecticut; Coles H. Phinizy, Senior Editor, SPORTS ILLUSTRATED, New York, New York; George A. Tice, Colonia, New Jersey; Bradford Washburn, Director, The Museum of Science, Boston, Massachusetts.

Picture Credits

Credits from left to right are separated by semicolons, from top to bottom by dashes.

COVER: Horst Haider from Meisterfotos Folge IV Ehapa Verlag; Paul Caponigro.

Chapter 1: 11—A. G. Wallihan. Reprinted from *Camera Shots at Big Game,* courtesy Doubleday and Co. 12—William Henry Fox Talbot, courtesy The Metropolitan Museum of Art, Harris Brisbane Dick Fund, 1936. 13—Photo Musée National d'Histoire Naturelle, Paris. 15—William H. Jackson, courtesy Denver Public Library, Western Collection. 17—A. G. Wallihan. Reprinted from *Camera Shots at Big Game,* courtesy Doubleday and Co. 21—Bradford Washburn. 22, 23—Eric Hosking. 24, 25—Ralph Morse. 26—George A. Tice. 27—Franz Lazi, Stuttgart. 28—John F. Deeks. 29—Nicholas Foster. 30—Dr. J. A. L. Cooke. 31—Douglas Faulkner. 32—Roloff Beny. 33 —Tom Tracy from Photofind. 34, 35—Co Rentmeester for LIFE. 36, 37—Carl W. Rettenmeyer. 38, 39—John Dominis for LIFE. 40, 41, 42—Eliot Porter. Photographs reprinted from *Glen Canyon: The Place No One Knew,* Sierra Club, 1964.

Chapter 2: 45—Richard Kearton, copied by Derek Bayes, courtesy The Nature Conservancy. 57

—Roger Tory Peterson. 58—Marjorie Pickens. 59 —Thomas W. Martin from Rapho Guillumette. 60, 61—Dr. J. A. L. Cooke. 62, 63—Roger Tory Peterson. 65—Thomas W. Martin from Rapho Guillumette. 66, 67—Dmitri Kessel for LIFE. 68, 69—Arthur Swoger. 71 through 76— Thomas W. Martin from Rapho Guillumette.

Chapter 3: 79—Helen Buttfield. 83—Al Freni. 84 through 93—Ken Kay. 94—Chart by Martus Granirer. 95—Al Freni. 96 through 101—Ken Kay except 99—Nicholas Fasciano. 103—Walter Iooss Jr. 104, 105—Nicholas Foster. 106, 107—Walter Iooss Jr. 108—Robert Walch. 109—Stephen Green-Armytage. 110, 111—John P. Porter III. 112 —Gerald Jacobsen. 113—Stephen Green-Armytage. 114—Dr. J. A. L. Cooke. 116, 117—Dr. Roman Vishniac—Terence Shaw from Annan Photo Features. 118—Joseph Adams from Frederic Lewis. 119—Dr. Alexander B. Klots. 120, 121, 122—Dr. J. A. L. Cooke.

Chapter 4: 125—Dr. Hank Frey. 127—Louis Boutan, copied by J. R. Eyerman, courtesy Mrs. Ruth Dugan, Los Angeles. 128—Bernard Aronson

Inc., Courtesy Philadelphia Maritime Museum.131 —Drawing by Kathleen Tanaka. 137 through 144 —Douglas Faulkner.

Chapter 5: 147—Orion Press-Pix. 149—Maitland A. Edey. 155 through 169—Maitland A. Edey. 170 —Nina Leen for LIFE. 172, 173—Douglas Faulkner. 175—Philip Teuscher. 176, 177—Dr. Jörg Hess-Haeser, Basel. 178—Helen Greenway. 179 —Philip Teuscher. 180, 181—Al Freni. 182 through 186—Nina Leen for LIFE.

Chapter 6: 189—Ansel Adams. 194, 195—George Haling. 196, 197—Wolf von dem Bussche. 198 —John Senzer—Al Freni. 199—John Senzer—Al Freni. 200, 201—Wolf von dem Bussche. 202 through 207—Robert Walch. 209—George A. Tice. 210—Wolf von dem Bussche. 211, 212—George A. Tice. 213—Nicholas Foster. 214—Michael Foster. 215—Robert Walch. 216, 217—Harald Sund. 218 —John F. Deeks. 219—Michael Foster. 220 —Charles Pratt. 221—Bullaty-Lomeo from Rapho Guillumette. 222, 223—Dean Brown. 224—George Ballis from Photofind. 225—Wolf von dem Bussche. 226—Harald Sund. 227—Stephen Green-Armytage. 228—Michael Foster.

Index *Numerals in italics indicate a photograph, painting or drawing of the subject mentioned.*

Printed in U.S.A.